A History of the Boston & Maine Railroad

A History of the
Boston & Maine Railroad

Exploring New Hampshire's Rugged Heart by Rail

Bruce D. Heald

Published by The History Press
Charleston, SC 29403
www.historypress.net

Copyright © 2007 by Bruce D. Heald
All rights reserved

Front cover: The Profile & Franconia Notch Railroad was a narrow-gauge line that served the Profile House and the Maplewood Hotel. This short line went as far as Bethlehem. Above the train station is Eagle Cliff (left) on Mount Lafayette. *Courtesy of the B&M Railroad Historical Society.*

Unless otherwise noted, all images courtesy of the author.

First published 2007

Manufactured in the United Kingdom

ISBN 978.1.59629.360.1

Library of Congress Cataloging-in-Publication Data
Heald, Bruce D., 1935-
 A history of the Boston & Maine Railroad : exploring New Hampshire's rugged heart by rail / Bruce D. Heald.
 p. cm.
 Includes bibliographical references.
 ISBN 978-1-59629-360-1 (alk. paper)
 1. Railroads--New England. I. Boston and Maine Railroad. II. Title.
 TF23.15.H43 2007
 385.0974--dc22
 2007035334

Notice: The information in this book is true and complete to the best of our knowledge. It is offered without guarantee on the part of the author or The History Press. The author and The History Press disclaim all liability in connection with the use of this book.

All rights reserved. No part of this book may be reproduced or transmitted in any form whatsoever without prior written permission from the publisher except in the case of brief quotations embodied in critical articles and reviews.

The story of the Boston & Maine must be told to remind us of the joy and pleasure it brought to the many vacationers and commuters in New Hampshire during the nineteenth and twentieth centuries.

Contents

Foreword, by Frederick N. Nowell III ... 9
Acknowledgements ... 11

Chapter One A New Hampshire Dynasty Is Born ... 13
Chapter Two The White Mountains Division: Merrimack Valley ... 25
Chapter Three The White Mountains Division:
 Pemigewasset and Franconia Valley ... 37
Chapter Four The Moosilauke & Jefferson Route:
 Valley of the Ammonoosuc ... 51
Chapter Five The Eastern Division (Maine Central Mountain Division):
 Boston to North Conway, New Hampshire ... 65
Chapter Six The Logging Railroads in the White Mountains ... 89

Bibliography ... 127

Foreword

While the Boston & Maine Railroad operated in Massachusetts, Maine, Vermont and New York, in none of those states was it as woven into the fabric of daily life as it was in New Hampshire. From 1895, when it acquired the Concord and Montreal Railroad and gained nearly total hegemony in the Granite State, until the end of World War I, when the automobile took hold, nearly everyone and everything that moved into and out of New Hampshire was carried on the B&M.

Visualize, if you can, a New Hampshire of not so long ago where paved roads are a rarity and the motorcar is nowhere to be seen. How will you visit your relatives in Claremont? How will your son get to school at Exeter or your daughter at Durham? How will the new icebox you ordered get to the local hardware store? How will the summer people who patronize your shop arrive in town? How will you escape the routine cares of daily existence for a trip to the World's Fair?

With relentless regularity the B&M conveyed the mail, carried the milk and delivered the flour, nails, stoves, newspapers and all the necessities of life. It did this in all kinds of weather, answering only to the demands of the timetable and the staccato click of the dispatcher's telegraph key.

And if the humdrum regimen of the B&M at work fails to conjure up appropriate images in the mind's eye, turn its gaze to where the B&M's myriad main lines and branches reached deep into the rural recesses of New Hampshire, bringing tourists and summer campers to its places of unparalleled beauty. If the B&M did not originate the tourism industry in New Hampshire, it surely institutionalized it. And if the automobile brought New Hampshire's recreational reputation to the broadest audience, it was the B&M and its predecessors that set the stage and created the demand.

Through its depot gateways summer visitors debarked from trains originating in Boston, New York or Philadelphia to enjoy the New Hampshire seashore, its refreshing lakes and its romantic hill towns.

Foreword

What are today's links with New Hampshire's railroad past? Some of the depot gateways, Ashland and Lisbon for example, have been restored by civic-minded citizens; still others have been thoughtfully preserved by their owners. The archaeologically inclined can trek through the woods or follow rail trails to discover bridges, culverts, mileposts and other evidence of the old B&M. Though most of the trains are gone, at least three scenic railroads polish rails that would otherwise have been abandoned.

For many of us, though, it is the photograph and the written word that remind us best of the time when vaporous clouds surrounded a steam engine on a cold day, when the streamlined Mountaineer was boarding at Fabyan's or when a visit to the depot found the freight men unloading from the flatcar anything from soup to nuts.

With Dr. Bruce D. Heald—college professor, veteran purser of the Mount Washington and keen observer of everyday life in New Hampshire—as your tour guide and the photos and materials of the Boston & Maine Railroad Historical Society Archives as your inspiration, come aboard with us and spend a few relaxing hours looking out a parlor car window in the days of the New Hampshire dynasty.

<div style="text-align: right;">
Frederick N. Nowell III

Author/Archivist for the

Boston & Maine Railroad Historical Society
</div>

Acknowledgements

I would like to thank the following people and organizations for their assistance: John C. Alden, John Anderson, the Appalachian Mountain Club, Charles E. Beals, Francis C. Belcher, the Boston & Maine Railroad Historical Society, Waldo G. Browne, Frank H. Burt, A.W. Cooper, Alfred K. Chittenden, Samuel A. Drake, Bill Gove, Karl P. Harrington, G.L. Johnson, Charles Kennedy, Thomas Starr King, Frederick W. Kilborne, Lisa B. Mausolf, J.W. Meader, H.H. Metcalf, James Nigzus, Frederick N. Nowell III, Henry V. Poor, Richard H. Sewell, Agnus Sinclair, M.F. Sweetzer, Stuart R. Wallace, the New Hampshire Department of Transportation, Reverend Julius H. Ward, the White Mountain Region Association and Arnold H. Wilder.

CHAPTER ONE

A NEW HAMPSHIRE DYNASTY IS BORN

There is no question among most railroad historians of New England that the Boston & Maine Railroad ranks as one of the most important rail systems in the Northeast. In less than sixty years, the Boston & Maine rightfully became a railroad dynasty.

The earliest date for the birth of the Boston & Maine Railroad is 1833, when the line was chartered under the name Andover & Wilmington Railroad. This was an eight-mile line in Massachusetts, which was intended to connect the towns of Andover and Boston over the tracks of the Boston & Lowell Railroad. It was recorded that the line was opened in 1836, its major stockholder being the Andover Academic and Theological Seminary.

In 1835, the stagecoach system and river boating companies were well established and New Hampshire folks felt that they were well-off as far as transportation was concerned. They paid little attention to any rumors about steam railroads. Then in a few years there was talk of running a railroad into New Hampshire. People everywhere fought the idea. They said these funny little engines and their trains of little cars would scare the cows, stop the hens from laying and set fire to their fields and forests. But the railroads came just the same.

In 1835, the Boston & Maine acquired a New Hampshire charter and was incorporated as a separate New Hampshire entity called the Boston & Maine Railroad. That same year the line was opened from the Massachusetts state line to Exeter in 1840 and to Dover, New Hampshire, in 1841. Soon after, a charter was procured for the rest of the planned extension to be known as the Maine, New Hampshire & Massachusetts Railroad. The strategy of incorporating in all three states soon proved to be crucial in the future development of the railroad line.

According to the New Hampshire Department of Transportation records:

> *No sooner had New Hampshire begun to build railroads than politicians in Concord got into the act. New Hampshire, at the time, was dominated by the Democratic Party, but*

A History of the Boston & Maine Railroad

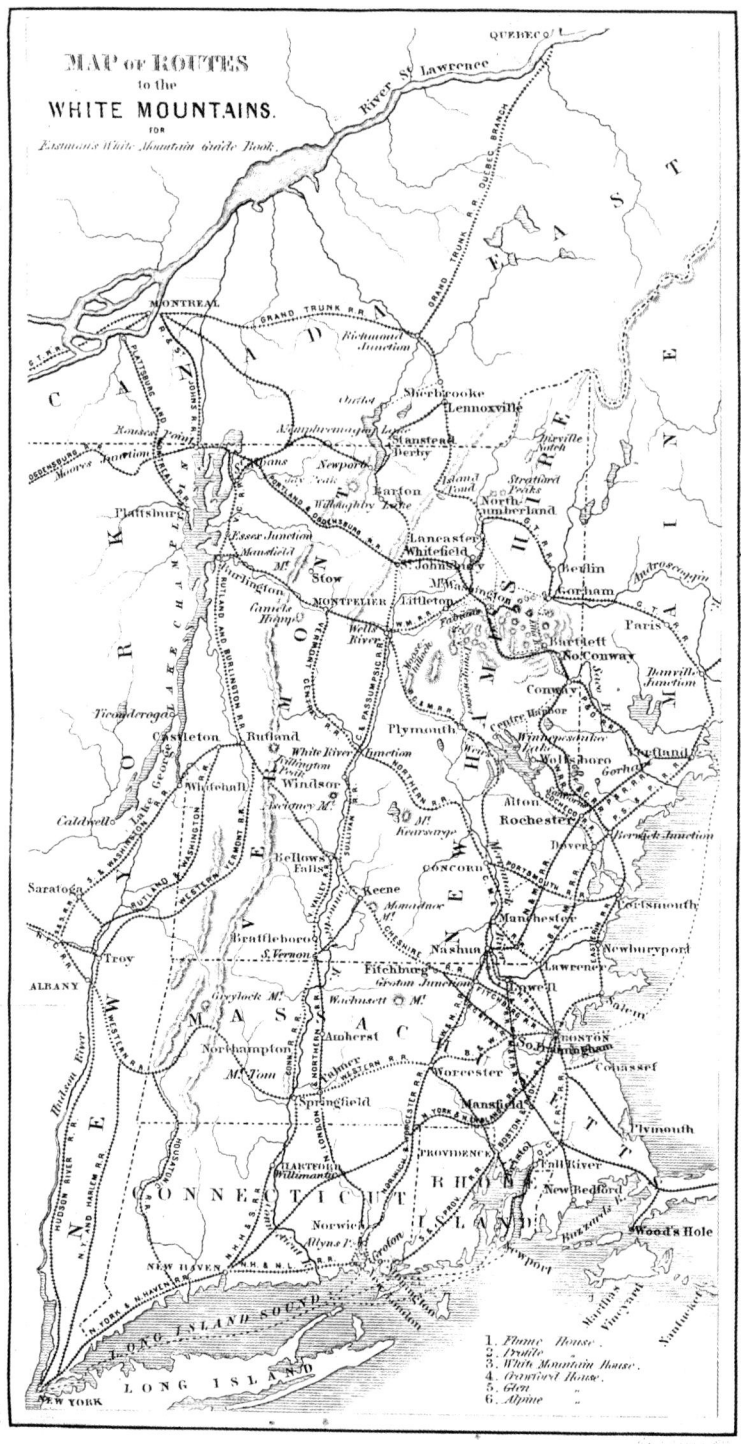

A map of routes to the White Mountains—*Eastman's Guide* late 1878. This map shows many of the independent railroad lines throughout New England and eastern New York before consolidation in the 1890s with the Boston & Maine.

on the railroad issue, the Democrats were split. A group of young radical Democrats led by Franklin Pierce and John Parker Hale argued that railroads should not be given the right to take land by eminent domain, but instead should negotiate with local landowners to determine if they could purchase land and at what cost. Radicals also argued that stockholders in all corporations should not be granted limited liability, but should be liable for all corporate departments. The more conservative Democrats, led by Isaac Hill, a director of the Concord Railroad at the time, felt the radical position was unworkable, and that railroads should actually be thought of as public entities, since they derived their corporate charter from state government and they provided a public service. If they were not allowed to acquire rights-of-way by eminent domain, then a single landowner could in theory stop a railroad from being constructed. The Hill Democrats further argued that in order to encourage investment in New Hampshire's transportation and industrial infrastructure, stockholders must be granted limited liability. Toward that end, they had won passage of a limited liability act in 1837.

According to the Boston & Maine Railroad Transportation records:

At the time railroad construction stopped in New Hampshire, the state had four lines in operation or nearing completion. A state law passed in 1843 designated a corporate headquarters for each. The Concord Railroad had it headquarters in Concord, the Eastern in Portsmouth, the Boston & Maine in Dover, and the Nashua & Lowell in Nashua.

Due to the legislative compromise of 1844 the floodgates were open for railroad interests in the state. Ten new railroads were chartered and between 1845 and 1850 there were an additional twenty-nine railroad charters. In 1860, Henry V. Poor published his *History of the Railroads and Canals of the United States of America*, in which he listed no fewer than fifty-seven railroads that had become incorporated in New Hampshire.

Now as communities grew and railroads merged and developed more capital, newer and larger passenger stations and depots began to replace the earlier structures. Expansion of the lines and their facilities grew with the times. A good example may be cited with the city of Concord, which had five passenger depots. Needless to say the newer station was more elaborate. Others were multi-story buildings. However, the railroads needed more than passenger and freight depots. They needed larger and more efficient yards that would service their rolling stock. Each railroad had at least one main yard, complete with shops needed to keep the trains in proper operation. The shops at Lake Port Village constituted the main yard for the Boston, Concord & Montreal Railroad, but as the company acquired the White Mountain Railroad and began expanding north, it became necessary to construct more yards.

July 3, 1869 marked the completion of the Mount Washington Railroad, better known as the Cog Railway, to the summit of Mount Washington. This was the first cog railway in the world.

The railroads were certainly making their impact on the nation. New railroad companies were being chartered, new tracks were being laid and industrial centers were

being constructed in the state. Factories were fast becoming capable of transporting unimaginable quantities of raw materials through this new form of transportation. Industry now had the means to deliver raw materials and finished products of every description throughout the country. Even the farmers noticed the change that was brought about by the railroad. They took advantage of this service, and noted that they could have beef, grain and wool brought to New Hampshire from the West and Midwest for less money than these items could be grown or raised locally. The New Hampshire farmers also turned their attention to perishable commodities like fruits, vegetables, butter, cheese and milk, all of which found their way by rail to nearby urban centers like Boston and Portland, Maine.

The tourist industry was progressively changing as well. They began traveling to the coast and particularly to the White Mountains in unprecedented numbers. The railroads took advantage of this new opportunity of travel and permeated every aspect of life in New Hampshire. In 1883 everyone in the Granite State began operating on "railroad time." Even the New Hampshire General Court scheduled its sessions in Concord to be compatible with train timetables. Local merchants as well as managers of White Mountain's "grand hotels" utilized the railroads "next day" service.

In 1872, a new Boston & Maine steam side-wheeler was built and launched on Lake Winnipesaukee at Alton Bay, which was christened the *Mount Washington*. It was longer, faster and more beautiful than any side-wheeler ever built in the United States up to that time. To compete with the Winnipesaukee Steamboat Company, later owned and operated by the Concord and Montreal Railroad, it had become the intent of the Boston & Maine Railroad to tap into the tourist business in the lakes and mountains of the state.

The growth of the railroad made it possible for New Hampshire residents to travel anywhere in New England and farther. Railroads also changed the shape of the villages—their stations became the hearts of the community, centers of manufacturing and commerce.

In 1886 the Boston & Maine Railroad system comprised, in addition to the main line, the Great Falls, now Somersworth branch; West Amesbury branch, Eastern in New Hampshire; Portsmouth, Great Falls & Conway; Wolfeboro, Portsmouth & Dover; and Worcester, Nashua & Portland, for a total mileage in New Hampshire of 227.54 miles.

In 1887, the Boston & Maine successfully negotiated the lease of the Boston & Lowell Railroad and its associated lines. During that same year the Portland & Rochester became absorbed by the Boston & Maine, and the Boston & Maine Railroad, under Frank Jones, obtained a lease for the Manchester & Lawrence Railroad, in hopes of putting pressure on the Concord Railroad. This act led to the railroad war of 1887, pitting the Concord against the Boston & Maine. The B&M sponsored the Hazen Bill, while the Concord sponsored the Atheton Bill. The Hazen Bill passed the General Court only to be vetoed by Governor Charles H. Sawyer. Both bills were for the purpose of obtaining control of the Northern and the Boston, Concord & Montreal Railroads. The strategy of incorporating separately in the three states enabled the Boston & Maine to gain control and gain a favorable position. The Boston & Maine signed a fifty-four-year lease for the Eastern Railroad Company, thereby allowing the Boston & Maine to consolidate the line completely under its eventual ownership in 1890.

A New Hampshire Dynasty Is Born

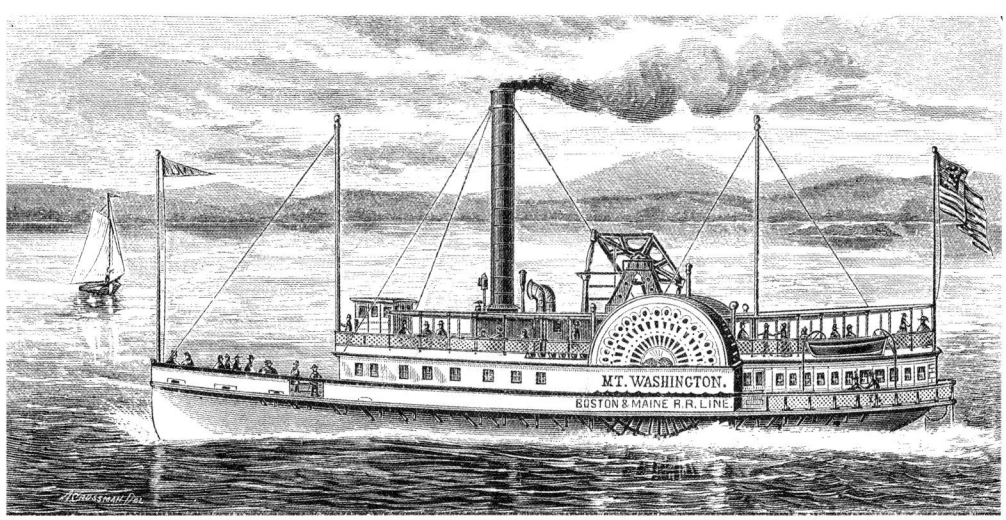

The side-wheeler *Mount Washington* on Lake Winnipisieogee (Winnipesaukee) during the 1890s.

On July 24, 1889, the New Hampshire General Court passed a railroad bill that allowed the Boston & Maine to lease the Northern Railroad, among others, and the Concord to unite with the Boston, Concord & Montreal, forming the new Concord & Montreal Railroad (New Hampshire Railroad Corporation). This was a sweeping piece of railroad legislation, authorizing a substantial number of combinations and virtually dividing New Hampshire between the Boston & Maine and Concord Railroads.

At this time it was said, and I quote from the New Hampshire Department of Transportation, that "no matter who was elected governor, the real governor of New Hampshire was the president of the Boston & Maine Railroad."

In 1893, A.A. McLeod assumed the presidency of the B&M, and Frank Jones became the chairman of the board. The very next year, J.P. Morgan forced McLeod out of the Boston & Maine and removed Frank Jones as chairman. Lucius Tuttle became the new B&M president; however, the Boston & Maine was largely controlled by S.C. Lawrence, American Express and Pullman. Tuttle was able to lease two major lines: the 424-mile Concord & Montreal Railroad in 1895 and the 478-mile Fitchburg system in 1900. With these acquisitions, the Boston & Maine Railroad truly became a dynasty and was able to compete more effectively with other major railroad systems on the East Coast.

The Boston & Maine was known throughout the nineteenth century as one of the most conservatively run railroads in the nation. The management was also considered among the finest, for they concentrated on maintaining the quality of the physical plant and improving the company's community image through their superior service and attractive fair rates.

At the beginning of the twentieth century, the Boston & Maine operated on 2,324 miles of track and controlled forty-seven major and minor independent lines in central and northern New England. It is interesting to note that the company only owned 519 miles of

A History of the Boston & Maine Railroad

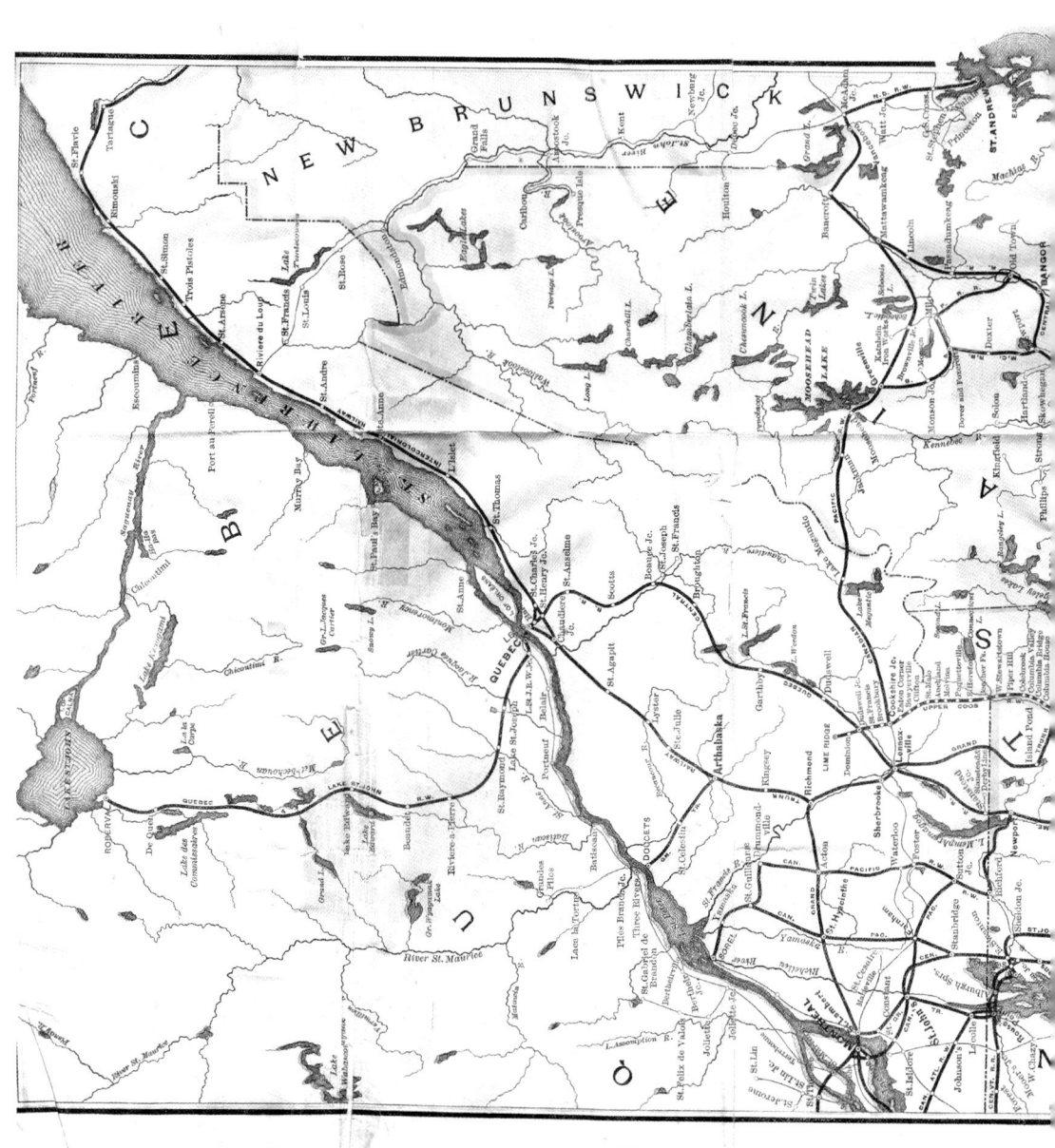

Concord & Montreal Railroad system map, 1880s. This map shows the major routes and principal connections of the Concord & Montreal Railroad throughout New England.

A New Hampshire Dynasty Is Born

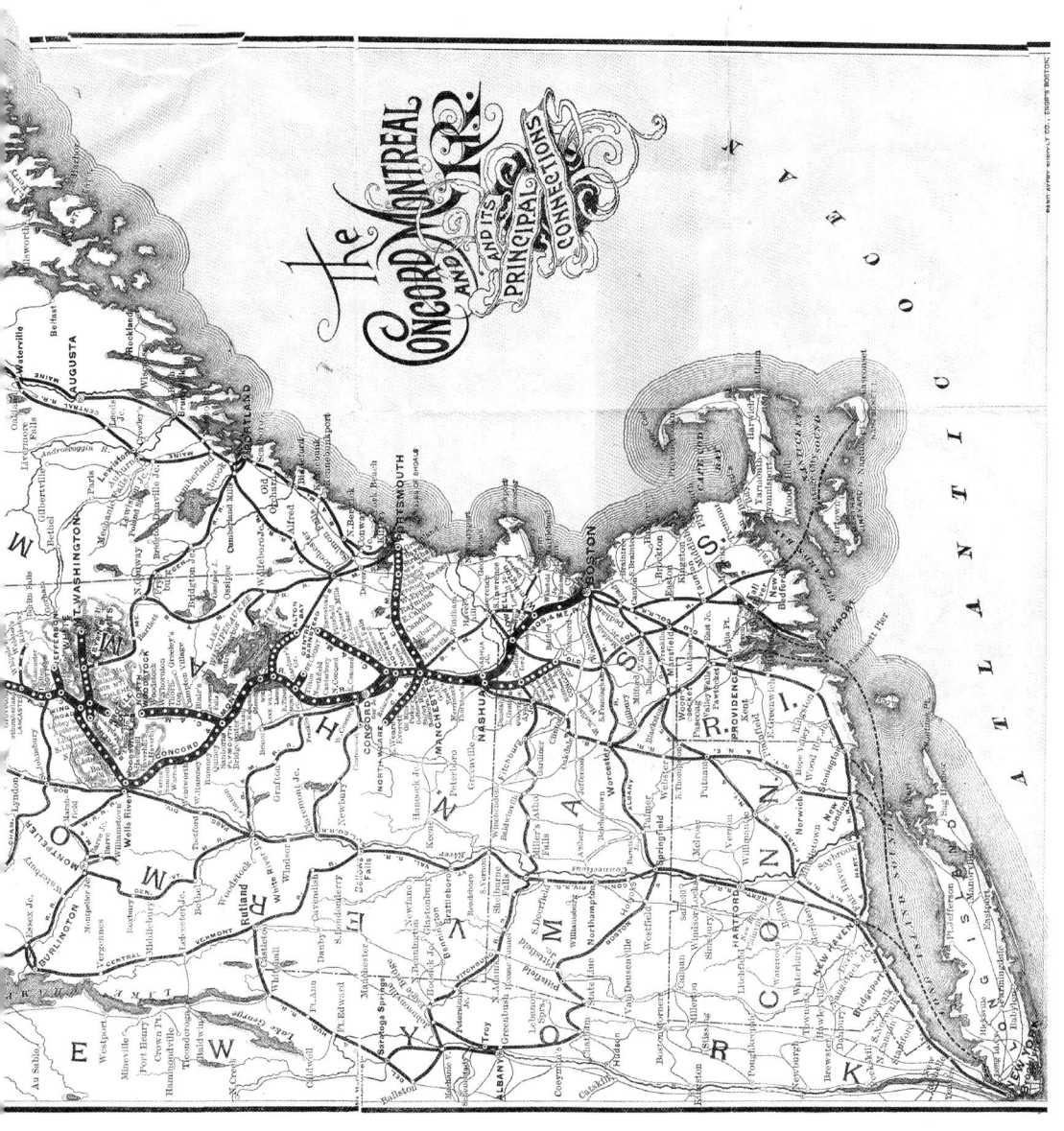

A History of the Boston & Maine Railroad

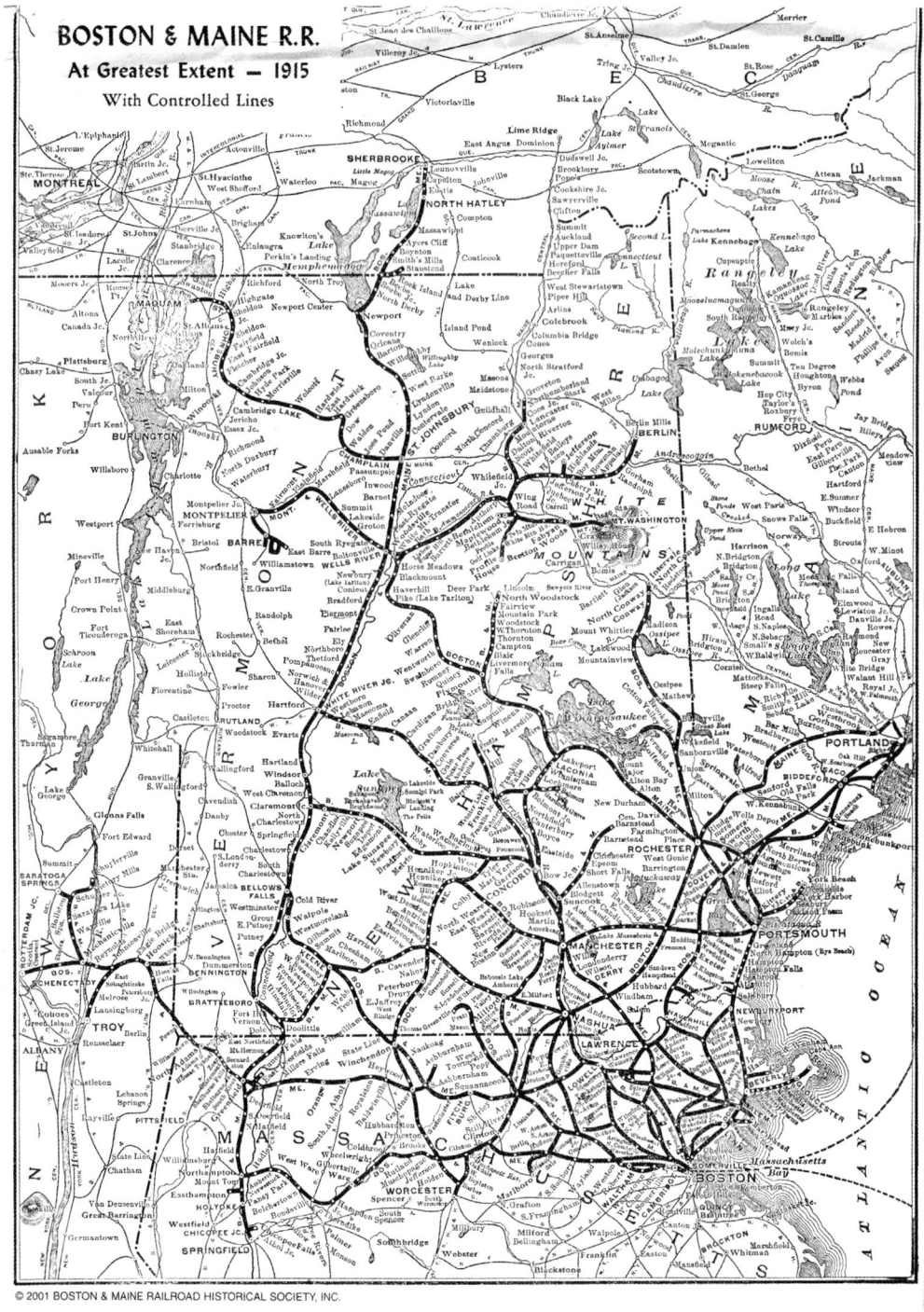

A 1915 Boston & Maine Railroad map, with controlled lines. This early map indicated the major route of the Boston & Maine and the principal connections with the Maine Central.

A New Hampshire Dynasty Is Born

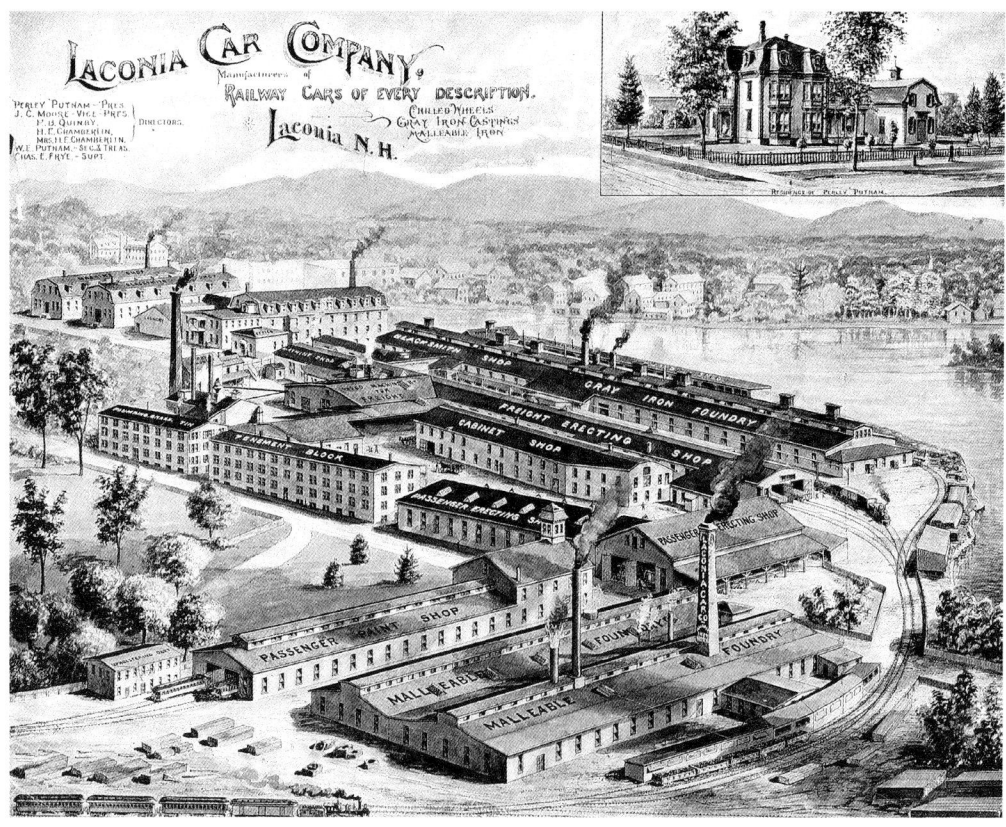

Laconia Car Company, Laconia, New Hampshire, 1892. The coming of the railroad greatly affected the industries of central New Hampshire. The shops of the Laconia Car Company—Laconia's leading industry for almost three-quarters of a century—were established in 1859. Many of the coaches for the early trains were products of the Laconia Car Company.

track; the rest of it was leased. Previous to this time the Boston & Maine had also acquired 51 percent of the capital stock of the Maine Central Railroad. This brought under Boston & Maine control 1,122 of the 1,174 miles of railroad in New Hampshire.

NEW HAMPSHIRE RAILROADS AT THE TURN OF THE CENTURY

The dynasty continued to grow. By 1901 the Concord and Manchester Branch of the Boston & Maine Railroad was incorporated to run between Concord and Manchester. It was New Hampshire's first official "interurban." By 1903 an act was passed allowing the Boston & Maine to acquire the Concord Street Railway and unite it with the Manchester Street Railway.

In addition to the electric railways, the Boston & Maine Railroad had locked in with the logging industry and built sixteen logging railroads in the White Mountains during the late nineteenth century. The logging railroads met the demands for the White

Mountain timber as well as the pulp and paper industries. In 1867 the first major steam line had been built to and through the White Mountains, making the once inaccessible region accessible.

Dr. R. Stuart Wallace and Lisa B. Mausolf, in their *New Hampshire Railroads Historic Context Statement*, wrote: "During the process of consolidation, virtually all of New Hampshire's railroad corporations disappeared or ceased operating independently. By 1905, the Boston & Maine Railroad controlled all but 52 miles of New Hampshire's 1,174 miles of commercial tracks." (These 52 miles of non–Boston & Maine tracks belonged to the Grand Trunk.)

It may be observed that Governor McLane's 1904 administration was the last one for a decade that could be described as generally peaceful. By 1906 the undercurrents of unrest and popular irritation referred to by President Roosevelt in his letter to William H. Taft were moving strongly in New Hampshire. The jumping-off point for the movement was the general antagonism toward the railroads and their alleged corruption of political life. Ex-Senator William E. Chandler for years had been charging that the Boston & Maine Railroad had an unwholesome influence on New Hampshire politics, and by 1906 his accusations were finding a more sympathetic audience. In the U.S. Senate the same bitter fight over railroads raged that year, culminating in the passage of the so-called Hepburn Act on May 18. Chandler had been brought into the political negotiations on this bill, and he had come out of them in the bad graces of the president.

Basically, the movement that arose from the popular distrust of the railroad magnates—known as the Progressive Movement—was founded on two fundamental propositions, namely: (1) the power of government, either state or national, must be invoked to restrain the selfish tendencies of those who profit at the expense of the poor and needy; and (2) the people as a whole must assert their control of government, taking it out of the hands of political machines, "state house rings," party hacks and corrupt alliances of "bosses" with men of great wealth.

In 1906 the Lincoln Republican Club was founded. It was the result of months of well-organized, behind-the-scenes work in the state. Managed by men not hitherto prominent in the Republican Party leadership, it was designed to elect the popular novelist Winston Churchill as governor of New Hampshire. His platform was based on strong opposition to the railroad dominance in the state. Thirteen men signed its manifesto, which was made public in July. The document demanded:

1. Prohibition of free passes on railroads.
2. Election of railroad commissioners by the people.
3. Correct and modernized valuation of railroad property for purposes of taxation.
4. A corrupt practices act and publicity for campaign contributions.
5. Registration of lobbyists and publication of their fees.
6. A primary election law in New Hampshire.
7. The establishment of a state tax commission.
8. Stringent enforcement of the liquor laws.
9. Stringent enforcement of the existing anti-gambling laws.

A New Hampshire Dynasty Is Born

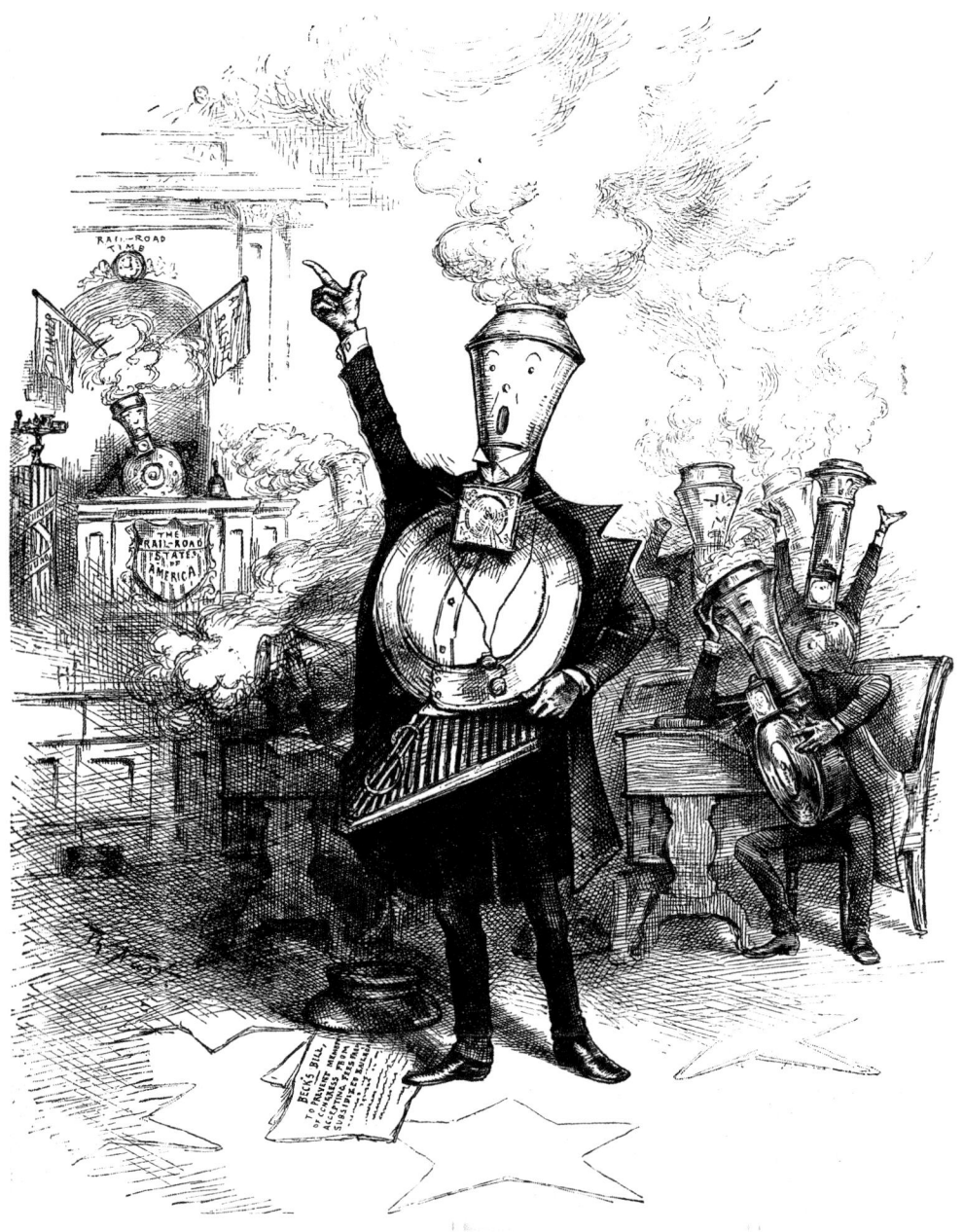

"The Senatorial Round-house," a *Harper's Weekly* cartoon by Thomas Nast, shows the honorable spokesmen for the American railroads blowing off steam on Capitol Hill. In 1887, after years of complaints against the railroads, Congress reluctantly created the Interstate Commerce Commission, the first government board to regulate private business. The commission was empowered to prevent rate discrimination but could not fix new rates. The railroad lawyers and the federal courts hampered its work so effectively that in a few years it ceased to function.

A History of the Boston & Maine Railroad

Political Changes on the Horizon for the B&M Railroad

In 1912 the tide began to turn and the Boston & Maine dividends slipped to only 4 percent after several years of much higher dividends. This was the beginning of a downward trend in the Boston & Maine dynasty.

In 1919 New Hampshire passed a sweeping law reorganizing the Boston & Maine Railroad in the state. By 1922 there was trouble on the horizon—a major Boston & Maine strike coincided with a strike at the state's main textile mills, and to make matters worse, the B&M petitioned the ICC (Interstate Commerce Commission) to abandon over one-third of its tracks.

The competition with the national highway system—automobiles, trucks, etc.—was becoming fierce; thus, in 1931 the B&M tried a partnership with Pan American Airlines for air service in northern New England. In that same year the company started running its first "snow trains" to New Hampshire's Mount Cranmore in North Conway. In 1933 the Concord and Manchester Branch of the Boston & Maine discontinued service; buses were used instead. On August 11, 1933, the Boston & Maine Airways made its first flight between Boston and Bangor.

Times became very difficult during these lean years, so an Emergency Railroad Transportation Act was passed by Congress to help railroads make it through the Great Depression.

Following the war, most railroad companies, including the Boston & Maine, spent a great deal of money in order to change from steam to diesel locomotives. Many felt that this conversion would save New England's railroads. So in 1934 the first diesel locomotives for passengers were introduced. However, they did not have the desired effect. New England's railroads also suffered simply because they were located in New England. It became too expensive to maintain the manpower needed to keep the tracks, yards and depots clear during the severe winters.

By 1960, the automobile and aircraft had come of age. Passengers had abandoned the railroads in droves and were lured to the interstate highways. During the final decade of the twentieth century, passenger service became limited to tourist railroads, and only a few short miles of Amtrak service remained. Many railroad rights of way were abandoned and lost, except to memory. The Boston & Maine declared bankruptcy in 1970, marking the official end of its railroad dynasty in New Hampshire.

Before the success of the railroad came to a screeching halt, the Boston & Maine experienced a golden age as the dominant railroad in New England. In the following chapters we will experience the romance and heritage of the early years of the Boston & Maine dynasty. We will travel up the shores of the Merrimack River to the Lakes Region and on to the White Mountains. We will tour the Franconia and Crawford Notches, take a close look at the "snow train" to the White Mountains during the 1940s–1960s and finally examine the lumbering railroads along the Pemigewasset Valley.

CHAPTER TWO
THE WHITE MOUNTAINS DIVISION
MERRIMACK VALLEY

The charm of the White Mountains is its infinite variety of scenery, inexhaustible in its natural resources and unlimited in its beauty. Each village commands the magnificent aspects of the many mountain ranges. Every mile of approach opens a new view of natural grandeur.

By the late 1860s, the desirability of the White Mountains of New Hampshire as a summer resort and vacation area had become apparent, and in July 1869 the Boston, Concord & Montreal Railroad received authorization to build a branch line into the fast developing region. This railroad was part of the Concord & Montreal Railroad system, which was created by a union of Concord Railroad with the original Boston, Concord & Montreal Railroad and the White Mountains Railroad. The system existed entirely within the state of New Hampshire, and its various parts were among the oldest railroad foundations of the country. The main line of the Concord Railroad was laid between the cities of Nashua and Concord, including the manufacturing centers Manchester and Hooksett in its course and following closely the direction of the Merrimack River for its route. Its branches included the Nashua, Acton & Boston Railroad, connecting Nashua with Acton, Massachusetts; the Suncook Valley Railroad, connecting Hooksett with the rural center of Barnstead by a line through a beautiful section of farmland; the Concord & Portsmouth Railroad, leaving the main line at Manchester and running directly to Portsmouth on the coast, which was forty-one miles away; and the Manchester & North Weare Railroad, connecting Manchester and North Weare by a spur line.

North of Concord, the single-track line continued on the old Boston, Concord & Montreal Railroad, known as the White Mountains Division of the Concord & Montreal system. The main line of this division was from Concord northward through Tilton, Laconia, Weirs (Lake Winnipesaukee), Plymouth, Woodsville, Littleton and a host of towns and villages interspersed along Wing Road, from which point the line divided with one continuing to Groveton Junction on the Grand Trunk Railway, and the other running directly eastward to Fabyan's. The charter for the line from Concord

A History of the Boston & Maine Railroad

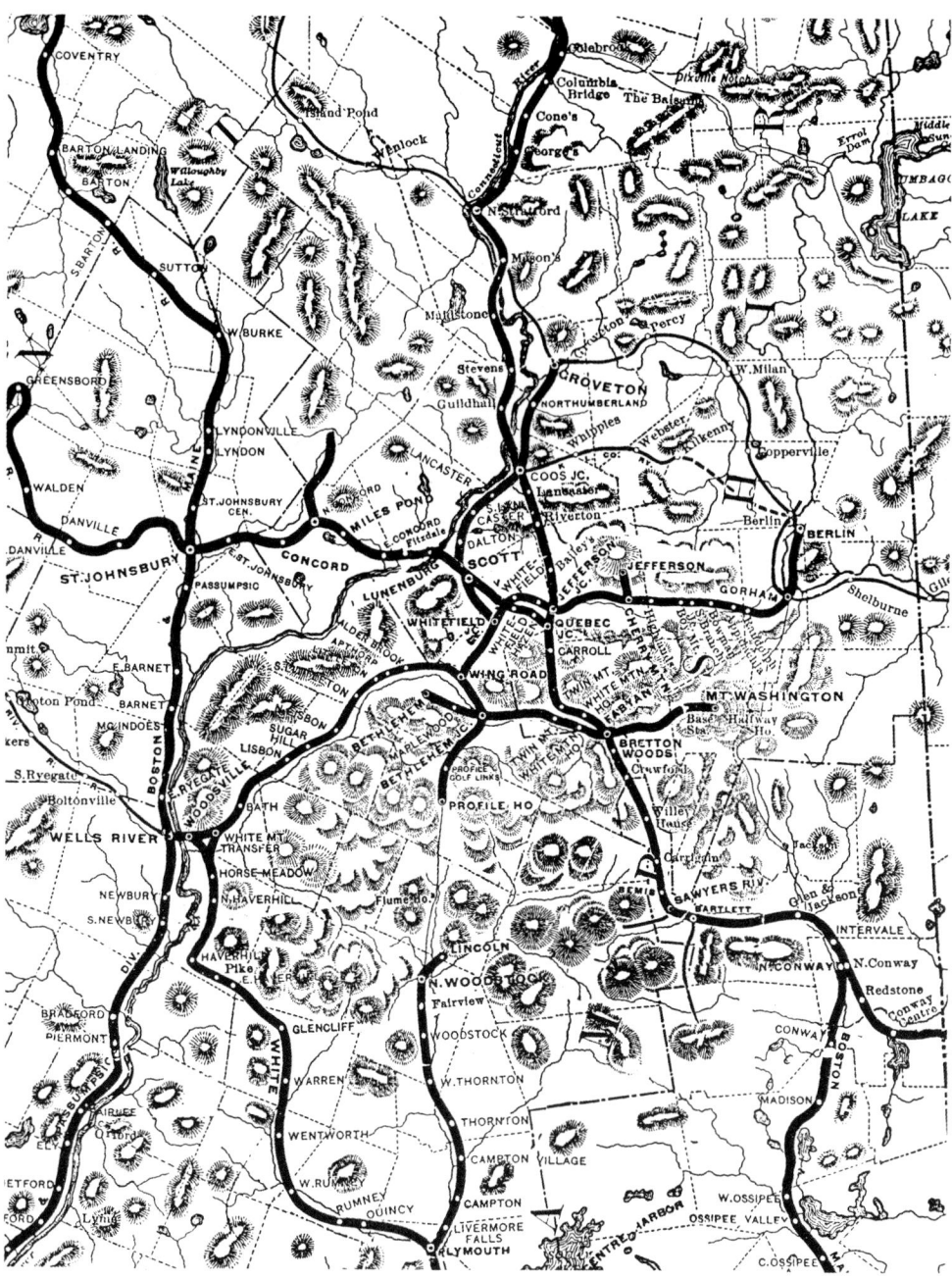

A Boston & Maine Railroad map indicating the lines, routes and divisions in the White Mountains at the turn of the century, circa 1900.

The White Mountains Division: Merrimack Valley

to Wells River, Vermont, was granted on December 27, 1844. The road was completed to Tilton, New Hampshire, in 1848, to Plymouth in 1850 and finally to Wells River in 1853. It was in 1895 that the Concord and Montreal Railroad was leased to the Boston & Maine Railroad. The total railroad mileage in New Hampshire at that time was 1,171. In 1900, the Boston & Maine completed its conquest of New Hampshire railroads with the lease of the Fitchburg system. The lease of this system was consistent with the intended plan to create a Boston & Maine Railroad dynasty.

During the process of consolidation at the start of the twentieth century, virtually all of New Hampshire's railroad corporations disappeared or ceased operating independently. By 1905, the Boston & Maine controlled all but 52 miles of New Hampshire's 1,174 miles of commercial track. The Boston & Maine Railroad responded to every demand for transportation of person and property, opening up every section and district of New Hampshire to visitation and occupancy. Its lines afforded some passing glances at the state's natural beauty—the wondrous Merrimack Valley; lovely intervals and glens strewn with homesteads and farmland; charmingly scenic lakes; grand old woods that roll down hills and mountainsides to meet the waters flowing in streams, glistening with sunlight; and elevations growing into hills that in turn swell into mountains bristling with crags and ledges and rugged natural formations. These great wildernesses are but fragmentary specimens of the natural characteristics of the country in which this system was planted, and to which it constantly ministered.

There is little question among travelers who have enjoyed vacationing in this region from the standpoint of scenic attraction and outlooks. The Merrimack Valley route of the Boston & Maine Railroad, which passes on the west side of Lake Winnipesaukee and the surrounding mountain ranges, was the best route to provide tourists with a positive introduction to the rugged New Hampshire landscape.

Merrimack Valley

The Merrimack Valley had a significant influence on natural and material affairs that the localities of but few watercourses could equal. It is almost uniformly characterized by pastoral scenery, and its overall mood is one of restfulness. Along its banks are towns and villages, isolated estates and businesses, the abiding and sojourning places of a population that represented the best development and outgrowth to the life of the New Hampshire region.

Here in the Merrimack Valley, the railroads had planted a steel highway to the lakes and mountains. Imagine you are a tourist traveling by the Boston & Maine Railroad during the early 1900s who is about to take a romantic sojourn into central and northern New Hampshire. Basically, this was the major highway for mass transportation into the White Mountains. Please join me on this nostalgic trip through the state of New Hampshire and up into the heart of the White Mountains, so we may relive the early years of the railroad.

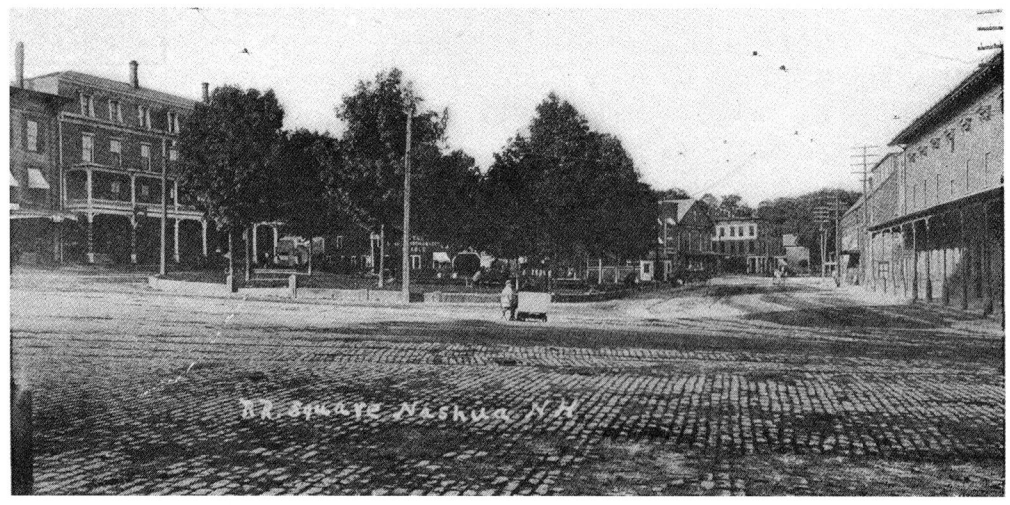

Railroad Square, Nashua, New Hampshire. Nashua, the gate city to New Hampshire, was considered an important junction point on the route between Lowell, Massachusetts, and Manchester, New Hampshire.

We will begin our trek on the shores of the Merrimack River where the state borders of Massachusetts and New Hampshire meet in the fair town of Nashua. Naturally enough, this valley was chosen early for the foundations of what are now some of the most thriving and prosperous communities in New England. Native Americans, in whom the practical and poetic have always been singularly blended, did not forget its significance when they named this stream "Merrimack," meaning "the strong and swift-gliding current." This strong current has been utilized in countless ways at various points within the Merrimack Valley. Great manufacturing establishments, cities brooding over the Merrimack waters, lesser villages and thriving towns have all made their home along the river.

Nashua was the southern terminus of the Boston & Maine Railroad. This station was considered an important junction point on the route between Lowell, Massachusetts, and Manchester, New Hampshire. Located approximately thirty-nine miles from Boston, Nashua was also the terminus of a direct line that ran to Keene from east to west. In past years, the depot was used by the Nashua & Lowell Railroad, the Concord Railroad, the Nashua & Keene line and the Worcester, Nashua & Rochester Railroad. As the train would move northward, passing through this beautiful Merrimack country, and following closely the windings and turnings of the river, its waters were scarcely more than a few minutes out of sight from the moving train. Still traveling through the valley, it throws off branches and spurs, so that the more remote farmlands and the beautiful scenery sure to be found in every part of central and southern New Hampshire are made practically part of the valley foundation. Numerous outlying roads afford fine drives, and here the accommodations of both city and country are very nicely blended, so that the visitor may pass from the enjoyments of one to another within the same hour and avail themselves of all that either may afford.

The White Mountains Division: Merrimack Valley

After leaving Nashua, the route northward follows the course of the Merrimack through the valley. Upon the banks of the river, planted atop some gentle, sloping hillside, large and small individual estates are profusely scattered, representing retired wealth and elaborate farming industries. Often these estates lend a peculiar attraction to the landscape, animating scenes that have been fair to look upon ever since the dawning of creation. But the river itself forms the main attraction in this section of travel. Its swift-moving current has worn a deep bed in the valley over the course of centuries, so that its banks on either side appear in miniature cliffs, although they are actually only a few feet above the surface of the water. Although in its natural course the river is usually straight, its shores are often sinuous in appearance, winding and circling around small plots of land that are covered with lovely groves, which seem to be floating on the surface of the stream.

Amid this scenery the valley roads were laid, and near these beneficent highways are the celebrated New Hampshire farms. However, midway between Nashua and Concord appears the thriving city of Manchester, a municipal establishment that actually retains more country than city features. The city's lovely natural landscape affords summer visitors with a level of satisfaction that few localities may boast. Although Manchester is the most populated city in New Hampshire, it had scarcely more than forty thousand residents during the early 1900s. Here the Merrimack River cuts a sort of gorge through the midst of an elevated plain (occupied by the city) and plunges majestically over the ledges in its hurried course, forming the picturesque Amoskeag Falls.

In all of New Hampshire, there is no larger grouping of fine estates around a common center than is the case with the suburbs of Manchester. The industrial metropolis of the state rises from both banks of the Merrimack to the heights beyond, loosely encircled by New Hampshire hills and surrounded by serene white-steepled New Hampshire towns. Its mills—the first being the Amoskeag Manufacturing Company, which once owned the largest textile mills in the world, as well as hundreds of smaller industries—drew workers from all parts of the world. The city is considered the financial and commercial center of the state and is now home to about one-fifth of the state's population. It is located fifty-six miles from Boston.

During the nineteenth century, before the Boston & Maine Railroad took control of most of the New Hampshire lines, the Manchester facilities had no fewer than three major roads at this terminal. Some of the lines that used the roads included the Manchester & Lawrence Railroad, Concord & Portsmouth Railroad, Manchester & North Weare Railroad and Concord Railroad.

A few miles above Manchester, on the river, is the town of Hooksett. Although its manufacturing establishments are similar to those of Manchester, Hooksett is considered a New England village, while Manchester is a full-fledged city.

All along its course the Merrimack is crossed at intervals by bridges of wood or iron. To enter Hooksett requires the crossing of a bridge 550 feet long. The site of this village forms part of the reservation anciently given by Massachusetts to Passaconaway, the great sachem of the Penacooks.

A History of the Boston & Maine Railroad

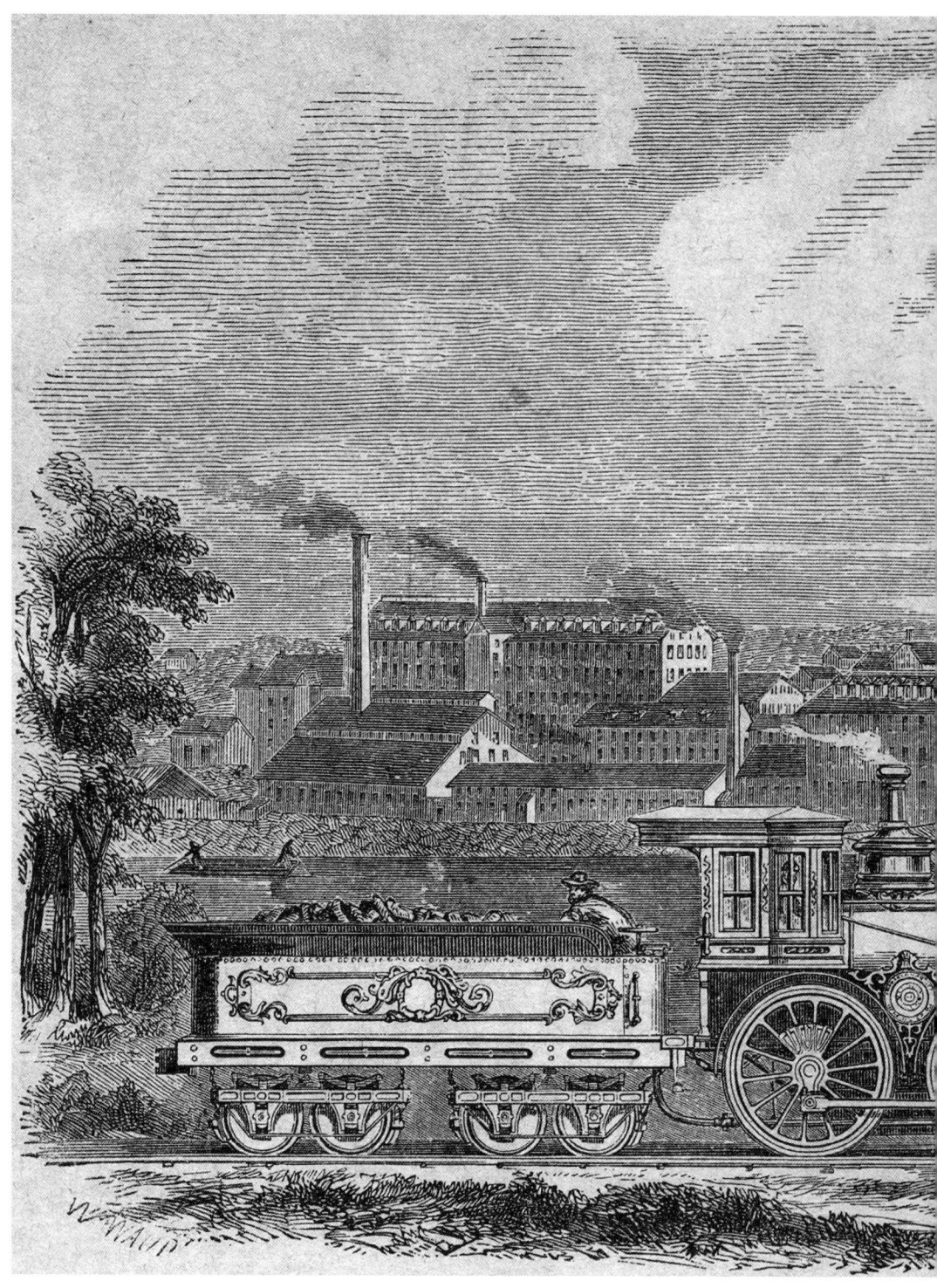

Amoskeag Locomotive Works, Manchester, New Hampshire, 1855. The "Big Shop" was one of the largest companies of its kind in the United States. The New Hampshire General Court later authorized the company to hold stock in the Concord Railroad.

The White Mountains Division: Merrimack Valley

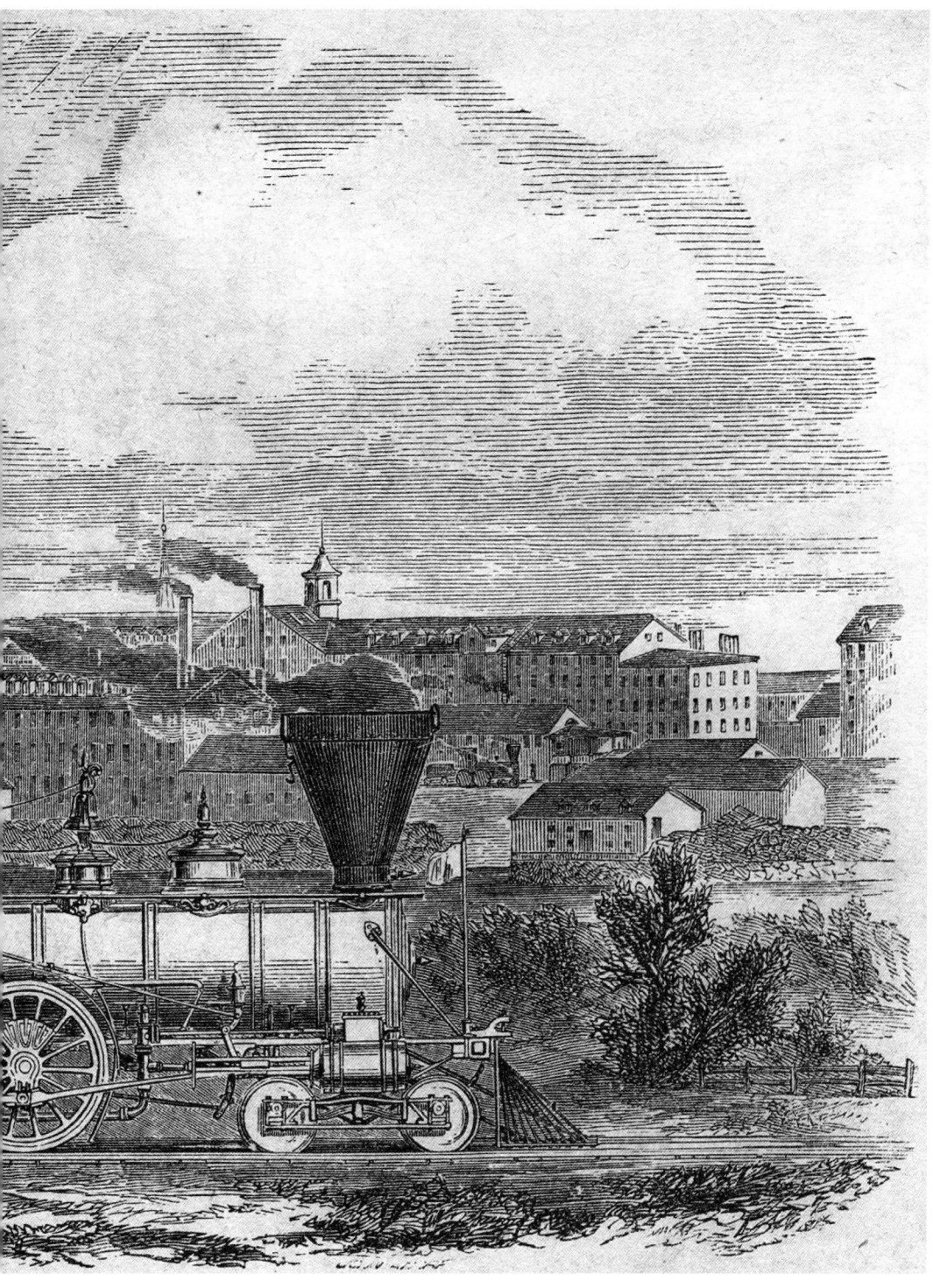

A History of the Boston & Maine Railroad

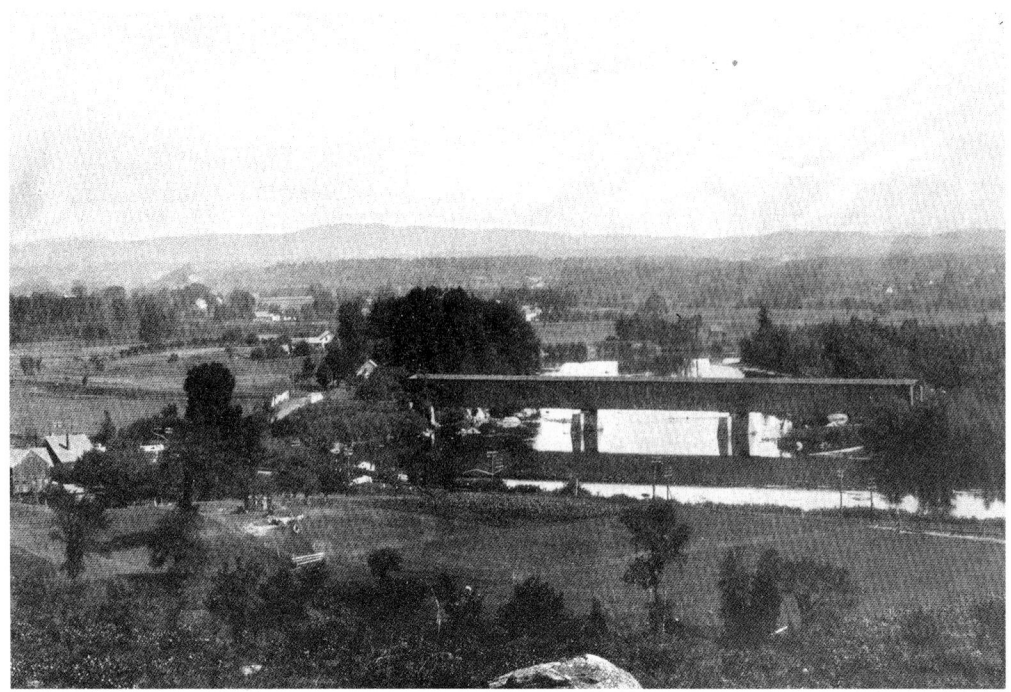

The Merrimack River and the Boston & Maine Railroad Bridge at Bow Junction. *Courtesy of the B&M Railroad Passenger Department.*

These characteristics of the Merrimack Valley continue as the course is held northward, until Concord, the capital of the state, is reached. Here and there the landscape opens for a panoramic view, and again and again, old Kearsarge, rising loftily like an advanced guard of the mountain ranges, suggests the change in scenic forms that is about to take place farther on.

Geographically, Concord occupies the center of the state. In 1725, its site was in the possession of and occupied by the Penacook Indians. In 1733, Massachusetts granted the land to the white settlers, who displaced the natives. A few years later it became a part of New Hampshire; and in 1808, Concord became the capital of the state.

As we enter Concord, we are greeted by a magnificent edifice—the elegant Concord Boston & Maine Railroad passenger station. The station was located 73.3 miles from Boston, and sat at the bottom of Pleasant Street. It was considered the largest building in northern New England. Passenger locomotives such as Tahanto, Penacook and the General Stark traveled up and down the tracks hauling the cars north, south and west. From this depot, a passenger would have traveled west to Claremont Junction via the old Concord & Claremont road or to the White Mountains via White Mountain Junction in Vermont and Woodsville, New Hampshire. Visitors might also travel through the Lakes Region to the White Mountains via the Boston-White Mountains Division through Laconia, Plymouth, Lincoln and finally Wells River.

The White Mountains Division: Merrimack Valley

STATIONS.		No. 51 Local.	No. 29 Mail.	No. 53 Mont'l Exp.	No. 75 Mt. Exp.	No. 145 Mont'l Exp.	No. 189 Local.	No. 285 Mont'l Exp.
		A.M.	A.M.	A.M.	A.M.	P.M.	P.M.	P.M.
Lv. Boston	B. & L. R.R.	7.30	8.30	9.30	1.00	3.00	7.00
" Salem	"	7.50	9.10	12.40	5.50
" Lawrence(via Lowell)	" "	8.15	9.30	12.05	3.15	6.40
" Lowell	" "	8.30	9.20	10.14	1.48	3.53	7.48
" Nashua Junction	" "	9.00	9.46	10.40	2.13	4.20	8.20
" Manchester	Concord R.R.	9.48	10.15	11.10	2.43	5.02	8.54
Ar. Concord	" "	10.30	10.50	11.40	3.12	5.42	9.25
Lv. Concord	B. & L. R.R.	6.55	11.00	10.55	11.42	3.17	5.50	9.30
" Canterbury	" "	7.14	11.21	*6.17	*
" Northfield	" "	7.22	11.28	*6.24	*
" Tilton	" "	7.32	11.39	11.27	3.50	6.35	10.11
" East Tilton	" "	7.39	11.47	*6.43	*
" Laconia	" "	7.49	11.58	11.43	12.25	4.08	6.55	10.30
" Lake Village	" "	7.54	12.03	11.50	4.12	6.59	10.35
" Weirs	" "	8.03	12.13	12.00	12.36	4.23	7.09	10.46
Ar. Centre Harbor	Steamer	1.00	5.10
" Wolfboro'	"	10.10	3.05	7.00
Lv. Meredith	B. & L. R.R.	8.10	12.21	12.08	4.32	7.16	10.55
" Ashland	" "	8.28	12.38	12.28	4.51	7.34	11.14
Ar. Plymouth	" "	8.38	12.50	12.40	1.05	5.02	7.45	11.26
Lv. Plymouth	B. & L. R.R.	8.50	1.38	5.20	P.M.
Ar. Livermore Falls	" "	8.55	1.51	5.26
" Blairs	" "	9.05	1.55	5.30
" Campton Village	" "	9.14	2.03	5.38
" Thornton	" "	9.22	2.07	5.42
" West Thornton	" "	9.38	2.18	5.53
" Woodstock	" "	9.49	2.25	6.00
" North Woodstock	" "	10.00	2.35	6.10
" Flume House	Stage	11.45	3.50	7.40
Ar. Profile House	"	12.45	4.50	8.40
Lv. Plymouth	B. & L. R.R.	8.48	1.40	1.15	1.35	5.17	11.36
Ar. Quincy	" "	8.59	1.52
" Rumney	" "	9.04	1.57	*	*
" West Rumney	" "	9.11	2.04	*
" Wentworth	" "	9.20	2.15	*
" Warren	" "	9.28	2.23	1.50	5.50	12.23
" East Haverhill	" "	9.48	2.45	*
" Haverhill	" "	9.58	2.55	2.16	*6.18	*
" North Haverhill	" "	10.05	3.03	*	*
" White Mt. Transfer	" "	3.11	2.50	6.32
" Woodsville	" "	10.15	3.15	2.30	6.38	♠1.20
Lv. Woodsville	" "	10.40	4.00	♠7.05
Ar. Bath	" "	10.57	4.13	P.M.	*6.42	7.16
" Lisbon	" "	11.10	4.27	3.15	6.53	7.28
" North Lisbon	" "	11.23	4.42	7.41
" Littleton	" "	11.35	4.54	3.37	7.14	7.52
" Wing Road	" "	11.50	5.10	3.50	7.25	8.05
Ar. Bethlehem Junc.	" "	12.04	5.26	4.04	7.37	8.17
Ar. Maplewood	P. & F. N. R.R.	12.15	5 40	4.16	7.50	8.32
" Bethlehem	" " "	12.20	5.45	4.21	7.55	8.37
" Profile House	" "	2.18	6.05	4.40	8.13	8.55
Ar. Twin Mt. House	B. & L. R.R.	12.15	5.38	4.16	7.48	8.31
" White Mt. House	" "	12.23	5.48	8.43
" Fabyan's	" "	12.25	5.50	4.28	8.00	8.45
" Mt. Pleasant House	" "	12.35	5.55	4.35	8.05	9.25
" Crawford House	P. & O. R.R.	6.00	5.00	8.30	9.20
Ar. Summit Mt. Wash.	Mt. W. Ry	6.30	11.00
Lv. Wing Road	B. & L. R.R.	11.55	5.15	4.00	7.27	8.28
Ar. Whitefield	" "	12.08	5.28	4.13	7.36	8.43
" Jefferson	W. & J. R.R.	12.30	5.55	4.40	8.00	9.10
" Scott's	B. & L. R.R.	12.14	5.34	4.19	7.42
" Dalton	" "	12.18	5.37	4.23	7.46
" South Lancaster	" "	12.23	5.43	4.29	7.50
" Lancaster	" "	12.35	5.55	4.40	8.00
" Guildhall	" "	6.50	6.50
Ar. Groveton	" "	7.00	7.00

Timetable—Boston to Winnipesaukee and the White Mountains. June 28, 1886.

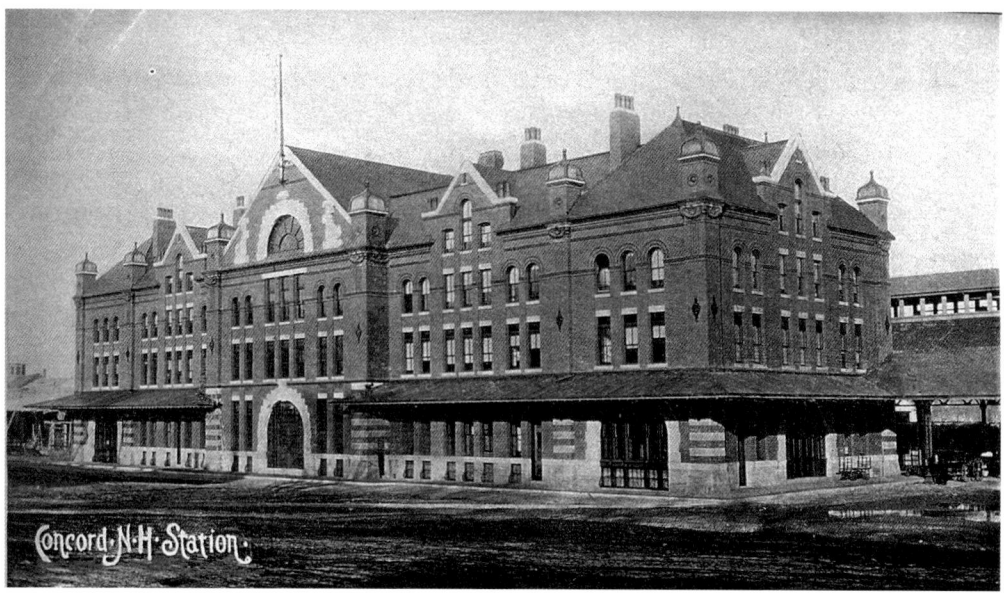

The Concord Railroad Station, Concord, New Hampshire, 1909. This elegant passenger station sat at the bottom of Pleasant Street. *Courtesy of the B&M Railroad Passenger Department.*

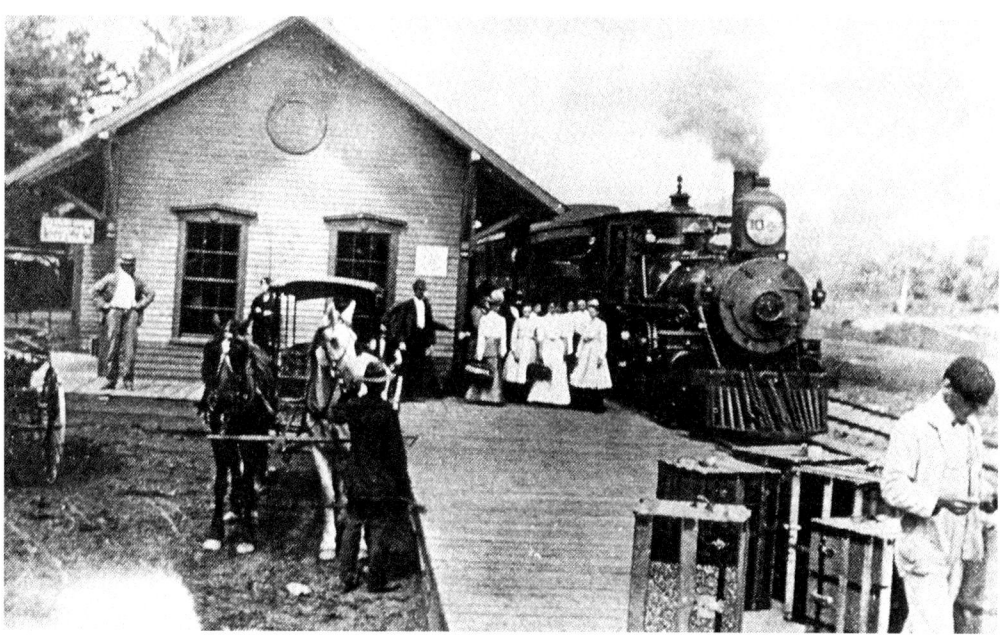

A typical rural railroad station during the early 1900s.

The White Mountains Division: Merrimack Valley

In the immediate neighborhood of Concord there are no prominent mountains, wild ravines or ragged wildernesses; no outspread lakes, with rock-strewn, wooded shores; not even a tumbling waterfall in the river to attract the traveler. The scenery of this area is rather peaceful and its attractions are of nature in perfect rest. There are vast meadow tracts stretching away from the riverbanks, and from the clustering hills on which the city stands, these meadowlands can be seen undulating gently amongst the groves and hamlets that dot the land.

CHAPTER THREE

THE WHITE MOUNTAINS DIVISION
PEMIGEWASSET AND FRANCONIA VALLEY

THE LAKES REGION—LAKE WINNIPESAUKEE

We are now leaving Concord on the White Mountains Division of the Boston & Maine Railroad en route through the Lakes Region and Lake Winnipesaukee. Passing northward, we enter upon the grand scenic region of New Hampshire, where the lakes and rivers, gorges and mountains, forests and ravines and almost every variety of wild and primitive scenery that may attract the admiration of a visitor is found. Four miles from Concord, the line passes the town of Canterbury, with its Shaker Village, and a little farther north is Franklin Falls, where the Merrimack River is formed by the meeting of the Pemigewasset and Winnipesaukee Rivers.

The next stop is Tilton, formerly called Sanbornton Bridge. Passing into the White Mountains Region from the south and west, the first extended view of mountain scenery is from points near Tilton. In Tilton was located the New Hampshire Seminary and Female College, presently the Tilton School, a private educational institution with as fine edifices as are to be found in any New England town. Tilton and its surrounding area attract visitors year-round. There are many homes of wealth and elegance, as well as the traditional New England houses of thrift and comfort, and in the vicinity may be found countless charming farms and country nooks, where even the most fastidious wanderer may find an ideal summer home. At Tilton this railway line bids goodbye to the Merrimack River and its valley and proceeds east to Lake Winnipesaukee.

And now the shores of Winnipesaukee River, of Little Bay and of Great Bay, can be reached within a few minutes. Laconia and its villages constitute a progressive and thriving manufacturing and textile center with their beautiful location in the midst of the lake section, and with the Belknap Range only a few miles distant on the east. The hotels and boardinghouses of the villages and the farmhouses and dwellings of the outer districts make the region an ideal place to enjoy summer. Laconia is built along the eastern shore of Lake Winnisquam, usually referred to as Great Bay. This water sheet, being one of the largest in New Hampshire, is a chain of small lakes extending

Advertisement for lakes and mountain resorts reached by the Boston & Maine Railroad, 1900s.

The White Mountains Division: Pemigewasset and Franconia Valley

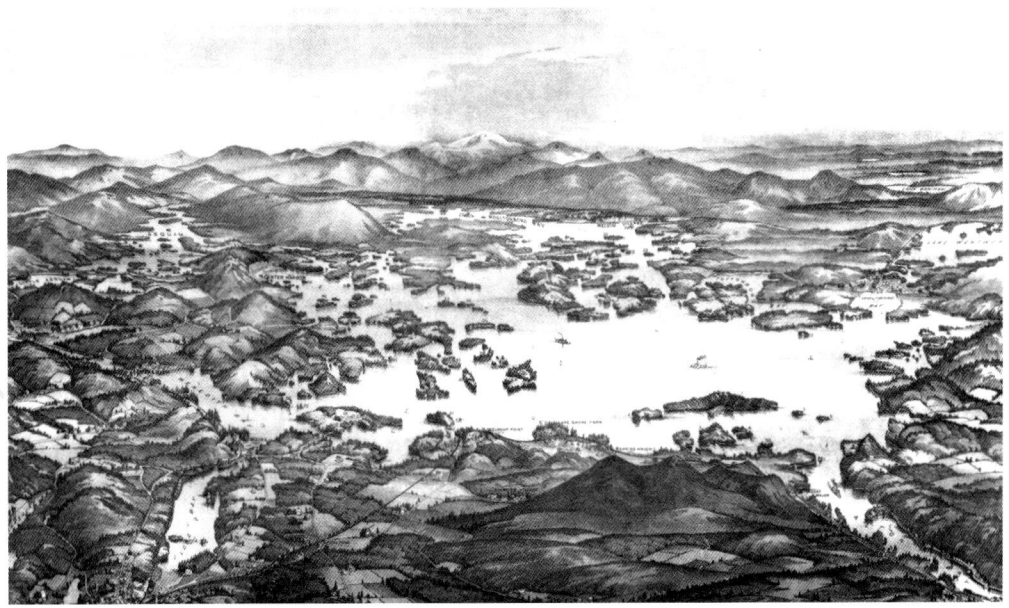

A map of Lake Winnipesaukee and its surroundings, issued by the B&M Railroad Passenger Department, circa 1903.

from the outlet of Lake Winnipesaukee to the Tilton territory. The symmetrical Belknap Mountain lies about eight miles southeast of the Laconia village, a beautiful natural object to look upon or visit. Between Laconia and the Belknap neighborhood is a section of the finest meadows in all New England. It is picturesque in every way and is traversed by roads, which in qualities of makeup and of surrounding scenery can hardly be surpassed. In the same neighborhood the early township of Gilmanton lies outspread and is considered to be one of the quaintest settlements in New Hampshire. Gilmanton's claim upon the summer tourists is its fine communion with nature and plentiful outdoor recreation. A spur of the railroad connecting the main line at Tilton with the Gilmanton neighborhoods without a doubt made this charming, almost ideal, summering place better known to the great army of visitors that enter upon the New Hampshire territory during the warm months.

After our visit to Laconia, we continue our northeasterly travel to Lake Village and the three-mile skirting of Long Bay beyond and finally arrive at the station of Weirs, located directly upon and overlooking Lake Winnipesaukee. Weirs takes its name from the fact that in earlier times Native Americans had fish weirs near its present locality (the Aquadoctan Bridge) whereby they took great quantities of shad in their proper season. They named this body of water "Smile of the Great Spirit"; however, a more proper translation might be "Beautiful Water in a High Place." Here the Aquadoctan village had its headquarters, which extended along the north bank flanking the channel for more than a quarter of a mile along the lakefront and well beyond the railroad station. Weirs is a very popular summer resort, and it is distinguished by its groves and

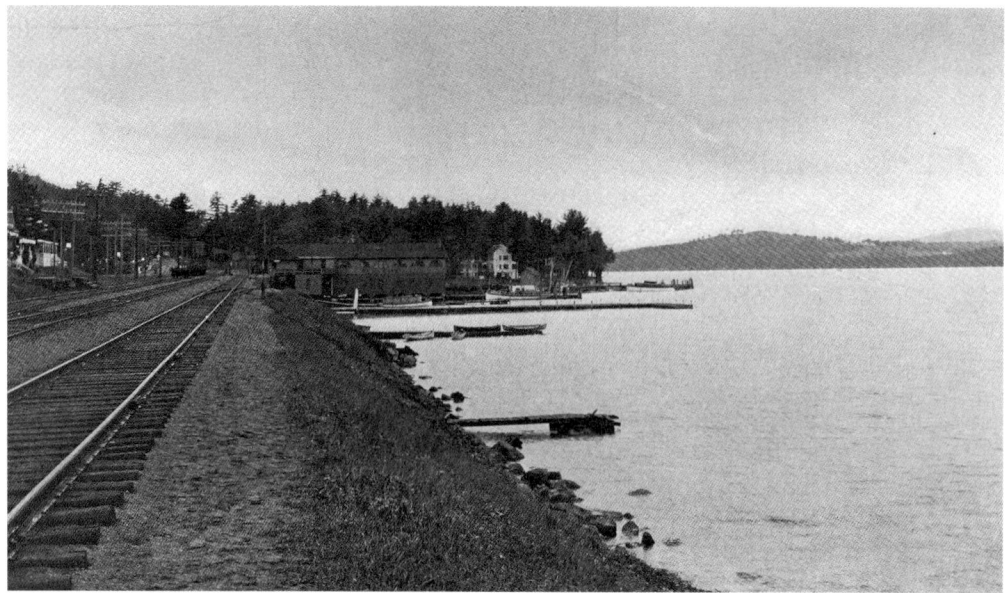

The shore and tracks at Weirs, 1900. On the right is Lake Winnipesaukee, and in the center is the railroad station. Notice the three sets of tracks that run on the left side of the picture—today there is only one track. *Courtesy of the B&M Railroad Passenger Department.*

the summer home of the New Hampshire Veterans' Association. Many hotels adorn the lakeshore near the Weirs Railroad Station where visitors may relax and enjoy the vista of the lake. From the lakefront and the surrounding heights, the guests may enjoy the views of the Ossipee Mountains, Chocorua, Red Hill, Paugus, Passaconaway, Tri-pyramid, Whiteface and the Sandwich Dome, with Mount Lafeyette in the far distance.

The beauty and grandeur of Lake Winnipesaukee make it one of the finest lakes in the world. It is approximately 23 miles long, between 1 and 9 miles in width and covers an area of 72 square miles. It is 504 feet above sea level. Rising above its surface are 365 islands, 274 of which are large enough for habitation and contain dwellings of various sizes. Beautiful islets dot the surface of the water in all distances. These islands are the objects of excursions for myriad visitors during the summer months. The shoreline of the lake is very irregular, and innumerable indentations and miniature bays diversify its coasts. The varied successions of mountain and upland formations make up its horizon. To the north the whole of the Sandwich Range bounds the view, with the inclusion of Mount Washington and the Presidential Range, the Belknap Mountain to the south and the mountains of the Franconia, Squam and Moosilauke Ranges to the northwest.

Many of the larger islands, and miles of the shores, are beautifully wooded, the varieties of coniferous growth affording every shade of foliage from the dark, somber, mourning effects of the hemlocks to the lightest shades of the cedars, while the bright shimmering greens of the maple and birches blend in glorious harmony over the vast expanses.

The White Mountains Division: Pemigewasset and Franconia Valley

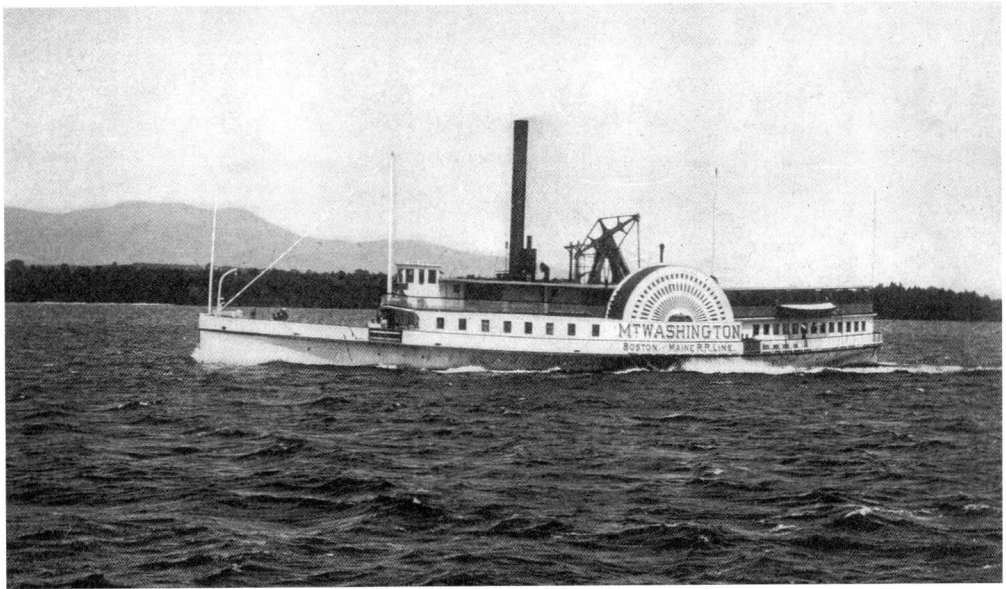

The Boston & Maine Railroad steamer *Mount Washington* is pictured on Lake Winnipesaukee in the early 1900s. *Courtesy of the B&M Railroad Passenger Department.*

It is here at the Weirs that many passengers from the train would disembark and, with a transfer ticket, board the Boston & Maine's own steamboat, the SS *Mount Washington*, for an excursion around "Big Lake" to enjoy the vistas from the famous side-wheeler.

If you were fortunate enough to have met Captain Leander Lavallee, who operated this side-wheeler for the B&M Railroad, he might have taken you to the wheelhouse where you could have enjoyed the sights of the lake, and he may even have given you a brief history of the vessel.

Captain Lavallee began his story.

> *Let us move back in time and reflect how a train company went into the boat business in New Hampshire. It was during the mid-nineteenth century that the population was growing and railroading was coming of age. Mid-century saw the construction of the famous SS* Lady of the Lake *steamer and the development of marine transportation in Winnipesaukee. The steamer* Lady of the Lake *was built in Lake Village in 1849, by the Winnipesaukee Steamboat Company. It was a large craft of 125 feet and completely designed for commercial lake travel. Thousands of people gathered to witness the launching of this vessel and four hundred rode with it on the maiden voyage.*
>
> *At that time the steamer* Lady of the Lake *had no rival, and business boomed for the rail company. In 1872 was the launching of a new steamer side-wheeler at Alton Bay, which was christened the SS* Mount Washington. *The* Mount *was considered to be longer, faster and the most beautiful side-wheeler ever built in the United States—and the pride of the Boston & Maine Railroad Company.*

A History of the Boston & Maine Railroad

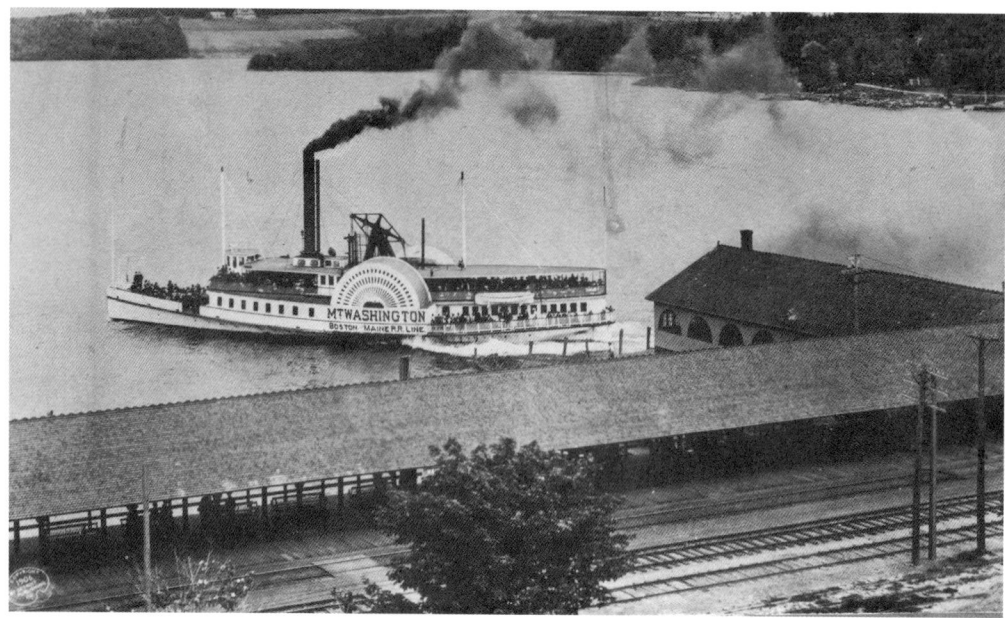

Mount Washington leaving the Weirs Station. In the background is Governor's Island during the early 1900s.

Howard R. Greene's "Winnipesaukee Voyage" states:

> *Even though the* Mount *outclassed the* Lady *of the Lake, their rivalry continued unabated for eighteen more years. The captain and the crew of the* Lady *pushed themselves even harder in their efforts to regain some of the lost business, until by 1890 the vessel ran three round trips a day from June 4 until October 20. Even with all the effort of the great* Lady, *she could not withstand the losing battle again the Boston & Maine's* Mount Washington, *and she made her last voyage in September 1893, after which, she was destroyed by the owner. The* Mount *was left alone and crowned the "Queen of the Lake." However the Boston & Maine officials finally decided to cease operation of the old* Mount, *and the steamship business; thus, during the 1920s the* Mount Washington *was sold to Leander Lavallee, who was the captain of the vessel.*

After a fine excursion on the lake, we return to the train and continue the scenic travel north. The scenes that open up on this lakeshore route are indeed among the most interesting of the excursion, and not only from the train are these to be witnessed—numberless jutting points and hilltops along the course of the line are an irresistible attraction for the admirer of nature, and the stations of the line are placed at short intervals to allow frequent opportunities for visiting favored spots.

This road skirts the entire western shore of Lake Winnipesaukee, passing through Meredith on its northwestern corner. At Meredith the railroad bids farewell to the great lake and passes for four miles along the shore of Lake Waukawen, and afterward the

The White Mountains Division: Pemigewasset and Franconia Valley

Among the islands—Squam Lake, Holderness, New Hampshire, 1880s. *Courtesy of the B&M Railroad Passenger Department.*

shore of Long Pond, before it reaches a station at Ashland. Ashland is a typical New England manufacturing village, the waters of the Squam and Pemigewasset Rivers uniting within its limits.

There is a very fine scenic road leading from Ashland via Squam Lake and Shepard Hill to Center Harbor. This road in the Lakes Region is a popular site for visitors during the summer months, and the circular excursion formed by making the trip on the *Mount Washington* from Weirs to Center Harbor on Lake Winnipesaukee, by team or horseback from Center Harbor to Ashland and by rail from Ashland back to Weirs, affords a round of pleasures that must be experienced to be fully appreciated.

PEMIGEWASSET & FRANCONIA—WHITE MOUNTAINS REGION

Of the several entranceways to the White Mountains, none is more romantic and majestic than the Franconia Gateway. The Pemigewasset Valley has always been an important route through the mountains via Franconia Notch. Some twenty-five miles long, it is at its widest no more than three or four miles across. For most of its length, the valley runs straight, and its angle of ascent is gradual. During the summer, it is a carpet of green, level as a floor, adorned with clumps of elms, groves of maples and strips of rich, brown, tilled soil.

The White Mountains Region of New Hampshire and the routes over which pass the iron lines of the Boston & Maine Railroad present at every turn a variety of natural scenery. Of the mountains there are individual peaks, isolated groups and ranges great

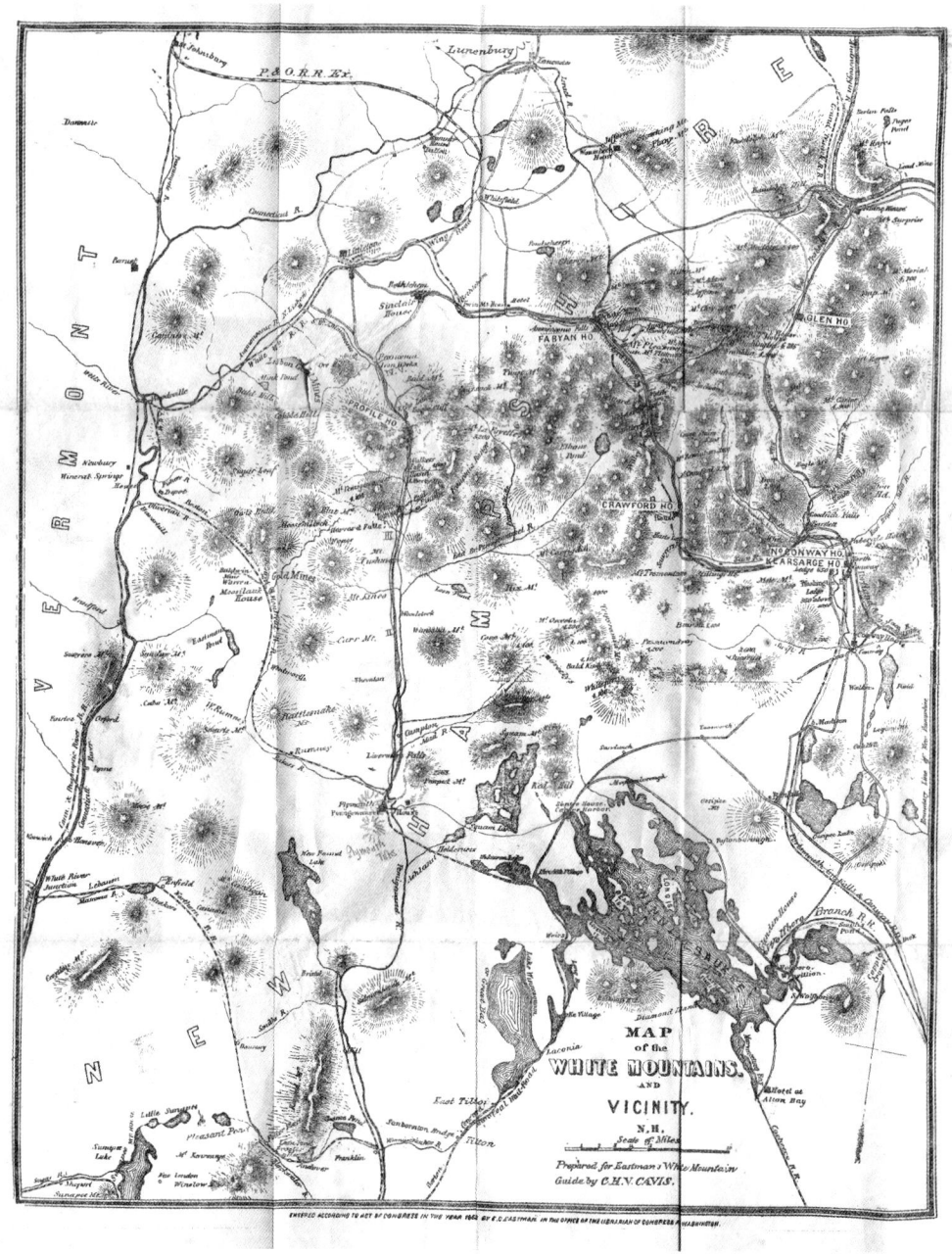

A map of the White Mountains, New Hampshire. Prepared for *Eastman's White Mountains Guide* by C.H.V. Cavis, circa 1863.

The White Mountains Division: Pemigewasset and Franconia Valley

and small, presenting every description of natural upheaval known in America east of the Rockies and north of the Carolinas. Of the rivers and stately streams, flowing constantly with the dignity and gravity that illustrate the latent powers in nature, there are the mad-rushing, reckless torrents that pour wildly through gorges and rifts and ravines. There are wide, rural valleys, extending quietly over the terrain, like that of the Merrimack earlier described. To this class also belongs the Pemigewasset Valley, occupied for at least twenty miles by a branch of the railroad line.

The Pemigewasset Valley Railroad was chartered on July 9, 1874, to build north from Plymouth through the Franconia Notch and on into Franconia. It was actually only completed as far as Lincoln, New Hampshire (22.93 miles), and was opened to North Woodstock, a mile south of Lincoln, on March 1, 1883. This road was leased to the Concord & Montreal Railroad. In 1895 the line was leased to the Boston & Maine Railroad.

Again the Native American name has been preserved, Pemigewasset, meaning the "place of crooked pines." The locality bearing this euphonious Indian title still gives plentiful evidence that the name still applies—crooked pines are scattered throughout this valley in great abundance. Summer visitors will never feel that they have made an undesirable landfall when they arrive within its limits. Indeed, the Pemigewasset Valley is one of the most charming mountain scenes in the north country.

At the foot of the Pemigewasset Valley stands the flourishing village of Plymouth, the Grafton County seat containing the old courthouse in which Daniel Webster made his first plea. But perhaps the town itself is as well known as a seat of learning, as it is home to the State Normal School for teacher training. Within a short stone's throw from the river sit grand hotels beside whose porticos the railroad stretches. The Pemigewasset House indeed lodged countless tourists and summer visitors.

The village conveniently lies in the midst of attractive scenery. On the opposite side of the river lies the quaint New England town of Holderness, presenting some charming bits of scenery. At Plymouth begins the series of mountain scenes that open more and more as the Pemigewasset Valley ascends into the White Mountains and finally culminates its grandeur and beauty in Franconia Notch.

The route through the Pemigewasset Valley is among the most attractive scenes in the White Mountains; the valley's landscape will fascinate the visitor. Many visitors consider the area a paradise for the artist. For the twenty miles that the B&M Railroad extends up this valley (from Plymouth to North Woodstock) successions of grandly rising mountains frame the valley, while the minor scenes contain the utmost that nature may offer. Occasionally, the valley broadens into liberal meadows, bordered by walls of the wildest peaks. Deep passes in the ranges appear occasionally, almost black with the dark masses of forest growth and the overshadowing of surrounding crags and nearly perpendicular hillsides, suggesting the wildernesses within their depths, irresistible to the lover of nature or of the wild and primitive in natural scenery.

As we travel through the unbroken landscape, there are several beautiful villages nestled in the valley, through which not long ago the ancient stagecoach had not ceased to rattle, and early methods of traveling were the custom. Even then the summer visitor

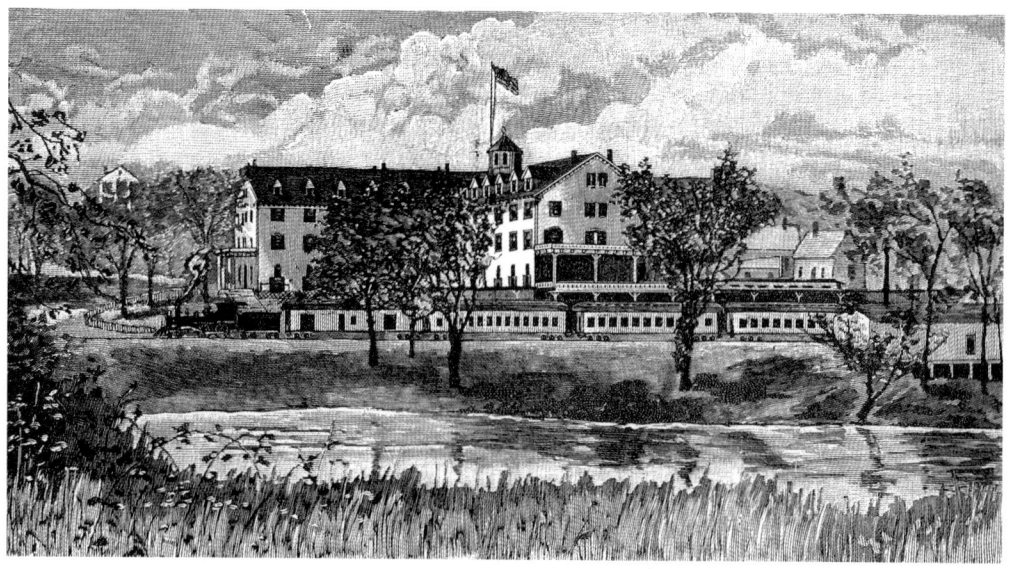

The Pemigewasset Hotel and train, Plymouth, New Hampshire, 1877. In 1850, the Boston, Concord & Montreal Railroad completed the road to Plymouth from Concord. In 1858, the company leased the White Mountain Railroad, which continued the road from Plymouth to Littleton. In 1877, the original White Mountain Railroad between Woodsville and Littleton was taken over by the Concord & Montreal Railroad. In 1895, the Concord & Montreal leased itself to the Boston & Maine Railroad.

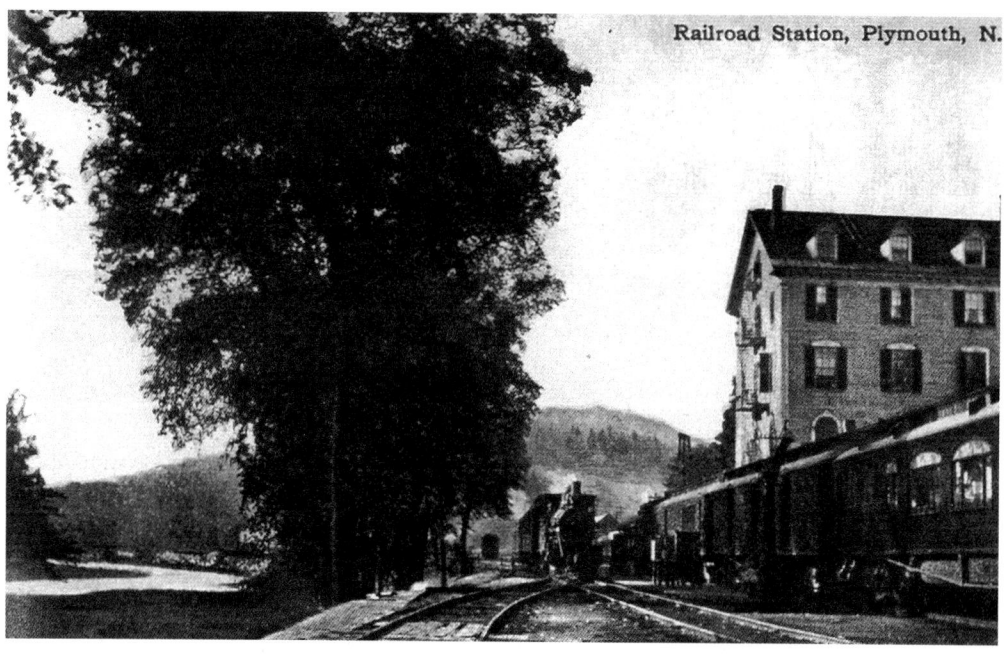

The White Mountains Division: Pemigewasset and Franconia Valley

The Franconia Notch State Park covers approximately six hundred acres along both sides of the Pemigewasset River for eight miles. There are more waterfalls located here than in any other area of equal size in the White Mountains. The natural beauty of this park is magnificent and majestic beyond words, but is well captured in this painting by George L. Brown.

formed no small group, but now the railroad has thrown its ministering branch into the locality, and the superlative merits of the place have become better and more widely known and appreciated. Within and about Livermore Falls, Blair's, Campton, Thornton and Woodstock villages are concentrated natural delights, and in their neighborhood are to be found all the wild characteristics of the New Hampshire region. In addition to the Pemigewasset River, the Mad River and Baker's River also furnish the water for the valley views. These waters become violent torrents when the winter snows break up and the spring rains begin to fall. But in the summer they become laughing, purring water courses, animating the scenes with the most benign influences.

At the turn of the twentieth century, the stagecoach had not yet been entirely banished from the valley. As stated earlier, the Pemigewasset Branch (once known as the Concord & Montreal Railroad but now in the possession of the Boston & Maine) extended from Plymouth to Lincoln. The objective point of this route, however, was the Profile House in the heart of the Franconia Mountains, and the Flume Gorge, which is about halfway between North Woodstock and the Profile. The distance from North Woodstock to the Profile House, via the Flume, was about ten miles of road that a line of mountain coaches ran. Once the passengers had chosen to make their advent upon the mountain scenes, they proceeded to travel via the primitive passage out from the depth of the Pemigewasset Valley.

Arriving in Woodstock it becomes obvious enough that the mountain region has been entered upon, for, appearing through the wonderful vistas from time to time are

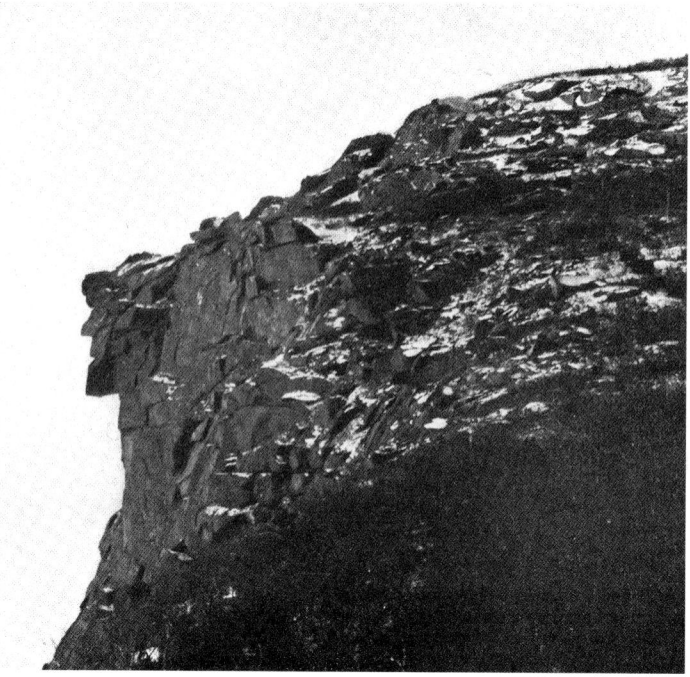

The Old Man of the Mountain, Franconia Notch, 1900s. The Old Man of the Mountain, the most perfect natural stone face in the world. Also called "the Profile," the "Great Stone Face" of Hawthorne's story is forty feet high and is located on the south end of Cannon Mountain, fourteen hundred feet above the beautiful Profile Lake. It is recorded that the Old Man of the Mountain was first seen in 1805 by Francis Whitcomb and Luke Brooks, two workmen on the Notch Road. The profile itself consists of five ledges that give it the appearance of a human face. *Courtesy of the B&M Railroad Passenger Department.*

seen the outlines of the Franconia Mountains—Flume, Pemigewasset, Liberty, Lincoln, Lafayette, Cannon and Kinsman. On the west is old Moosilauke, with its attendant peaks, and from a path leading forward from the stage road, all the summits of the Pemigewasset Range in the east are visible.

A side trip on the stage road may be in order from Woodstock to the Profile, so that all these natural beauties may be unfolded for us to enjoy. The great mountains lift their heads on all sides. Cascades prattle and murmur and shimmer in the daylight. The foliage of the birches and maples and the piney growth rustles and whispers on every hand. The road winds over and around rocky steeps, the pebbly beds of streams and among the crags and bare trunks. The rays of the sun beat directly upon the sweating team and the passengers shaking in their seats, and soon they struggle through masses of leaf-burdened branches that sway and creak with every breath of the summer wind. The ascent becomes steep, and within a few moments, the horses are flying down a chasm-like depth. As has been stated, the destination of the coach ride from the train through the Franconia Notch is the Profile House, a hostelry taking its name from that wondrous phenomenon of natural carving known as "the Old Man of the Mountain."

The White Mountains Division: Pemigewasset and Franconia Valley

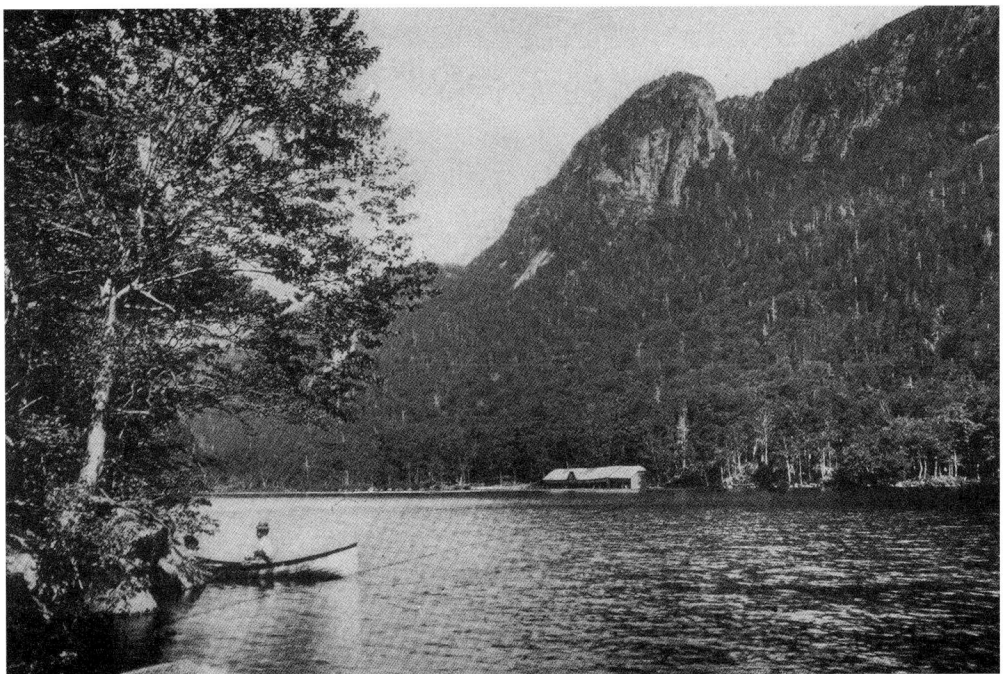

Profile Lake with Eagle Cliff, 1900s. Eagle Cliff (1,500 feet) is a precipitous foothill of Mount Lafayette; below is Profile Lake. *Courtesy of the B&M Railroad Passenger Department.*

The face of the "Old Man" was set inflexibly upon the top line of the southeastern ledge of Cannon Mountain, near the entrance of Franconia Notch. The crest of this mountain is approximately six hundred feet higher and on the opposite side of the Profile, which marked its steep front. (Unfortunately, we lost the Profile in May 2003 when it collapsed from the side of the mountain—nature has reclaimed a classic New Hampshire icon.) Near the top of this crest is yet another natural outcropping of mountain rocks, one being piled upon another so that the well-defined form of a cannon appears, seemingly mounted and ready for service. This "Quaker Cannon" is elevated about eight hundred feet above the plateau, and it is pointed directly in the line of the Old Man's position, and appears only to be a waiting a signal from the sentinel to belch forth an alarm to the world. This natural effect in the stone gives name to the mountain, as the face of the old man does to the Profile. There is but one Franconia, as there is but one Niagara. The natural wonders found here are not repeated anywhere else in the world and should be seen to be fully appreciated.

On the opposite side, the boundaries of the plateau are completed by Eagle Cliff, a succession of ragged rock masses, wild and grand in all their proportions, and readily suggesting the home of the eagles. Behind these cliffs rises Mount Lafayette; one of the most majestic of mountains, its summit can be reached by a bridle path three and a half miles from the plateau.

In the opposite direction from the plateau, and approximately the same distance from it, another glimmering sheet of pure sweet water reposes. This is Echo Lake, the home

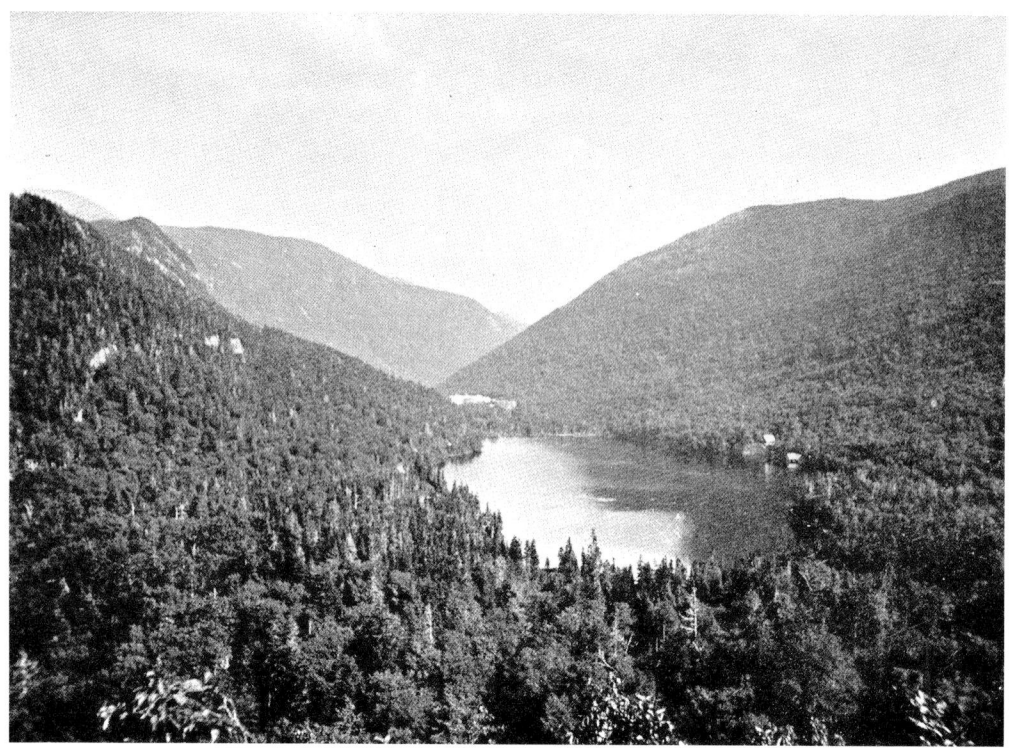

Echo Lake and Franconia Notch, 1900s. Echo Lake, a lake 1,940 feet above sea level, lies under the purple ledges of Eagle Cliff. Echoes from bugle or voice leap from cliff to cliff far up the great crevices. *Courtesy of the B&M Railroad Passenger Department.*

of the pickerel and black bass, and an attractive area for summer visitors. From the shores we may advance to the center of the lake surface, where clear notes of a bugle blown are returned again and again from Eagle Cliff and other surrounding walls that frame the lake. Rising abruptly upward from the north shore of the lake, Bald Mountain appears, a favorite with visitors on account of the superb outlooks commanded from its summit. All around this lake the most beautiful roadways are laid out and maintained through woods and groves, and along the bases of the hills that come down to meet the waters of the lake in all directions.

Thus it will be seen that from the meadow of the Merrimack Valley, to the wilds and canyons of the Pemigewasset, to the mountain heights and primitive depths of grand old Franconia Notch, provisions are made for all visitors. In the valleys and along the riverbanks and upon the hillsides, many farmhouses and homesteads are places of welcome refuge for the summer boarder. In the villages, many accommodations are more elaborate caravansary, grand and luxuriant in all their amenities, which afford every convenience to the visitor. A must for a side excursion is the famous Flume Gorge, a noted feature of the Franconia Notch scenery.

CHAPTER FOUR

THE MOOSILAUKE & JEFFERSON ROUTE
VALLEY OF THE AMMONOOSUC

The first railroad to serve this growing vacation area was the White Mountains Railroad, which reached Littleton in 1853. Even though travel by stagecoach beyond these points was time consuming, those who made the trip were enthralled by the broad vistas of the White Mountains. Spacious summer hotels were quickly constructed for the mass of tourists that was invading the hills. Hotels were erected at Fabyan's, Twin Mountain, Whitefield, Jefferson, the Profile, Franconia and Bethlehem, catering to a growing number of tourists who sought to escape the cities and to share the cool comfort of the Granite State's Presidential and Franconia Ranges.

In spite of the depression years of the 1870s, new railroad construction had begun. The Boston, Concord & Montreal Railroad, having acquired control of the White Mountains line, extended its track to Lancaster in 1879, and in 1874 completed the line to Fabyan's from Wing Road. The following year the Portland & Ogdensburg Railroad arrived by way of Crawford Notch, providing additional rail transportation for the growing list of hotels in the mountain area. The Mount Washington Branch from Fabyan's to the Cog Railway Base Station was completed in 1876, providing the final rail link from distant cities to the summit of Mount Washington.

To resume our journey north through the White Mountains, let us return to the Plymouth Boston & Maine Railroad station so we may pursue the main line northward over its White Mountains Division. This route follows for several miles the western border of the state, and finally reaches the Connecticut River—the dividing line between New Hampshire and Vermont—near the point where the river joins the Ammonoosuc. The Ammonoosuc is a river born upon the steep side of Mount Washington that travels the bases of the northern peaks of the White Mountains until its union with the Connecticut River. Swerving to the east the railroad begins to follow the course of the Ammonoosuc from its mouth to its source, as it has previously followed the majestic Merrimack.

Immediately after leaving Plymouth, the main railroad line makes a sharp turn westward, and from here passes up the valley of the Baker's River. This excursion is

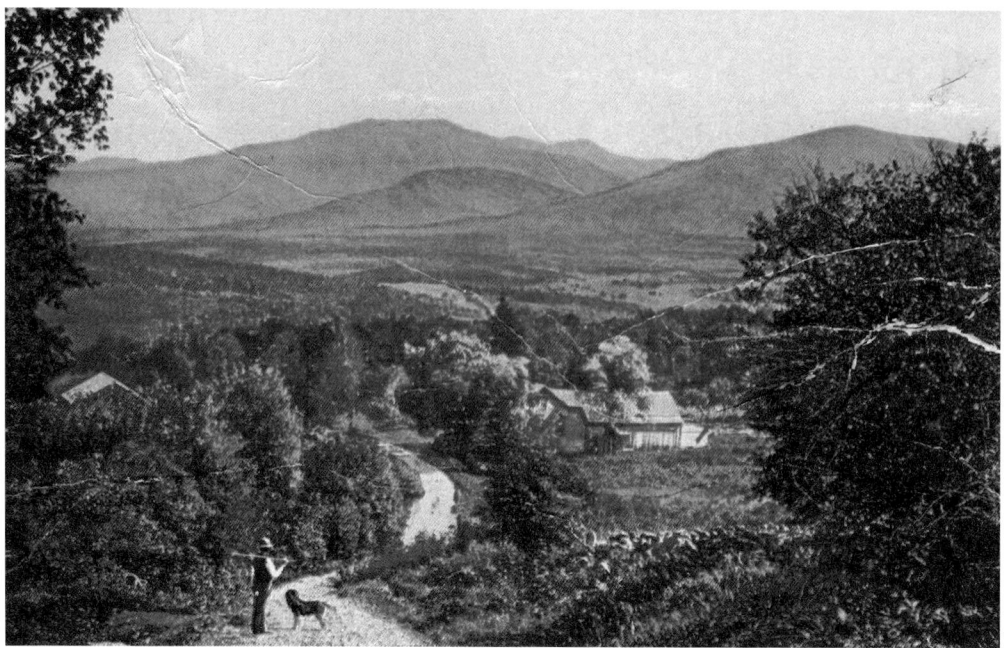

The Franconia Mountains from Sugar Hill.

a steady ascent where the road stretches for a considerable distance along hillsides, with suggestions of mountain ranges on one side of the road and the loveliest of views downhill into summer valleys on the other.

Our trek to Littleton will take us through the towns of Rumney, Wentworth, Warren, Pike, Haverhill, Woodsville, Sugar Hill and finally to our destination at Littleton and Bethlehem. With tempered sunshine and grand scenery, these are the chief attractions of the train route. Within a five-mile distance, Mount Moosilauke lifts its head, the single great mountain peak of the western route, although grand mountains in the distance are met with every mile of travel. The stations in the valley between Plymouth and Warren are not entirely without mountain attractions. Rumney has Mount Stinson and Pond Mountain, and Wentworth, considered the fairest of the intervale villages, reveals Carr's Mountain on the east and Cuba Mountain on the west.

Mount Moosilauke is the patriarch of this western region. From its isolated position and great height, this peak commands a grand and unique view. Its name is of Native American origin, Moosi signifying "bald" and aukee "place." A good carriage road leads from Warren Village to the summit where there was once a fine hotel called the Tip-Top House. The outlooks from this peak are superb, including the hill towns of Grafton County to the south, Owl's Head to the west, large reaches of the Connecticut Valley in the northwest and to the extreme north of the peak are some of the Canadian mountains. The Green Mountains of Vermont are in full view when the weather is clear, and on the east are the Pemigewasset Mountains. A panorama of mountains extending from Sugar Loaf to the serrated peak of Chocorua embraces the principal

The Moosilauke & Jefferson Route: Valley of the Ammonoosuc

These are reproductions of portions of the B&M public timetables for June 26, 1916, showing service that does not appear to be much different from the pre–World War I era. These tables include Profile Branch, Bethlehem Branch, Whitefield Branch and the Connecticut River Line.

summits of the White and Franconia Ranges. Looking southeast, the fair surface of Lake Winnipesaukee is seen, and looking over the lake will reveal portions of the state of Maine. The sunrises and sunsets from the elevation fully equal those from the top of Mount Washington, and many people are of the opinion that the variety and extent of the outlooks from Moosilauke are superior to those obtained from any part of the Presidential Range.

The whole Warren neighborhood is full of attractions for summer visitors, and this may be said of all the towns on this section of the Boston & Maine Railroad. Warren is located 71 miles from Concord and 146 miles from Boston. The village lies parallel with the railroad. There are said to be more than one hundred brooks in the town, some of them with picturesque falls. One of the loveliest of these streams is Hurricane Brook, which flows from Mount Carr.

As the route travels northward the Ammonoosuc River grows more serpentine in course, winding and twisting in the rich bottomlands. In the neighborhood of Haverhill a notable turning of the river takes the name of Ox-Bow Bend. Haverhill is one of the numerous quaint villages along this route and contains the Grafton County buildings. Just across the river from Haverhill, and standing on a terrace, is the town of Newbury. The meadows, with their carpet-like expanses, furnish visitors with charming walks along the town's borders. It is interesting to note that the lands here were once the home of a large tribe of Native Americans, who fished the rivers for their salmon and trout and hunted wild game in the mountains.

At Woodsville, a few miles above Haverhill and forty-two miles above Plymouth, the Connecticut River is crossed by a bridge, and the Boston & Maine Railroad connects with the Passumpsic Division of the Boston & Maine system and with the Montpelier & Wells River Railroad, running directly to Montpelier, Vermont. From Woodsville the Boston & Maine line continues up the valley of the Ammonoosuc River, passing through Bath, Lisbon and Littleton to a terminus still farther north.

From Littleton the railroad continues northward, passing Wing Road, from which point the main line extends to Fabyan's and the base of Mount Washington, and the Whitefield & Jefferson Branch extends to Berlin. Owing to its location in the northwestern section of New Hampshire, this branch sits on the natural shelf above the Ammonoosuc River. Littleton quickly became a trading center for northern New Hampshire. Its railroad station, which served Bethlehem and Franconia, was considered the busiest station north of Concord.

The Ammonoosuc is essentially a mountain stream. The valley with its river is enclosed by the grandest elevations of the White Mountains, while the remaining portions of its course are through rough-and-tumble country, always with a background of mountain ranges and lofty hills. In the Franconia area, the descent from the mountain fringes is over the loveliest meadowlands imaginable. It harbors such villages as Bethlehem, outlying hotels such as the Maplewood and there repeats again and again a series of the most beautiful panoramic views, such as are spread between the Twin Mountain station and Lisbon.

Perhaps one of the finest vistas here is nestled along the banks of the river. Between the steep sides and lofty summits of the surrounding elevations, the riverbanks are marked by

The Moosilauke & Jefferson Route: Valley of the Ammonoosuc

The Presidential Range as seen from the Whitefield & Jefferson Branch, Jefferson, New Hampshire, circa 1900s. *Courtesy of the B&M Railroad Passenger Department.*

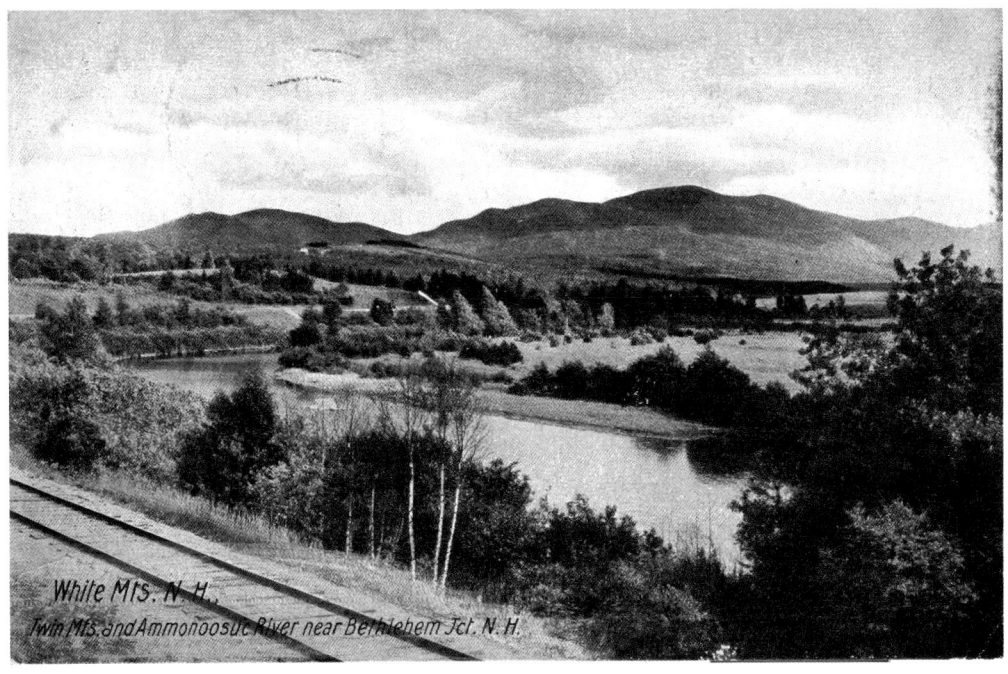

Twin Mountains and Ammonoosuc River near Bethlehem Junction, 1907.

A History of the Boston & Maine Railroad

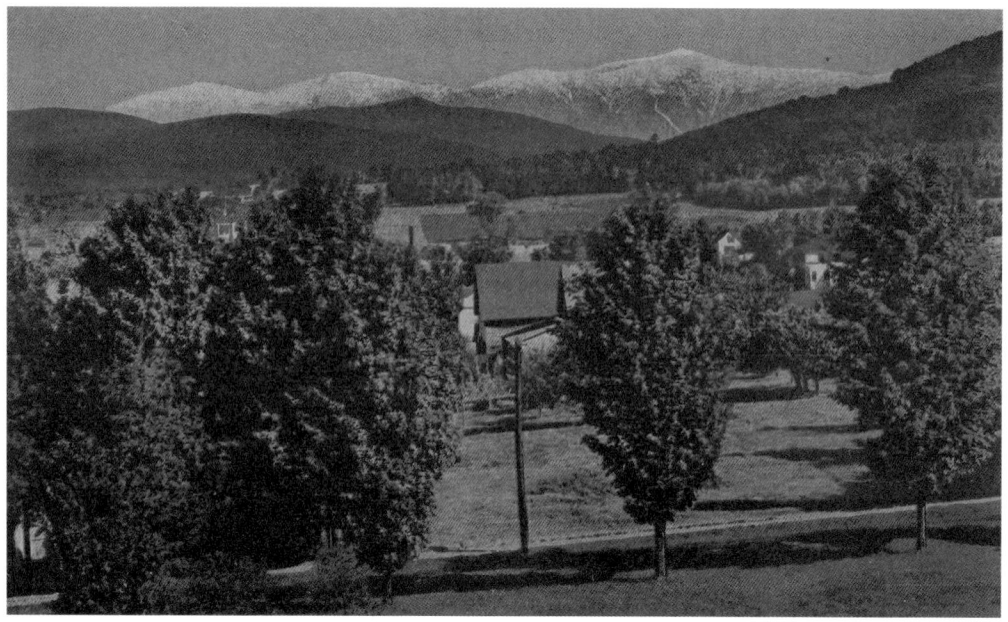

The Presidental Range in September from Bethlehem, New Hampshire.

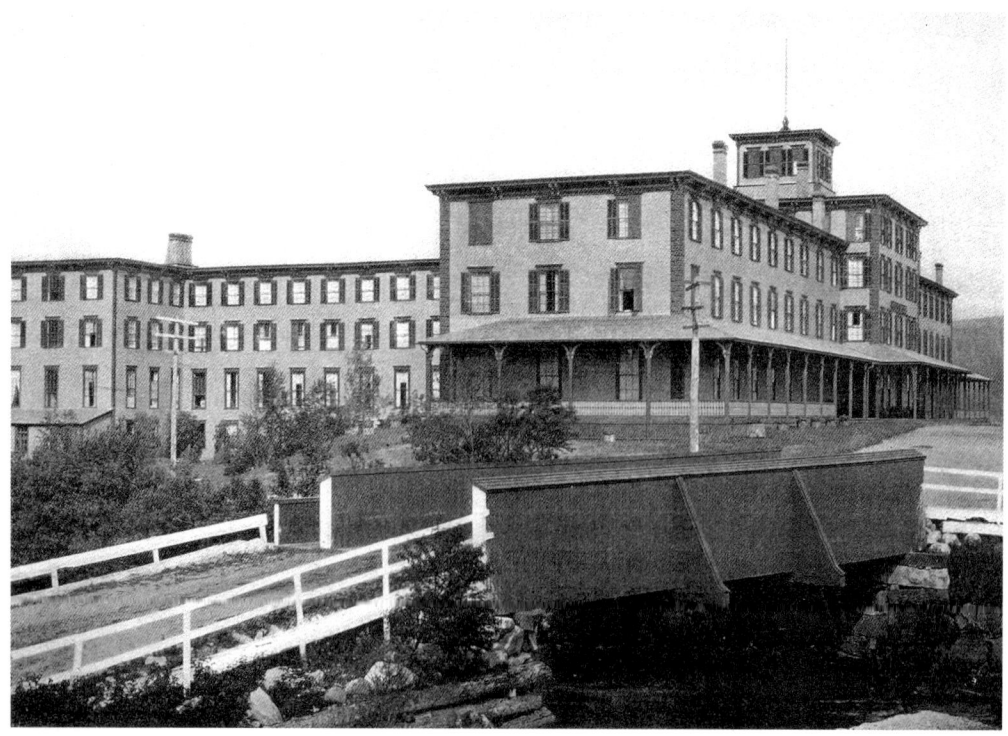

The Fabyan House. This hotel had long been the summer home of tourists who desired a view of the grandeur of the Presidential Range from its spacious verandas.

The Moosilauke & Jefferson Route: Valley of the Ammonoosuc

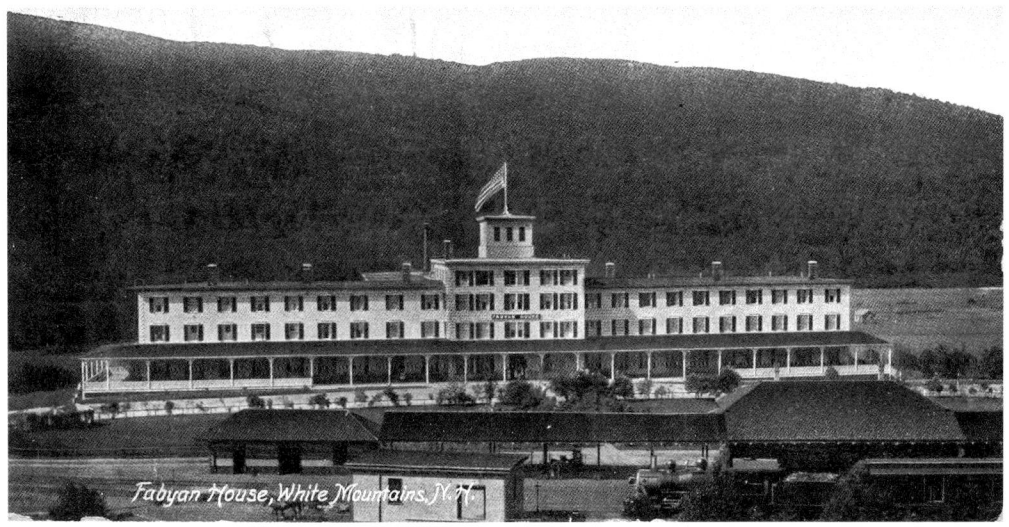

The Fabyan House and Station, 1909. This station was considered the most important railroad point in the White Mountain region. All Boston and New York express trains ran to and from this station, as did the Mount Washington trains. The Fabyan House was situated opposite the station.

bewitching pastoral scenes, dotted villages, clumps and groves of wood-growth and farms and centers that have been chosen for the establishment of summer communities.

Passing from one end to the other of the Ammonoosuc Valley, the central destination known as Fabyan's is reached. Fabyan's is a mountain resort, the beating heart of a giant body of mountains, including the Presidential Range in the White Mountains.

Fabyan's was not a town, not a village, not even a crossroads establishment accommodating a widespread outlying population. Fabyan's was a terminal of a different sort, a composite of facilities of the early Boston, Concord & Montreal and the Portland & Ogdensburg Railroads, which were eventually leased to the Boston & Maine and Maine Central, respectively. It was simply a great White Mountains caravansary, much like the original Profile House and the Maplewood resorts. Until the early 1920s, Fabyan's was a day and night train order office for the Maine Central, and it doubtless shared its wires with the Boston & Maine. As such, Fabyan's was indeed a post office, community and a first-class resort; it was considered the most prominent railroad point in the White Mountains. This station was the grand center of the mountain region. Here the eastern and western lines of railroads made their connections. All the Boston and New York express trains ran to and from this station, which would make it a prominent mountain resort. The Fabyan House was situated opposite the railroad station.

The track layout at Fabyan's was quite interesting. The Boston & Maine arrived from the south, joined the Maine Central west of the White Mountain House and their parallel lines continued to the station. Just west, the Boston & Maine had two long sidings on which to yard and service trains after their long trips from the city.

During the mid-1800s the entire hotel business of the mountain region of New Hampshire was done by six hotels that could accommodate about 150 guests at one

time. Before the railroads came into the area, the transportation was by stagecoach lines, and thirty-six horses sufficed for the whole business over a sixty-five-mile route.

But many years previous to the time mentioned above, there had been a hotel at Fabyan's. The celebrated Crawford family had taken an interest in the first erection of this kind ever taking place in the White Mountains. The name Fabyan was given to the hotel about the year 1837, when there came to this neighborhood a gentleman by the name of Fabyan, who purchased the hotel and 250-plus acres of property in the midst of the White Mountains. Thus came into existence the first Fabyan House, which was destroyed by a fire in 1853. The succeeding Fabyan House was built about 1865. This house was originally located almost within the shadow of the towering Presidential Range, and the airline distance between it and the summit of Mount Washington was seven and a half miles.

ASCENT OF MOUNT WASHINGTON VIA THE RAILWAY

From the Fabyan House, the course to the base of Mount Washington, a distance of about four and a half miles, is over a gentle plain, the surface of which is hidden by a jagged growth of firs and hemlocks. This course is occupied by a spur of the Boston & Maine Railroad system, which connects directly at the base of the range with the unique "cog railroad" leading up the almost perpendicular side of Mount Washington. This wild plain, which occupies nearly the entire basin formed by the mountain surroundings of the locality, is certainly not without peculiar attractions of its own during the summer months. The dark shadings of the foliage of its coniferous growth, the suggestiveness of its mysterious depths and its overshadowing by the grand elevations all around lend it almost supernatural qualities not wholly uninviting.

The Cog Railway has been in operation since 1869, carrying thousands of passengers. In 1895, the Boston & Maine leased the line connection from the Base Station with Fabyan's Station. The ascent of Mount Washington via the "Cog" is an extremely simple affair. The essential feature of the Cog Railway is the driving mechanism. If you were to look closely at the engine you could see the central cogs as well as the outside rails. The cog consists of two pieces of wrought-angle iron placed parallel and connected by iron pins four inches apart. Teeth on the driving wheel mesh with the cog rails and draw the whole train up the mountainside. Trains began running over this railway in 1869, and from the beginning of its operation to the present, no person is known to have been injured upon it, nor has any serious accident ever taken place along its line.

The distance up the mountain from the Base Station to the summit by rail is three miles. The average grade is 1,300 feet to the mile, but occasionally this increases to nearly 2,000 feet to the mile, or sinks to about 800 feet. On "Jacob's Ladder," the steepest portion, the grade is 1,980 feet to the mile in some areas, or thirteen and a half inches to the yard. There are nine curves in the line, varying from a 497- to 945-foot radius. Water is taken from tanks located at proper distances on the route. In making the trip in either direction, it is nearly two hours from the Base Station. The cars seat

The Moosilauke & Jefferson Route: Valley of the Ammonoosuc

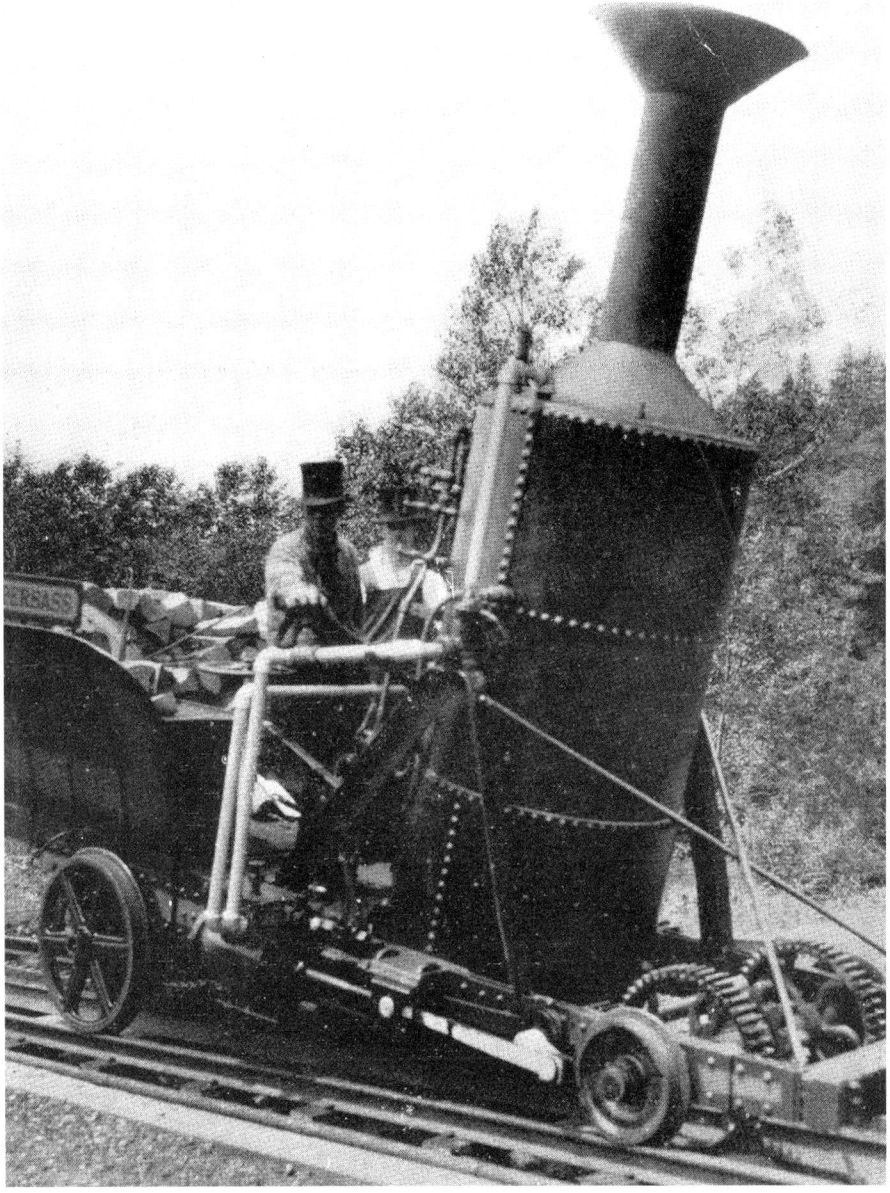

"Old Peppersass," the first Cog Railway engine, 1866. At first, the engine was christened the "Hero." However, one old-timer thought it looked like a bottle of peppersass and the name stuck.

forty persons each, and when business is brisk, as many as six trains are passing over the tracks at one time, upward and downward, rarely more than a few yards apart. Whether ascending or descending, the locomotive is always below the passenger cars, pushing them upward, or holding them back, as the case may be.

If one is so fortunate as to have chosen a clear, bright day for making the trip up the mountain, the novelty of the railroad rapidly disappears as the majesty and supremacy

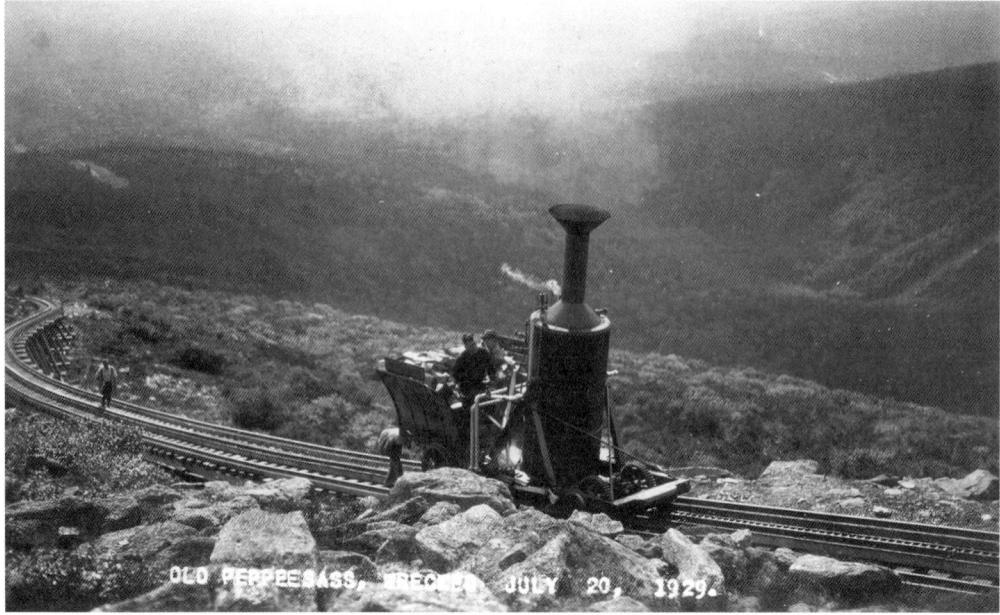

"Old Peppersass" as seen on Mount Washington just above the tree line, entering the region of sub-alpine vegetation on the summit of the mountain.

of this king of the ranges asserts itself. The broadening outlook, extending on every side as the train toils upward foot by foot, reveals the vistas of ancient forests and glorious vales in rapid succession; grand views over treetops and lesser elevations, far away toward mountain chains and winding rivers; the changing vegetation, becoming more and more sparse as it nears the line where all will vanish; and the great gulfs and rifts in the mountainside, appearing as openings to infernal dens in the bowels of the earth. The sensation is like one were flying in the air with the birds or swinging on the edge of a cloud.

Mount Washington is the most prominent part of the Presidential Range of the White Mountains, and it is the highest mountain peak east of the Rockies and north of the Carolinas, rising to a height of 6,288 feet above sea level. From the summit of Mount Washington we may gaze as far east as the Atlantic Ocean at Portland, Maine, and as far west as Lake Champlain. To the south can be seen the shimmering surface of Lake Winnipesaukee, and to the north the misty outline of Lake Memphremogagog.

Needless to say, it is always cool on this lofty summit, and often there is a difference of thirty or forty degrees in temperature between that of the lowlands. Snowstorms are not uncommon here during the summer, and those who are appalled by a 40- or 50-mile-an-hour "blow" would probably not want to be on the summit when 100 more miles an hour are added to this velocity. In April of 1934, the highest official wind velocity on the surface of the earth was recorded on the summit of this mountain. The wind reached a velocity of 231 miles per hour right as the measuring equipment was blown off the top of the mountain.

The Moosilauke & Jefferson Route: Valley of the Ammonoosuc

A scenic view from Mount Washington, 1900s. This view, looking toward the southwest, includes forty or more peaks from Carrigain at the left to Mount Hale at the very right edge of the picture. Mount Moosilauke stands out plainly just to the right of the center, with Mount Liberty in front of it. The Lake of the Clouds AMC hut may be seen in the foreground. Note: The Lake of the Clouds is the name of the lake located near the summit of Mount Washington. *Courtesy of the Appalachian Mountain Club.*

In describing an impression of the view from the summit of "the great autocrat of New England," Samuel Drake wrote:

> *I consider this first introduction to what the peak of Mount Washington looks down upon, an epoch in any man's life. I saw the whole noble company of mountains, from highest to lowest. I saw the deep depressions through which the Connecticut, the Merrimack, the Saco, and the Androscoggin wind toward the lowlands. I saw the lakes, which nurse the infant tributaries of those streams. I saw the great northern forests, the notched walls of the Green Mountains, the wide expanse of level land, flat and heavy, like the ocean, and finally the ocean itself. This entire vista is mingled in one mighty scene. The utmost that I can say of this is that it is a marvel. You receive an impression of the illimitable such as no other natural spectacle. Astonishment can go no farther.*

Through this landscape of the mountainside runs the infant Ammonoosuc, which rising high up the side of Mount Washington, flows here a purling trout brook, much sought by visitors to the mountains. Besides the railroad spur already mentioned are straggling roads leading to neighboring hotels and inns as well as to outlying lumbering localities.

One feature of the Ammonoosuc Valley neighborhoods commands the earnest attention of the mountain traveler—its healthfulness. The elevated lands bordering

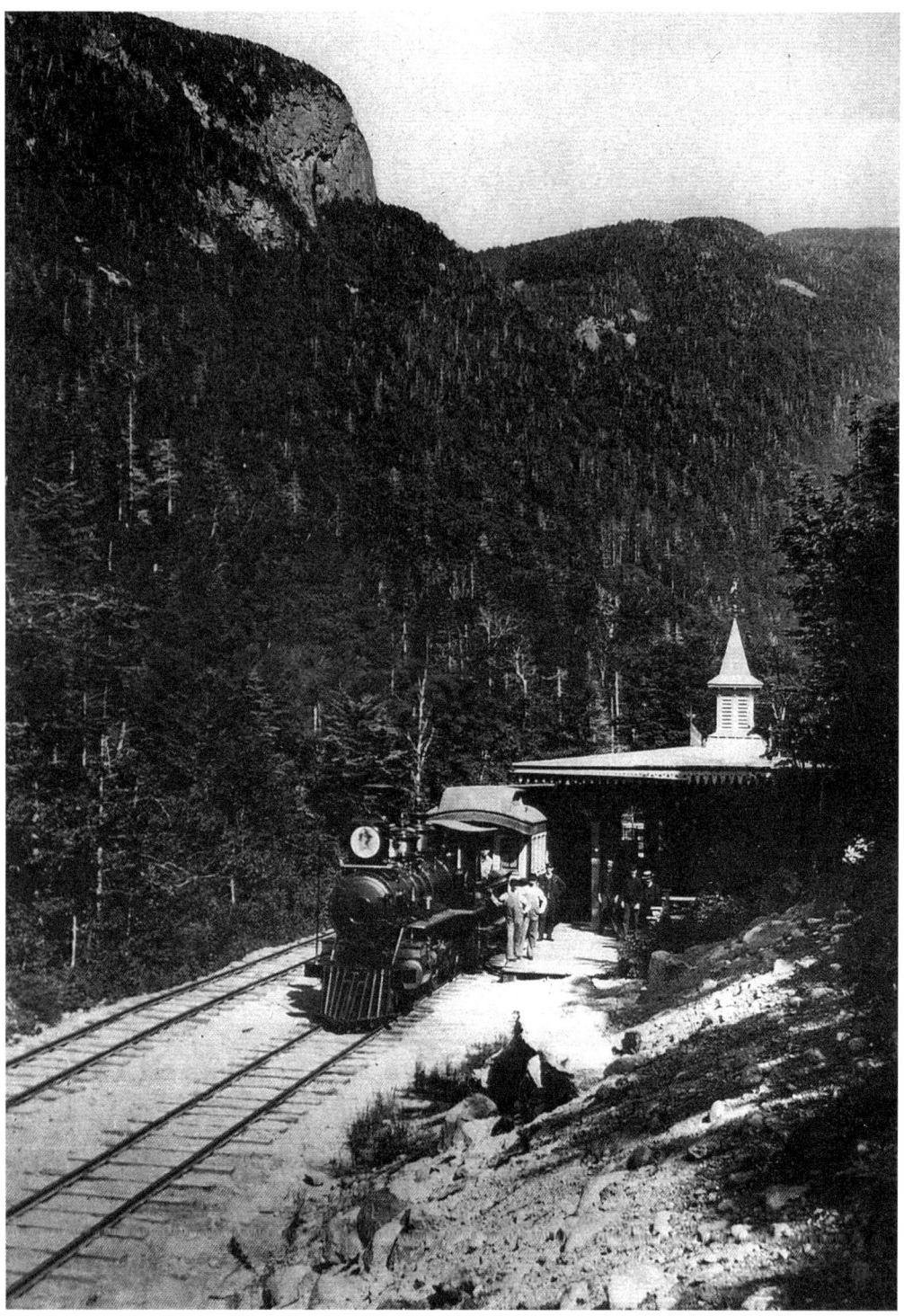

The Profile & Franconia Notch Railroad was a narrow-gauge line that served the Profile House and the Maplewood Hotel. This short line went as far as Bethlehem. Above the train station is Eagle Cliff (left) on Mount Lafayette. *Courtesy of the B&M Railroad Historical Society.*

The Moosilauke & Jefferson Route: Valley of the Ammonoosuc

this valley, its hillsides and raised plateaus, are absolute sanitariums with regard to hay fever and such similar diseases, and as such have long since become well known. Every advantage is taken of the medicinal and curative qualities of these localities, particularly in Bethlehem and Twin Mountain, New Hampshire.

Following the stream in its windings down the valley, pastoral scenes of natural beauty succeed each other for some miles of our train ride. This branch of rail follows closely the course of the river as far as the Wing Road. Here the railroad leaves the main line and continues up the Ammonoosuc Valley through the Mount Washington Branch. The matchless scenery and constantly changing vistas of this route would fascinate any passenger. The Franconia Notch Railroad chartered on July 11, 1876, and jointly owned by the Boston, Concord & Montreal and Taft and Greenleaf proprietors of the Profile House—was a narrow-gauge road built and referred to as the Pemigewasset Valley. It was later extended to Maplewood and Bethlehem (opened July 1, 1881). The road operated its own property until 1891. In the later years it began to be operated by the Concord & Montreal Railroad, successor by merger to the Boston, Concord & Montreal Railroad. This was the first narrow-gauge line to be built in New Hampshire and the directors were determined that the motive power and equipment would be the finest money could buy. Two locomotives, each costing $5,000, were obtained new from the Hinkley Locomotive Works. They were of the 4-4-0 wheel arrangement and were named the Echo No. 1 and the Profile No. 2. Four passenger cars and six flatcars were also purchased new. According to H. Bentley Crouch's article "Narrow Gauge to the Notch," published in the B&M summer bulletin, 1976: "The passenger cars were 45 feet in length. Two of them were of conventional design with 50 seats while the other two were observation cars and had 60 movable chairs. All were equipped with large windows which let down so that passengers could better view and savor the forest wilderness."

Bethlehem may be considered the most famous of the mountain towns. It is a village of hotels, inns and boardinghouses, and its entire existence is given over to the accommodation, entertainment and welfare of tourists. Its excellent sanitary features are in excess, and the healthy, clean air cannot be surpassed by any mountain area. It is a favorite resort community with every class of summer travelers, and its accommodations are considered first class. Nowhere in the mountains are assemblages gathered who are more cosmopolitan in character, or more representative of every class and locality than in the Bethlehem neighborhood.

About midway down the narrow-gauge spur leading from Bethlehem Junction to Bethlehem is situated the Maplewood Hotel. This establishment occupies what was originally an outlying Bethlehem farm. The original farm was added on to piece by piece until the present extensive Maplewood Hotel was created. Maplewood sits on a broad, undulating plain, with mountains all around, so that the horizon on every side presents a great natural wall, grand and magnificent beyond description.

Looking northward from Maplewood, the view extends far across the valley of the Ammonoosuc, and in Vermont, forty miles away, appear the Stratford Hills. In the interval, the most beautiful valley views imaginable are presented. Looking in a northeasterly

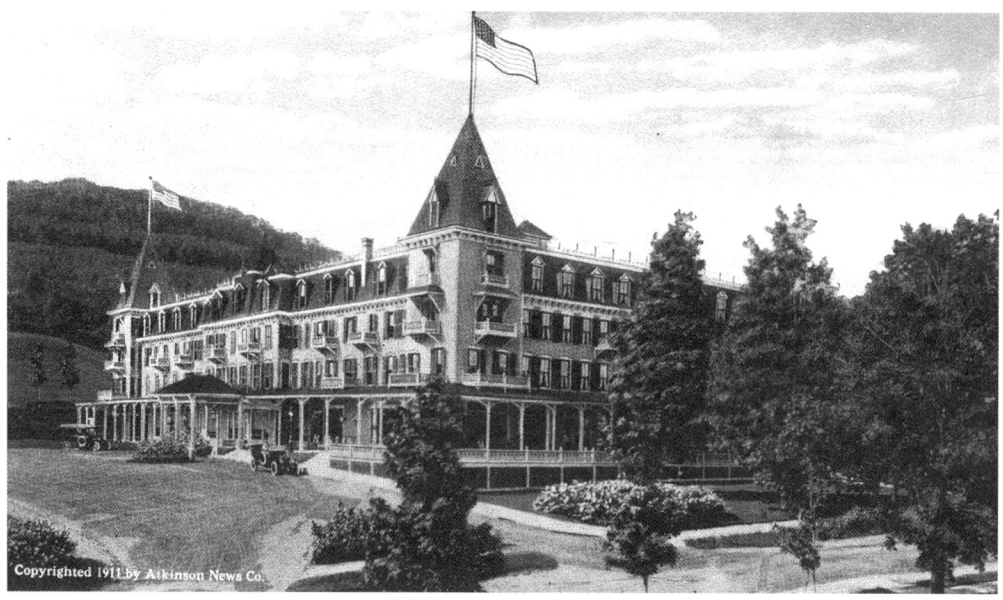

The Maplewood Hotel, circa 1911. Located in the town of Bethlehem, the Maplewood was considered to be one of the finest resort hotels in the White Mountains.

direction, Cherry Mountain is in full view. Looking westward and directly over the site of Bethlehem Village, the Green Mountains of Vermont are distinctly visible.

From Bethlehem, all the mountain and valley landscapes within the state are readily accessible and furnish objective points for the most beautiful and inviting drives in the summertime. One other mountain locality in this area demands notice—the village of Franconia. Franconia, though so near the valley of the Ammonoosuc, really occupies the valley of the Gale River and is situated only a little north of the Franconia Notch. Franconia is reached by stage road both from Littleton and Bethlehem, being half a dozen miles from the first and about five miles from the latter. It is interesting to note that Franconia has large mineral deposits, which distinguish it from most of the mountain neighborhoods in this region.

But the crowning attraction of Franconia is Sugar Hill. The town is full of hotels and boardinghouses; some of them are popular, fashionable resorts and others are more quiet, domestic and reserved in their features.

We may find it hard to visualize scenes of rolling wheels and panting steam power and the hectic activities that accompanied the great amount of resort traffic in the White Mountains. Historians of a new day might still seek out traces of abandoned roadbeds and old bridge abutments, but evidence of the equipment and the men who spent so much effort maintaining and operating this vast network becomes increasingly harder to find with the passing of time.

This concludes our train trip through the valley of the Ammonoosuc, from the Connecticut River to Mount Washington, as it was during the early twentieth century.

CHAPTER FIVE

THE EASTERN DIVISION
(MAINE CENTRAL MOUNTAIN DIVISION)
BOSTON TO NORTH CONWAY, NEW HAMPSHIRE

THE CRAWFORD NOTCH

Of the three principal avenues to the heart of the White Mountains, two follow the course of great New England rivers—the Merrimack and the Connecticut. The third enters into it by way of the famed Crawford Notch, the eastern gateway to the region, unfolding to the eye of the tourist a scenic panorama unequalled this side of the Rocky Mountains. This is the route of the traveler who prefers to reach the mountains by way of the Eastern and Western Divisions of the Boston & Maine Railroad.

The rails of the Eastern Division unite at Intervale with those of the Maine Central Railroad through lines from Portland, and from there, the line proceeds with a large proportion of the annual army of summer tourists to the White Mountains and the scenic beauties of the Crawford Notch. The passenger trains are drawn by powerful locomotives up through Bartlett and into the majestic defile that gives excess to Crawford's Bretton Woods. The line's stops include the railroad stations for the Mount Pleasant House, the Mount Washington Hotel and Fabyan's, as well as other notable points of interest beyond.

The eastern route from Boston, after passing through Salem, Newburyport, Portsmouth and other seaboard cities, deflects at Conway Junction and takes the tourists through a charming section of the foothill country, of which several Ossipee villages are considered popular centers for vacationing. Ossipee is a paradise for those who desire to enjoy the pure air, delightful mountain scenery and beautiful drives, with an abundance of brooks, ponds and lakes within easy distance of village centers.

From here excursions may be made to Lake Winnipesaukee, North Conway, Jackson and the White Mountains, either by the railroad or by carriages, which are always available for these outings. On Lake Winnipesaukee is the quiet hamlet of Wolfeboro. It was here in 1764 that colonial Governor John Wentworth completed Province Road from Portsmouth to Wolfeboro. The establishment of his summer home here gives Wolfeboro just claim to the distinction of being the oldest summer resort in America. Wolfeboro reclines on Lake Winnipesaukee where the Boston & Maine steamer *Mount Washington* once sailed the lake. However, for the sake of our nostalgic journey, if you

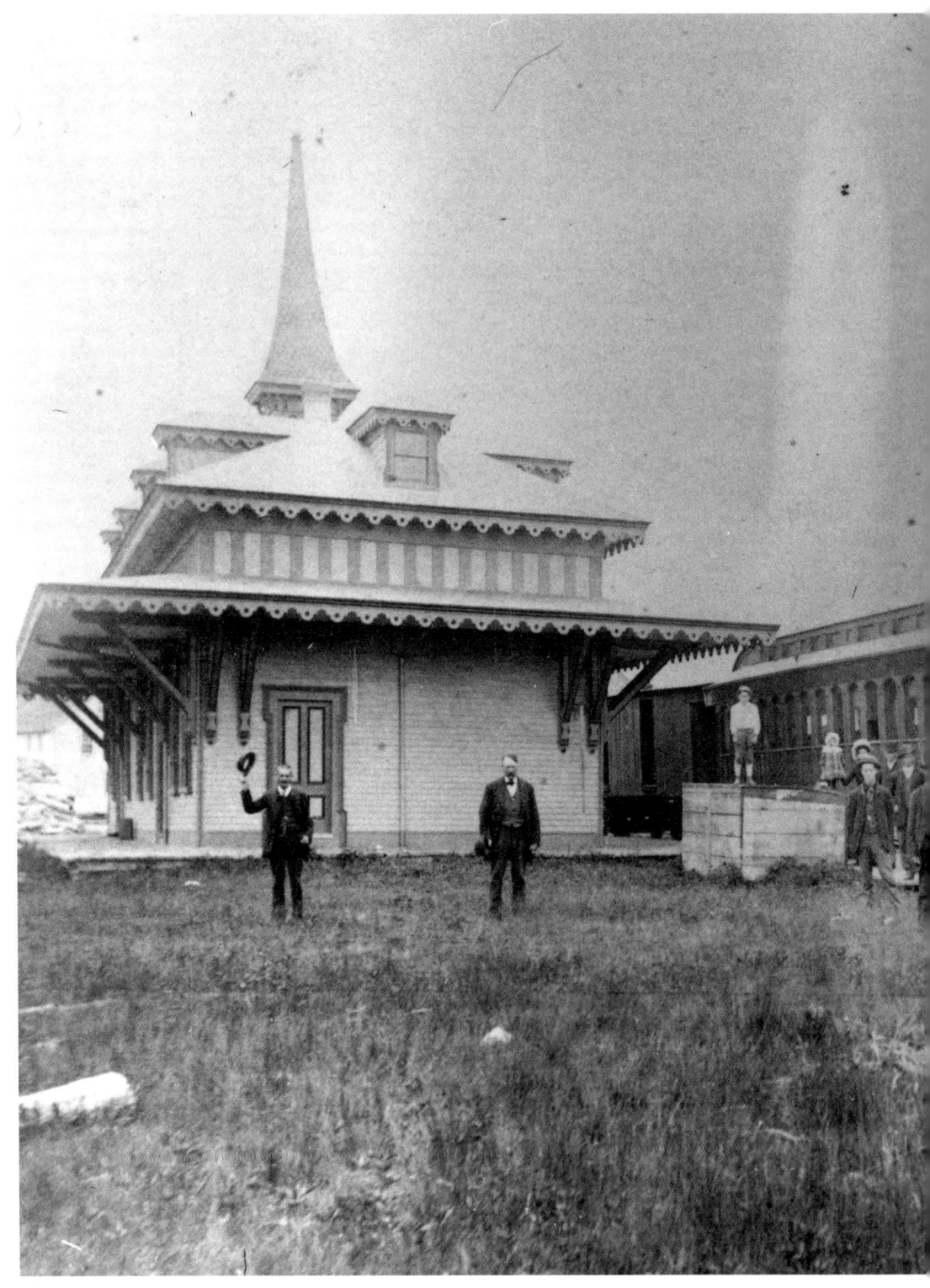

The Portsmouth Great Falls & Conway Railroad, 1900s. *Courtesy of the B&M Railroad Historical Society.*

The Eastern Division (Maine Central Mountain Division)

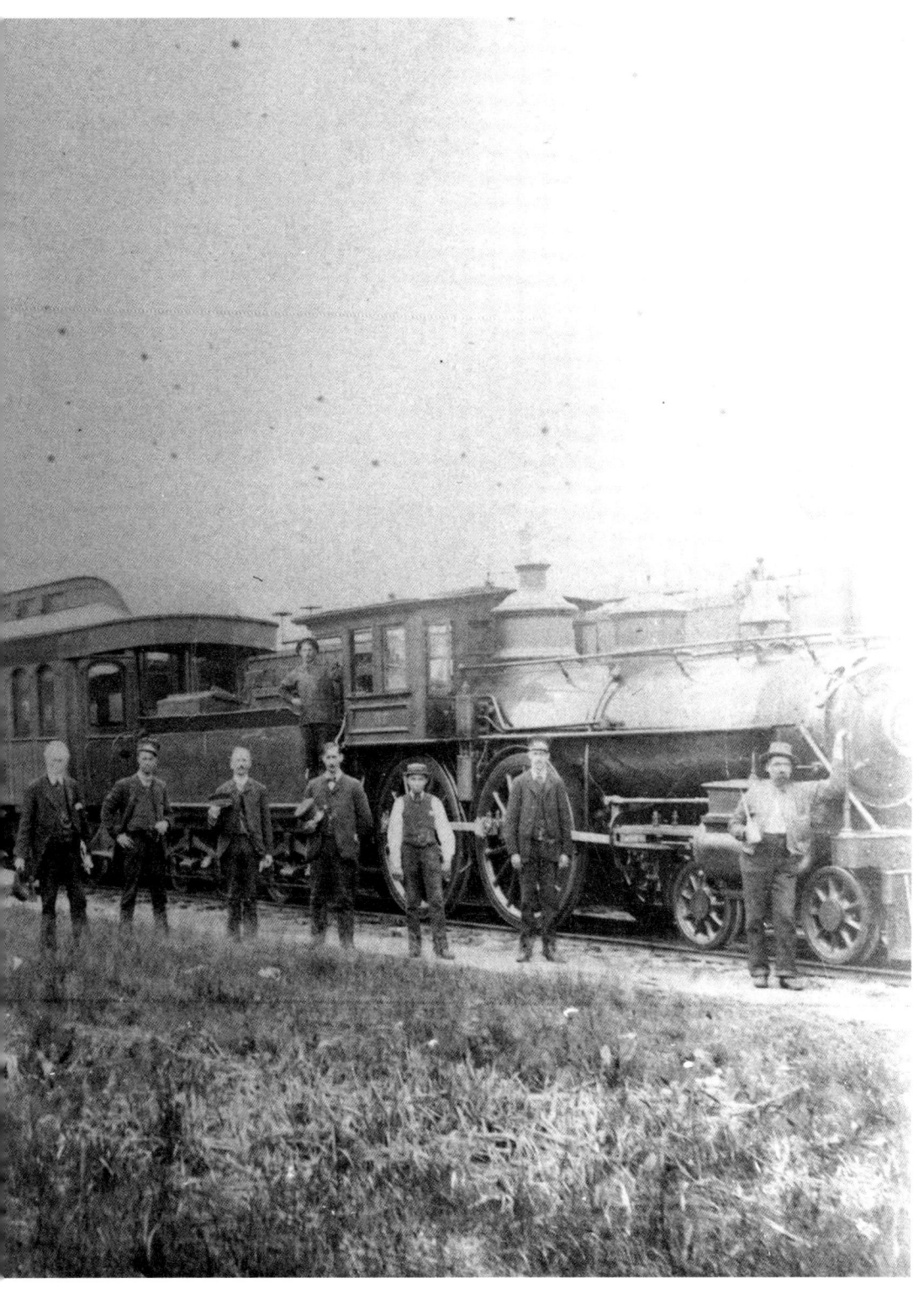

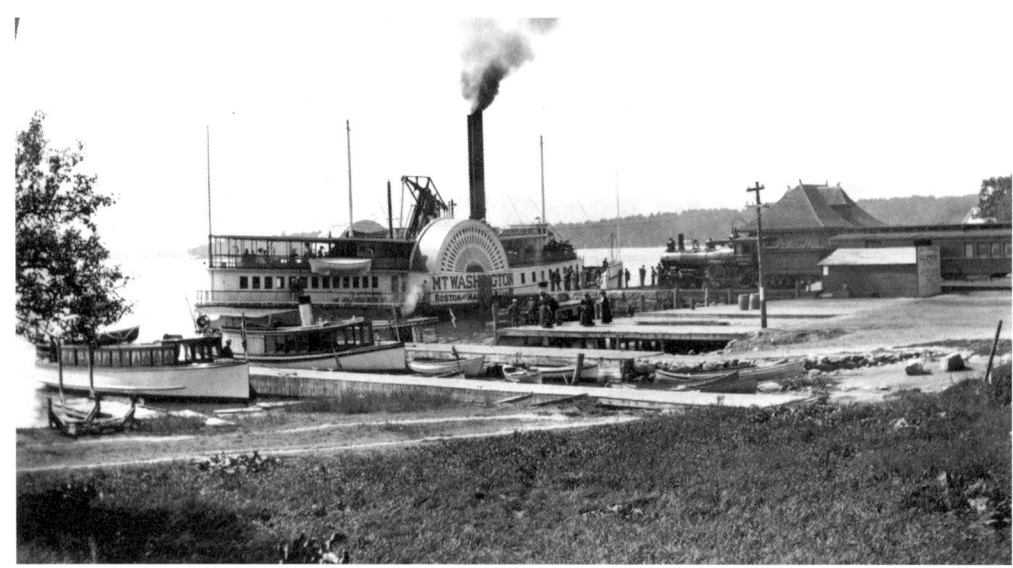

The Boston & Maine Railroad steamer *Mount Washington* at Wolfeboro Town Docks with railroad, early 1900s. Shown here is the Eastern Railroad train connecting with the *Mount Washington*. The large Boston & Maine building in the rear burned in 1899. In 1884, in accordance with general legislation obtained for the purpose, the Boston & Maine leased the entire Eastern Railroad system. *Courtesy of the B&M Railroad Historical Society.*

wish you still may transfer from the train to the boat on an excursion ticket—enjoy the lake and return to the train in Wolfeboro and then go back to Sanbornville and change there so as to continue your trip north to the White Mountains.

That portion of the White Mountains Region adjoining Ossipee, of which North Conway, Intervale, Kearsarge Village and Jackson are the conspicuous centers, is one of the most delightful of the Eastern Division. Ever since the people of New England began to seek the uplands of New Hampshire for relief from the summer heat and business cares, this particular domain of the benignant vacation spirit has been favorably known as a mountain resort. The first of its boardinghouses was opened many years ago, when the mountains themselves were an almost undiscovered country.

There is something satisfying in the vistas one enjoys here, both verdant meadows and distant snow-capped peaks of the Presidential Range, as well as the indescribable balmy air that wafts down from those noble peaks and across those luxuriant meadows, that one seems to be almost in some land where the crowded cities and the noises of commerce were never heard.

The ministration of the Saco River, that delightful stream whose beauties have been described by many writers and placed upon artists' canvases, has much to do with the scenic primacy of the area landscape. Some of the most superb views of Mount Washington are unfolded to us from a distance.

Ever since Darby Field first saw the White Mountains more than 275 years ago, they have drawn people to the Saco River Valley. The first explorers journeyed here on foot and in the saddle through the trackless forest; they were followed by the pathfinders

The Eastern Division (Maine Central Mountain Division)

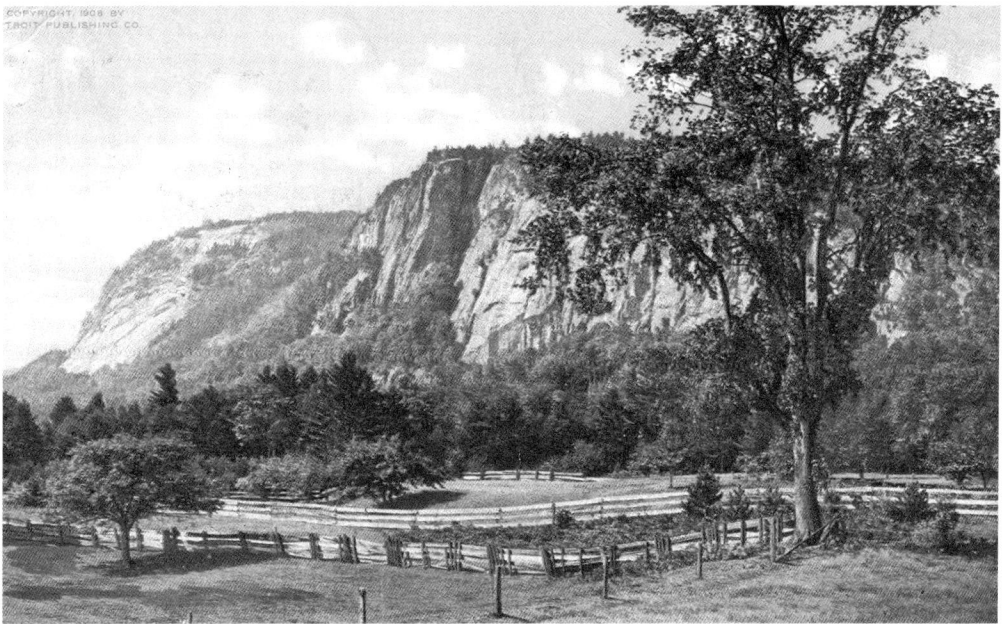

Cathedral Ledge, North Conway, 1908.

of the region, the Crawfords, Rosebrooks and Willeys, who established the first White Mountain inns. They were in turn succeeded by an ever-increasing number of people seeking relief from the heat and dust of the cities, willing to journey to this garden spot of the state. Crawford Notch easily met their requirements.

A large share of its glory, too, is due to the inviting meadows already mentioned, through which the widening Saco wanders, and also to the splendid heritage of noble trees that have fallen to the lot of this portion of New Hampshire's summer playground, and of which the Cathedral Woods of Intervale are famed.

The close proximity of Mount Kearsarge, too, is another strong card in favor of the North Conway–Intervale section of our travel, not to mention White Horse Ledge and the indescribable Crawford Notch, which lures the visitor toward its narrow and mysterious defile. North Conway is in reality the southern gateway to the Notch and the delectable land of mountains, valleys and ravines lying beyond it.

At the North Conway Station we may disembark from the train for a pleasant visit to the village. The passenger station is considered the centerpiece of the rail complex and is certainly the most striking edifice in the village of North Conway. It was constructed in 1874 in a Russo-Victorian style. In its natural setting, North Conway is the perfect approach to the Presidential Range in the White Mountains

The village, situated on the rim of a delightful valley, is about three miles wide and bordered on the west by White Horse Ridge, and on the east by the Rattlesnake Range. Its superb location gives a splendid outlook upon the rich meadows that so greatly delights the eye and soothes the spirit, and all around, the air is a tonic and the sunshine a healing balm.

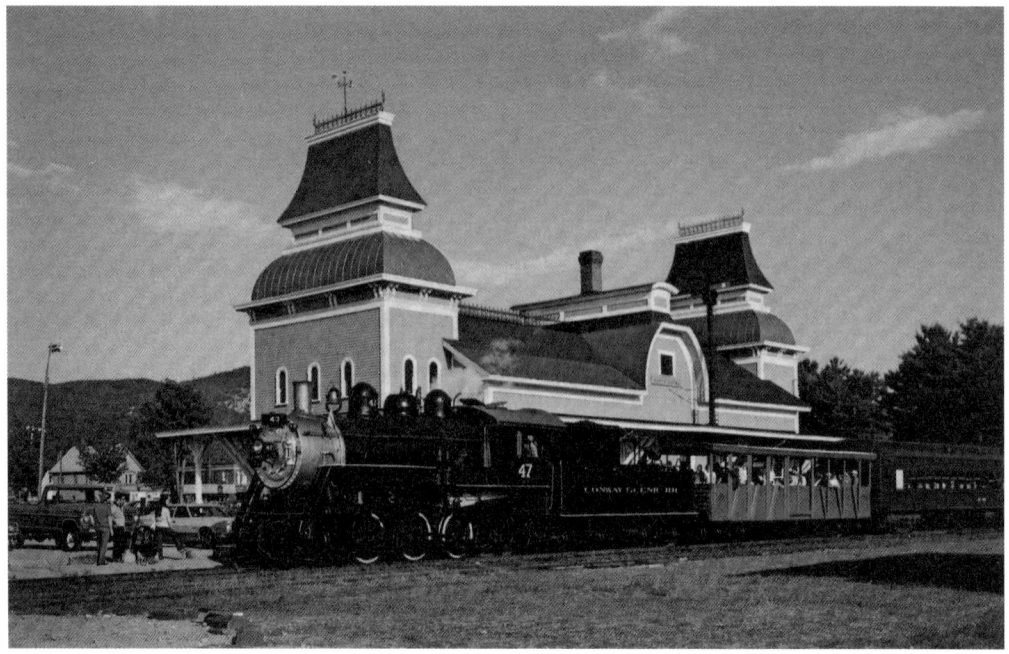

North Conway Railroad Station, North Conway, New Hampshire. From this station, built in 1874 on Main Street, rail service continued north through Crawford Notch to Fabyan's at the base of Mount Washington.

 From this depot, we will continue our trek through the White Mountains via Crawford Notch to Fabyan's Station, Mount Washington and the famous Cog Railway. One of the most scenic pictures to be enjoyed from here may be at the turn of the road on the train from Intervale; the meadow to the north is one of the most pleasant views of this region, with Mount Washington and its companions of the Presidential Range closing around the landscape.

 There is nothing to mar the perfect peace of the valley scene. Nothing in view but wide meadows, clusters of trees and an expanse of green over which the sunlight plays in arabesques of light and shade around the dark maples and through the foliage of graceful elms.

 Excluding the twenty-eight-mile trip to Mount Washington from North Conway, which many vacationers sooner or later travel, the points of interest of the area include Artist's Falls, Diana's Bath, Humphrey's Ledge, Mount Surprise, Goodrich Falls, Bartlett Boulder, Conway Corner, Jackson Falls, Pitman's Arch, Hurricane Mountain, Ridge Ride, Porter's Farm, Carter's Notch, Buttermilk Hollow, Fryeburg and Lovewell's Pond, Highland Park, Ellis Falls, Swift River, Chocorua Lake and the Crawford Notch.

 Few New England resorts furnish a more diversified program of side trips, on foot or by vehicle, than the White Mountain communities.

The Eastern Division (Maine Central Mountain Division)

THE CONWAY SCENIC RAILROAD THROUGH CRAWFORD NOTCH— A SPECIAL EXCURSION

Two years ago I wanted to reenact the rail excursion through Crawford Notch as it was in the early twentieth century and compare it with today's railroad travel experience. I was fortunate enough to be a guest on the locomotive CNL No. 6516 with my host engineer Rudy Hood, a forty-five-year veteran engineer—first with the B&M Railroad and finally with the Conway Scenic Railroad. Rudy is sixty-nine years old and holding. From that experience I wrote the following adventure of this five-hour ride on the Conway Railroad, following the Saco River from North Conway to the Fabyan's Station. The Conway was built in 1875, and it was, and still is, regarded as a triumph of engineering that leads through some of the most imposing mountain scenery in the Atlantic states.

From the grand Victorian depot on Main Street in North Conway Station, we departed at 11:00 a.m. We crossed Routes 16 and 302 and entered Whitaker Woods, a large, arched pine forest. We are now traveling on the rails of the northern end of the Boston & Maine Railroad's Conway Branch, which left the Boston-Portland main line at Dover, New Hampshire, and came up through Rochester, Milton, Wakefield, Ossipee, Madison and Conway, and then to North Conway and Intervale.

We reach the Intervale station, where the great Intervale House once stood. The small, green building beyond the station site was the Intervale Post Office. On our right is the site of an Abenaki Indian encampment, and the property is still in the hands of Abenaki descendants.

The White Horse and Cathedral Ledges are seen across the meadow on the left. This massive ledge, a seven-hundred-foot, near-vertical wall, was formed as result of granite shearing. The Echo Lake State Park lies along the floor of Cathedral Ledge. It may be noted that these remarkable cliffs attract many seasonal visitors. It is recorded that the imaginative can trace the head and shoulders of a rearing horse, an image only visible from the Main Street of North Conway. Cathedral Ledge received its name from the cathedral-like arch formed by the cliff. At the foot of the ledge is a small cave known as the Devil's Den. From here there is a steep dirt road to the top of Cathedral Ledge.

Traveling north is the ravine of Diana's Bath (Lucy Brook), bounded on the north by Mount Attitash and the long spur of Humphrey's Ledge. This flowing brook flows over a table of granite, terminating with a beautiful fall some ten feet in height. The brook plunges into a great number of holes (or basins) worn smooth by the action of the water. The largest of these, sparkling in the sunlight or quiet in the shadows, seems to be a bath the goddess might use.

On the right is Mount Kearsarge, nearly hidden by the heights of Mount Bartlett. The line now runs along the edge of the beautiful meadows, with the Saco River on the left bordered by lines of trees. The lonely church in Lower Bartlett is seen on the right, beyond which is the high truncated cone of the south peak of Double-Head, flanked on the right by a small, white segment of Bald Mountain. After passing Humphrey's Ledge, Iron Mountain is on the left front, supported by the range on the north of the river. Soon after crossing the East Branch, the Saco River is seen on the left, and Mounts Stanton

A History of the Boston & Maine Railroad

Mount Washington from Intervale.

The Eastern Division (Maine Central Mountain Division)

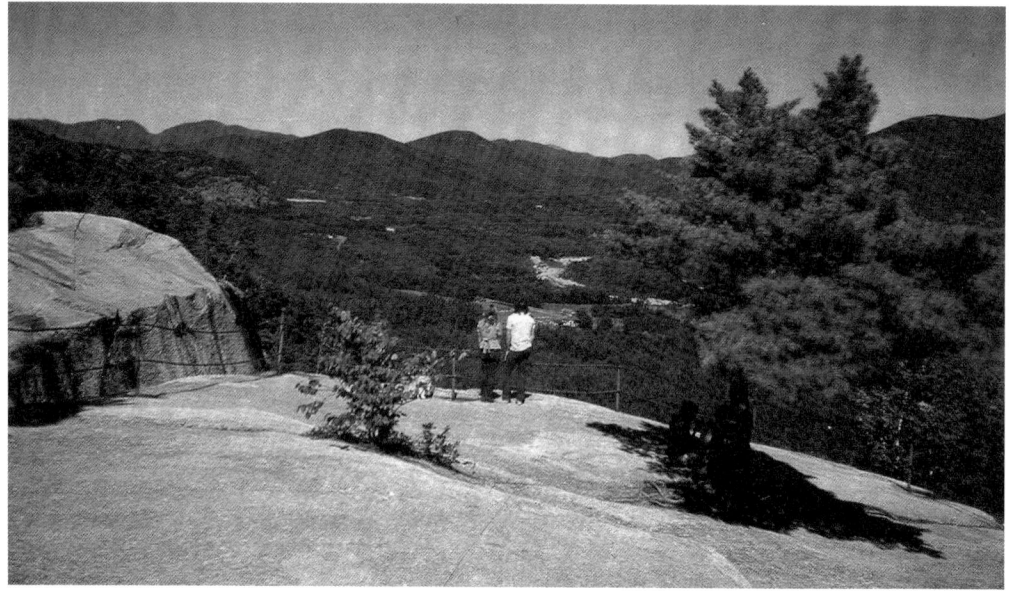

This photo was taken from the top of Cathedral Ledge looking northeast.

and Langdon come into view, while a momentary glimpse is given of Mounts Haystack and Tremont near the head of the valley.

Our next feature is the railroad station known as the Glen & Jackson Station, often referred to as "the ideal mountain village." Carriages were often seen waiting to convey passengers to Jackson, where, during the nineteenth century, the Glen House stages would meet some of the trains. At this point the view includes Iron Mountain on the right, and the blue heights of Mount Wildcat and Carter Dome separated by the remarkable cleft of the Carter Range.

Just beyond Glen Station, the line crosses the Ellis River with a noble view of the Carter Notch from the bridge. Open glens are now seen with fine views of Kearsarge on the left and the high slopes of Iron Mountain ascending on the right. The Saco River is next crossed, with Mount Haystack ahead on the right, and then to the west of Iron Mountain, up the Rocky Branch ravine to the rear, the long and lofty plateau of Mount Resolution is seen, with the Giant's Stairs falling upon its right verge.

The Saco is near at hand on the right, over and beyond which are the imposing dark cliffs of Mounts Stanton and Pickering. Beautiful fields and farms are clustered on the right, but the valley narrows perceptibly, and the mountains encroach more and more on the lowlands. Toward the front of the train, views are given of the conical peak of Haystack, the wavy crests of Tremont and the majestic, dark summit of Mount Carrigain. Bear Mountain is approached on our left—a long and chaotic ridge covered with woods—to the west of which is the level plateau top of Table Mountain. As the train draws up at the upper Bartlett station, the ledge flanks of Mount Langdon are seen on the right, beyond which is the conical crest of Mount Parker.

The Eastern Division (Maine Central Mountain Division)

Bartlett Village was originally named after Dr. Josiah Bartlett of Kingston, New Hampshire, who later became New Hampshire's first chief executive to have the title of governor, his predecessors having been called president. Dr. Bartlett was the second signer of the Declaration of Independence.

On the left of the station are Table, Bear and the forest-bound Haystack Mountains, and Mount Carrigain may be visible from the outer platform of the station, looming over the great Pemigewasset Forest. As the line bends from west to north, and advances toward the narrowing Notch, it slowly ascends the ridge on the west, keeping so near the mountainsides that the view in that direction is limited. It is not so, however, with the prospect on the right, which affords an ever-changing panorama of stately peaks rising from the narrow forests below the lines. At first the positive cliff of Hart's Ledge looms upon the right and is slowly rounded in a great outer curve. Then the symmetrical cone of Mount Hope is seen, and next appears the reddish ledges of Mount Crawford. As the train crosses Nancy's Brook, the deep flume, where the water has cut the obdurate rock, and the foaming falls of the stream should be noticed. Slowing into Bemis Station, the old Mount Crawford House once stood on the right. This rich center of mountain scenery lies nearly in the center of Hart's Location, a division that includes the Saco Valley from Sawyer's Rock. The glen is between the mountains of the Crawford group on the east and the Nancy Range on the west and was formerly occupied by valuable intervales that have been nearly ruined by slides and avalanches from Mount Crawford. Nancy's Brook enters the Saco here from the west and Sleeper Brook from the northeast.

There is an interesting legend concerning Nancy Barton. She was a young servant employed at the farm of Colonel Joseph Whipple in Jefferson. She became engaged to another of the workers whose name apparently was Jim Swindell and she gave her entire dowry to him. Upon returning home from Lancaster one cold December day in 1778, she found that her love had left. Against all advice, she fled and pursued him, following his trail southward through the snow toward Crawford Notch. She stumbled onto the remains of his campfire, which were less than twenty-four hours old. Unable to continue, Nancy sat down beside the brook that bears her name today. At that location, searchers later found her frozen body. It is unknown whether Mr. Swindell left her faithlessly or not, but legend says that he was so unsettled by her death that he died shortly after.

The railroad crossed the highway here at Bemis Station, just south of which was the gabled cottage of Dr. Bemis, the patriarch of the mountain.

Our train is now on an upward grade of 116 feet to the mile and advances along the faces of rugged cliffs. Above Bemis Station the bed of Davis Brook is crossed, and across the valley on the right, the bold terraces of the Giant's Stairs are seen up the ravine of Sleeper's Brook. Bemis Station was later known as Notchland. Dr. Samuel A. Bemis, a prominent Boston dentist, developed a great love for the White Mountains. He started visiting the area regularly in 1827. In 1860, he completed his stone cottage, in which he lived until his death in 1881. After his death it was passed into the Morey family. They owned most of the land in the Notch. Florence Morey operated the Inn Unique from 1920 until the early 1970s. Presently, the stone cottage of Dr. Bemis is open to the public as the Notchland Inn.

Frankenstein Trestle, Crawford Notch. Just before the trestle is reached, vigilant travelers looking forward on the right will get one of the grandest views of Mount Washington. The deep Frankenstein Gulf is crossed by the trestle of iron, five hundred feet long and eighty feet high. After crossing the trestle, there is nothing but a shelf cut by the indomitable will of man from the mountainside for the passage of the train, ever increasing in altitude until the summit of the divide is reached. *Courtesy of the B&M Railroad Passenger Department.*

The Eastern Division (Maine Central Mountain Division)

Glimpses of Frankenstein Cliff may be seen ahead of the train. Now the line crosses Bemis Brook, which flows down from the upper forest-hidden Arethusa Falls, known as the highest of the New Hampshire falls at two hundred feet. Fine views of the plateau summit of Mount Resolution are obtained on the right, below the Giant's Stairs, and the line is now on a high grade, far above the forest in the Saco Valley.

The train climbs upward as though it is rushing through wilderness and clinging to the sides of the great cliffs. Just before the trestle is reached, vigilant travelers looking forward on the right will get one of the grandest views of Mount Washington; this prospect has long been famed for its sublimity. Passengers should lean over the sides of the cars and take notice of the apparent slenderness and the rare gracefulness of the lofty iron piers that support the trestle. Presently, the deep Frankenstein Gulf is crossed, five hundred feet long and eighty feet high. Crossing the gorge of the brook that flows from the Ripley Falls, the line winds around the mountain at a high elevation with rock walls far below on the left and right, the unbroken forest overlooked by the dark Montalban Ridge.

Mount Crawford is next to be enjoyed. On the right is the crest of Mount Jackson, and to the left of the ravine, separated from Mount Webster, is a short, deep gorge. Swinging around the upper slope of a long, rocky ridge, the train comes in sight of the upper part of the valley, with the white Willey House 350 feet below on the right. In front is the superb alpine peak of Mount Willey, rising sharply from the great plateau of Pemigewasset and covered with light-colored ledges. Due to the tragedy that occurred at the Willey House in 1826, this house is often visited by tourists. It was built in 1793 as a public house on the Coos Road. In 1825, it was occupied by Samuel Willey Jr. and his family. In June 1826, two slides fell off the flank of Mount Willey near the house, a forewarning of the coming disaster. On the night of August 28, 1826, a deluge of rain fell, washing out the sides of the ridges, flooding the valley and inflicting great damage in all the adjacent towns. It is supposed that the family left the house in apprehension of the rising floods of the Saco and retreated to a point farther up on the mountain, where they were overtaken by the avalanche and swept away to a fearful and united death.

In precise language, the White Mountain (Crawford) Notch is the chasm extending from the Willey House to the gate, a distance of about three miles. As this section is entered, the immense purple cliffs of Mount Willard are seen in front, striped with lines of fracture and dotted here and there with clinging trees. On the right is the sharp slope of Mount Webster, denuded of trees by the procession of avalanches and banded by the long lines of slides, wherein red and yellow are the chief colors. These vivid stripes start from the very crest of the long summit ridge and extend down into the forests that enclose the Saco. As the Brook Kendron is crossed, an attractive cascade is seen on the left, and soon afterward a glimpse of Mount Deception is gained in advance through the gate of the Notch, which Mount Crawford rises behind.

In Dwight's "Travel in New England and New York" we read:

> *When we entered the Notch we were struck with the wild and solemn appearance of everything before us. The scale, on which all the objects in view were formed, was the*

A History of the Boston & Maine Railroad

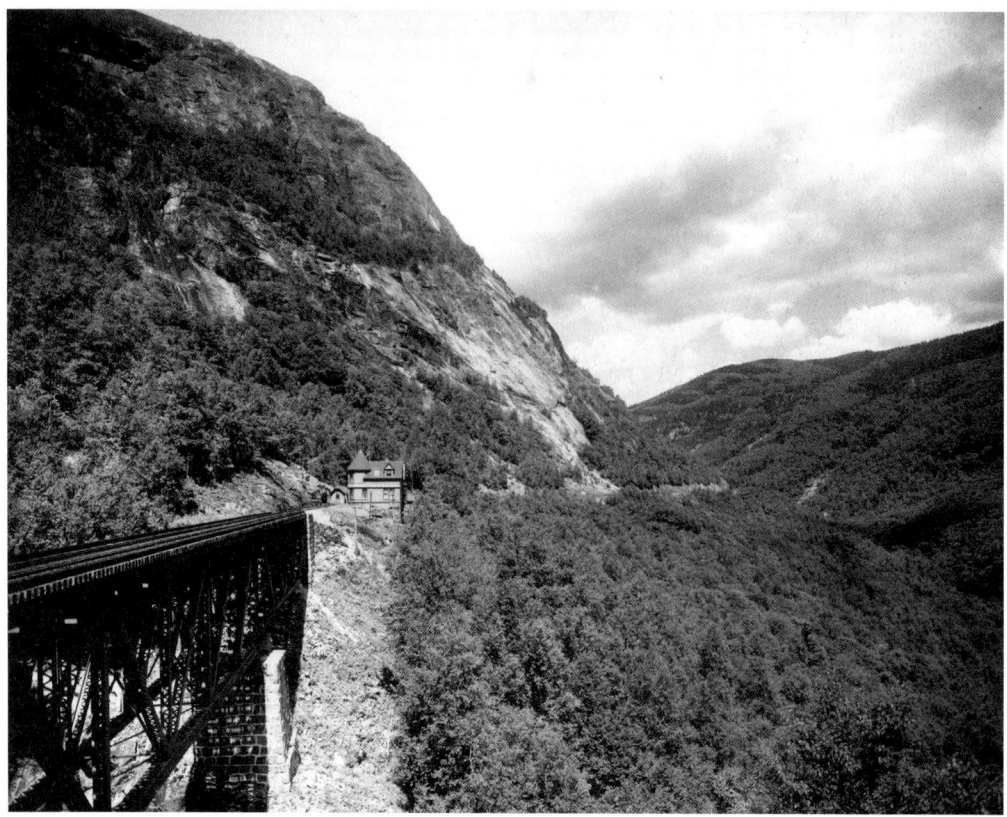

The heart of Crawford Notch and the Willey Brook Bridge. To the left Crawford Notch is seen from the Willey House (1931) spanning the deep chasm between Mounts Willey and Willard. Through this rocky gorge dashes the Willey Brook, a wide mountain cascade on its way to join the Saco River.

> *scale of grandeur only. The rocks, rude and rugged in a manner rarely paralleled, were fashioned and piled on each other by a hand operating only in the boldest and most irregular manner. As we advanced, these appearances increased rapidly. Huge masses of granite of every abrupt shape rose to a mountainous height. Before us, the view widened fast to the southeast. Behind us it closed almost instantaneously; and presently nothing to the eye but an impossible barrier of mountains.*

As the train bends to the right toward and around Mount Willard, the whole extent of the upper Saco Valley is open to view, stretching away to the south and finally closed by the dark mountains of Albany. After crossing the gorge of the Willey Brook, the retrospective view continues to open on the right including the southerly ranges, the edge of the broad Pemigewasset plateau and the east peak of the Nancy Range.

The Willey Brook Bridge is four hundred feet long and ninety-four feet high. It was originally built of an iron section and a wooden section. The wooden section was later replaced with iron, and after 1900 the iron was replaced with a whole new steel bridge.

The Eastern Division (Maine Central Mountain Division)

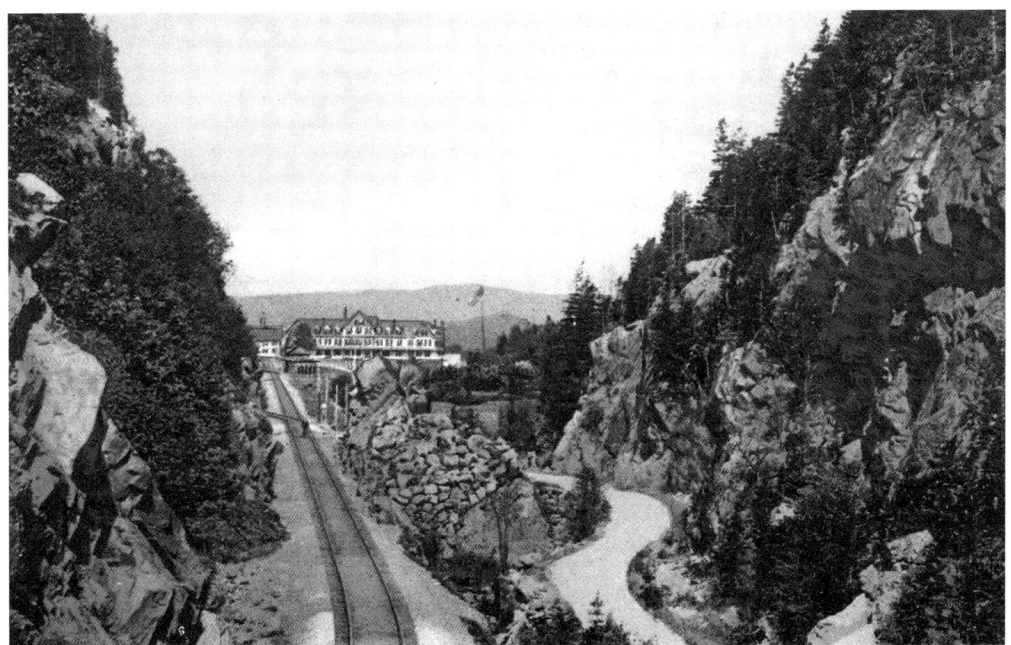

Gate of the Notch with the Crawford House in the distance, 1880s.

This bridge crosses the Willey Brook, which cascades down from between Mounts Willey and Willard. During World Wars I and II, U.S. Army guards were posed at the bridges here in Crawford Notch, since this was a strategic route for the transportation of troops and materials.

As we proceed out onto the bridge, you may see to the right, across Mount Webster and down in the valley of the Saco River. Crawford Notch is a U-shaped valley, having been carved out by a glacier. At the west end of this bridge stood another house, the Mount Willard dwelling built in 1887. The well-known Evans family lived here for nearly forty years, as they were responsible for the maintenance of this section of the railroad. The four Evans children traveled to school by train from this location. Groceries and supplies were ordered by Mrs. Evans and were delivered by train. Remains of the house may be seen on the right—note the small backyard, garden and play area for the children.

The most impressive feature of this prospect is the vast concavity of the Saco Valley below, with its carpet of treetops and the narrow stripes of road and river banding its center. A glimpse is obtained of the Hitchcock Flume, far up on the mountain on the left. The Silver and Flume Cascades are approached on the right, and far below, the dark waters of Dismal Pool may be seen.

The train now swings rapidly around Mount Willard and soon passes through the New Gate of the Notch (the Big Cut), which the railroad has made for itself. It is interesting to note that the first Portland & Ogdensburg train passed through here after the Golden Spike was driven. Just east of the Gateway at 12:24 p.m. on August 7, 1875, General Sam Anderson, president of the P&ORR, did the honors.

A History of the Boston & Maine Railroad

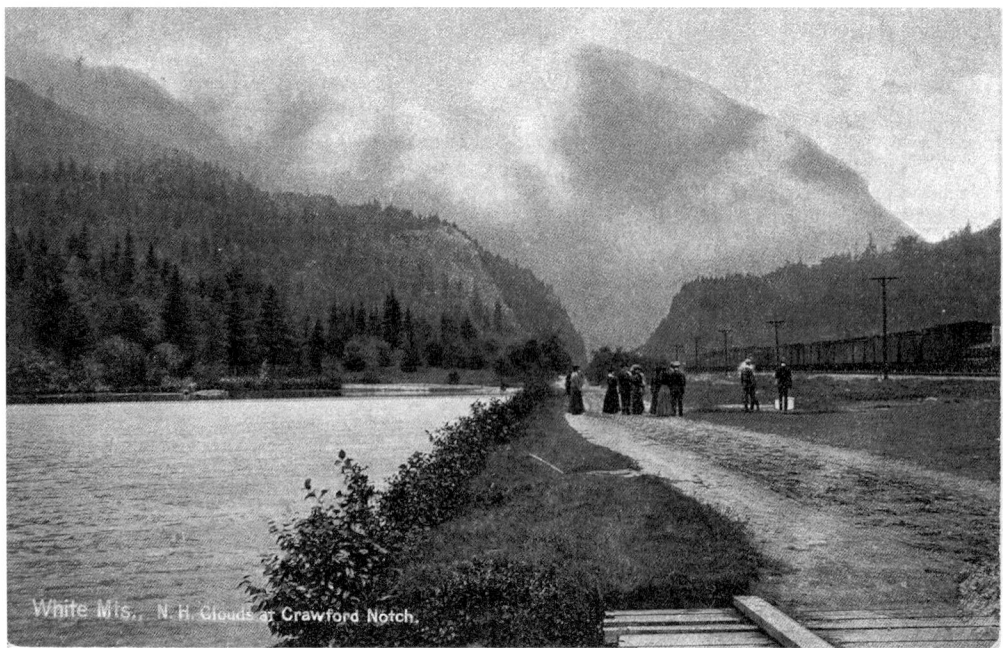

Passengers are seen waiting at Crawford Station.

Starr King, in *The White Hills*, writes the following of Crawford Notch from Mount Willard:

> *The only way to appreciate the magnificence of the autumnal forest scenery in New England is to observe from the hills. I never before had a conception of its gorgeousness. The appearance of the mountainsides as we wound between them and swept by, was as if some omnipotent magic had been very busy with the landscape. It did not seem possible that all these square miles of gorgeous carpeting and brilliant upholstery had been the work of one week and had all been evoked, by the want of frost, out of the monotonous green which June had flung over nature.*

After passing through the Gateway we can see the Saco Lake on our right, the headwaters of the Saco River. The elevation of the lake is 1,887 feet. The small brook to the right is the beginning of the Saco.

The train slowly approaches the Crawford Station, which was built in 1891 by the Maine Central Railroad. The Appalachian Mountain Club owns twenty-six acres of land here, including the former site of the Crawford House, once a grand hotel in the White Mountains. The hotel burned on November 20, 1977.

After we stop here, we are free to walk around, enjoy a picnic and visit the information center in the station. The train soon continues on a northward trek past the Mount Washington Hotel at Bretton Woods and on to Fabyan's Station. This area received its name in recognition of Horace Fabyan, a provisions dealer from Portland, Maine.

The Eastern Division (Maine Central Mountain Division)

At Fabyan's, our locomotive uncouples from the passenger cars and proceeds to cut off from the west end of the train, passes us on the adjacent track and hooked onto the east end of the coaches. For our return trip, Al Cloughlin joins us in the locomotive to guide us on the important historic treasures along the line—treasures they are!

Little has changed since the early 1900s when the Boston & Maine and the Maine Central dominated this line. The beauty and charm of nature and the many attractions still prevail. The romance is not gone. Indeed, the five-hour excursion did retain the same nostalgia and adventure as if it were one hundred years ago. We arrived back at North Conway at 4:40, right on time.

THE BOSTON & MAINE SNOW TRAIN—1931–1971

The snow train, introduced to New England in 1931 by the Boston & Maine Railroad, was widely adopted by many other sections of the country. However, nowhere else in the country was so designed by nature to give such a varied number of ski trails for the experts, gentler slopes for the beginners, wooded trails for the snowshoers, speedy chutes for the toboggan enthusiasts and pleasant roads and trails in the woods for the hikers than those offered in the White Mountains of New Hampshire.

During the heyday of the snow train, it visited such places as Laconia, Lakeport, Intervale, Plymouth, Crawford Notch, Fabyan's, Lincoln, North Woodstock, Goffstown, Franconia Notch, Wilton, Canaan, North Conway and East Jaffrey in New Hampshire to name a few. The weekend snow train visited Littleton, North Conway, Intervale, North Woodstock, Whitefield and Lancaster in New Hampshire and White River Junction and Woodstock in Vermont.

The regular snow train operated from North Station in Boston on weekends when there were good winter sport conditions in the North Country. The train would traditionally leave Boston's North Station on Saturday, shortly after noon, and return late Sunday night.

The snow train devotees ranged from all ages, from six to sixty (and even a few who were younger and older). The round-trip fares on the Sunday snow train trips averaged about four dollars for rail fare, and some of the best hotels cooperated by offering dinner and lodging on Saturday night, with breakfast and lunch on Sunday for three dollars to five dollars per guest. Dining cars on the train provided low-priced breakfasts, luncheons and dinners, with service by the waiters continuously from the time the train left North Station or the Worcester Union Station until it returned.

To know the real romance of the early snow trains is to examine the early diaries and memories assembled and published in the Boston & Maine Historical Society Bulletin in December 1973. Such a diary was compiled for us to enjoy by John C. Alden. His firsthand experiences provide a better insight into what a snow train was all about.

The Boston & Maine Railroad operated its first "Sunday Winter Sports Train" to Warner, New Hampshire, on January 11, 1931. The idea for such an unusual type of train is attributed to Frederick T. Grant, general passenger agent of the B&M. He was

A History of the Boston & Maine Railroad

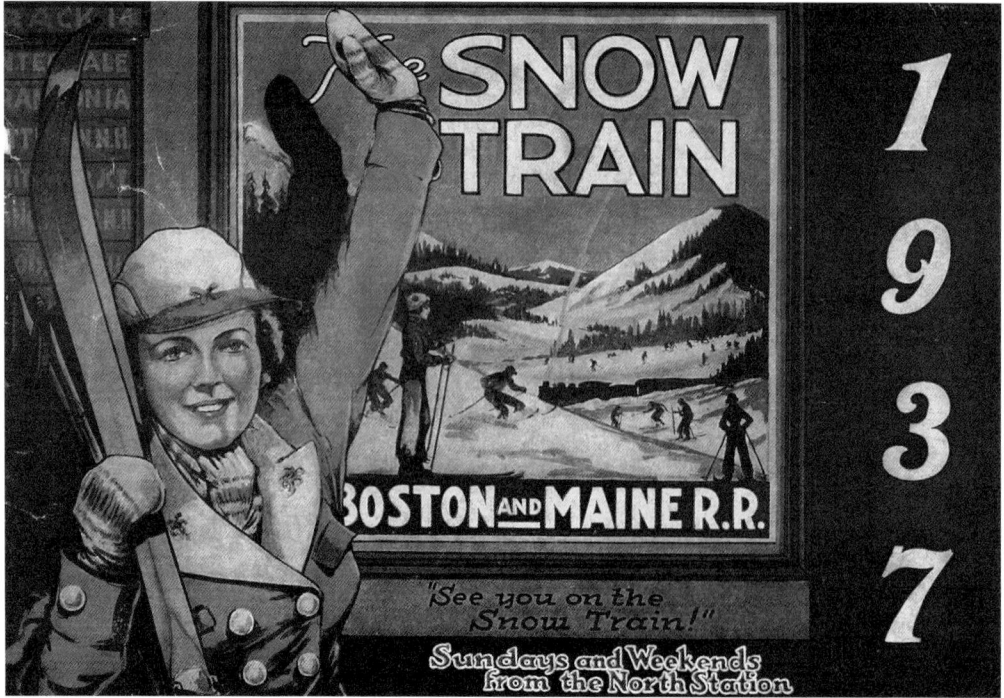

A Boston & Maine train poster promoting Sunday snow train service (weekend trips to North Conway, New Hampshire), February 1, 1937.

assisted in the experiment in passenger train operations by members of the Appalachian Mountain Club (AMC) who never missed the opportunity to get out in the open, winter or summer. There were 196 passengers on this first train, the predecessor of a group of trains that soon became known as snow trains.

During the 1931 season, the snow train went to several towns in New Hampshire—twice to Goffstown, where there is still the covered bridge for the train to pass through. Upon arrival at Manchester, the large, pacific-type steam locomotive was detached from the head of the train, and Moguls were coupled onto what had been the rear of the train for the remainder of the trip, the ultimate goal being the Uncanoonsucs, which was reached via trolley car up the mountain. Two trips went to Canaan, where the entire train was turned on wye tracks. For the rugged sportsmen, Mount Cardigan's granite cone stood out as a real challenge. Both skiers and snowshoers were transported from Canaan to the foot of this mountain by bus or truck. One Sunday, the train discharged its load of winter sports enthusiasts at Greenfield, New Hampshire, and then continued on to Elmwood, where the wye track was used to turn the train. The view of Grand Monadnock with snow swirling about its rocky summit on such a bright, sunny day was something to behold from Greenfield. The largest group of passengers was taken to Wilton on February 22. There were 1,744 people counted on the train to this town. A glance at the dining car menu showed a "Special Dinner" for only one dollar! North

The Eastern Division (Maine Central Mountain Division)

Conway, New Hampshire, a regular destination for snow trains of later years, did not appear on the 1931 program.

Much preparation went into the snow train operation. Each Thursday, the destination for the following Sunday's train(s) was determined by a conference of B&M officials with AMC experts and weatherman E.B. Rideout, using reports from station agents in the snow country to aid in the selection of the best spot. A sufficient amount of equipment—locomotives, baggage cars, coaches and dining cars—had to be assembled for the train and the required number of engines and train crew had to be on hand to man them. Members of the Passenger Traffic Department were assigned to each train in addition to the regular train crew. They were ready to answer questions about the ski trails, snow conditions, etc. On their snowsuits was a red badge reading, "Boston & Maine—Passenger Representative—Snow Train."

Sunday, February 9, 1936, was a bleak, cheerless winter day. Throngs of winter sport enthusiasts were gathered at North Station. The snow train was ready to roll north to Laconia. Tickets were purchased at special windows marked "Snow Train Tickets" and then the passengers proceeded to the track where the steam-powered train was ready to speed them to snow country. The first section, Train A, departed as soon as the cars were filled. They were not crowded; there was room enough for passengers and their skis, toboggans or snowshoes in each car. An essential part of the train was the Armstrong Company's Service Car, presided over by genial Sam Averback, who was ably assisted by Ms. Gertrude Slosson and others. In this car, one could buy or rent skis, boots and poles. As John C. Alden records in his diary,

> *The train left on time, 9:00 a.m., as advertised in the Boston newspapers and on local radio stations. I had much to learn and observe. One thing was very evident—this was a fun train. People were relaxed and happy with the prospect of a fast, safe trip to the Lakes Region. The passengers left the train at Laconia and Lakeport. Four trains stood side by side in the Lakeport yard, two of which had come from points on the New Haven Railroad. Train No. 5, "The Allouette" for Montreal, went through at 11:50 a.m.*
>
> *We had a leisurely meal in the dining car after the crowds had left for the snow slopes at Mt. Belknap. (Today it is known as the Gunstock Ski Area in Gilford, New Hampshire). It seemed to have been a very short afternoon, for soon passengers were returning to the warm, steam-heated cars looking very healthy but thankful to get in out of the cold. The trains started south shortly after 5:00 p.m. The dining cars were doing big business. Appetites were excellent and prices were still reasonable. On the way back to Boston, one elderly lady told me that she had a wonderful day just watching people having a good time. Some passengers slept most of the way to Boston while others played music or card games to pass the time. The order of the cars is difficult to describe, but it was something to remember along with my first Sunday assignment to the snow train. North Station was reached in short order and the happy throng was safely back home again.*
>
> *February 22, 1936, was a bright, sunny Saturday. The snow train was to run to North Conway. The T.N. (Transportation Notice No. 322) called for three trains. Train A was to run via Reading, leaving as soon as loaded and run express to Conway and*

A History of the Boston & Maine Railroad

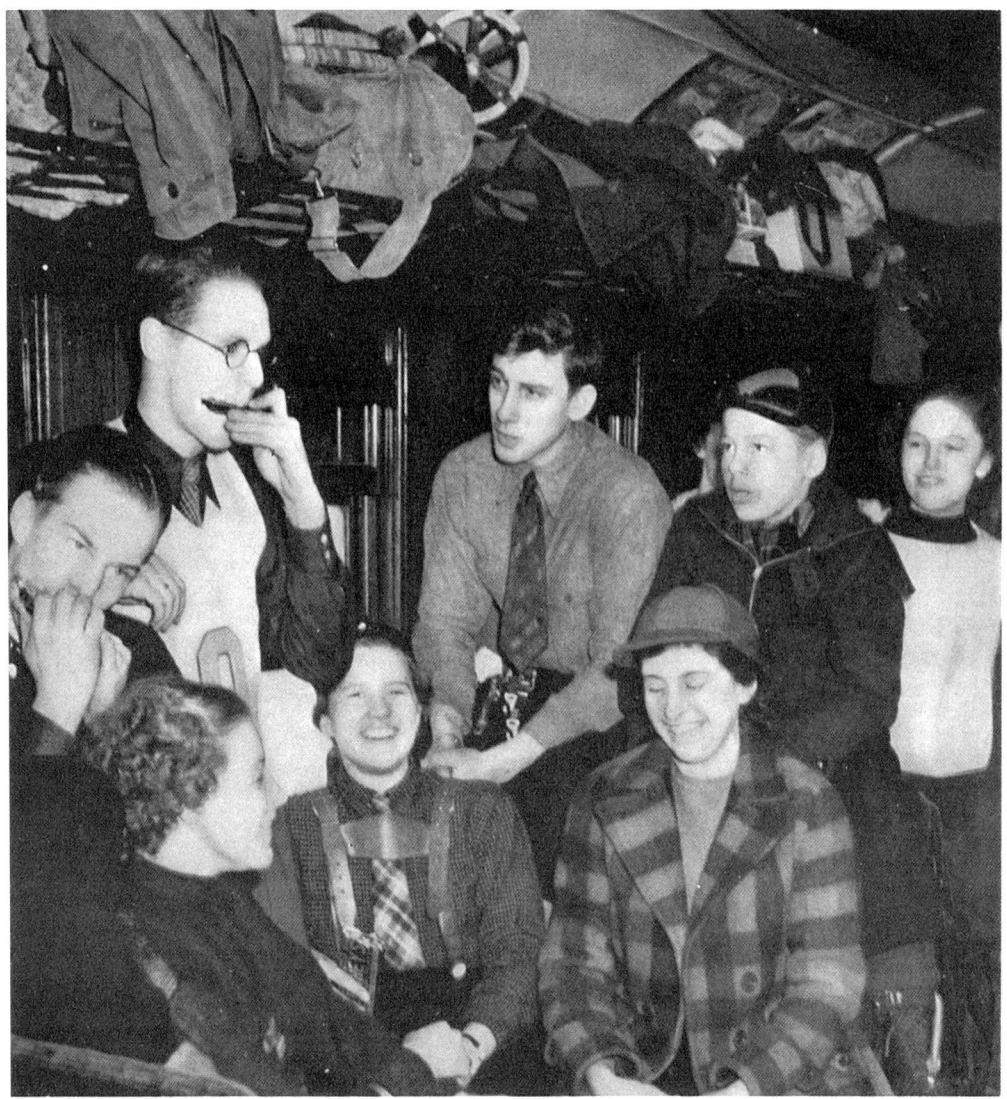

Good times on the snow train—just one "Happy Family," 1937. *Courtesy of the B&M Railroad Passenger Department.*

North Conway. Section Three—Train C—was to leave at the advertised time of 8:00 a.m. with local stops via the Western Route. Train B was to go via Portsmouth thence the Conway Branch from Jewett. I was assigned to this train. H.F. McCarthy, general passenger agent was in charge. Our train followed the classic route taken many times by Frank Boles, author of At the North of Bear Camp Water *(1893). He states: "On reaching Portsmouth, I found the sun shinning brightly…no snow on the Kittery pastures." He continues: "Gazing out of the train window, I have seen the Sandwich Range from afar over the melting greens of spring, the rich verdure of summer, and the cold, still snow of winter."*

The Eastern Division (Maine Central Mountain Division)

A SUNDAY SNOW TRAIN

FROM WORCESTER, MASS.

To the EASTERN SLOPE (N. H.) REGION
SUNDAY, FEBRUARY 1, 1942

Snow Conditions Permitting

Read Down	SCHEDULE	Read Up
8:15 A.M.	Lv. Worcester, Mass.	Ar. 9:50 P.M.
8:18 A.M.	Lv. Lincoln Sq., Mass.	Ar. 9:45 P.M.
12:37 P.M.	Ar. North Conway, N. H.	Lv. 5:20 P.M.
12:42 P.M.	Ar. Intervale, N. H.	Lv. 5:10 P.M.

DINING SERVICE

Watch Worcester Newspapers for additional Snow Train Announcements.

You may make reservations, and purchase tickets in advance at Worcester (Union Station) Ticket Office or 'phone WOR 5-4343.

$2.75 ROUND TRIP PLUS TAX

FROM ROCKPORT, GLOUCESTER

To the EASTERN SLOPE (N. H.) REGION
SUNDAY, JANUARY 25, 1942

Snow Conditions Permitting

GO	SCHEDULE	RETURN
Read Down		Read Up
7:10 A.M.	Lv. Rockport	Ar. 10:20 P.M.
7:17 A.M.	Lv. Gloucester	Ar. 10:10 P.M.
7:28 A.M.	Lv. Manchester	Ar. 10:00 P.M.
7:43 A.M.	Lv. Beverly	Ar. 9:50 P.M.
7:50 A.M.	Lv. Salem	Ar. 9:42 P.M.
7:55 A.M.	Lv. Swampscott	Ar. 9:37 P.M.
8:00 A.M.	Lv. Lynn	Ar. 9:30 P.M.
12:00 P.M.	Ar. No. Conway	Lv. 5:20 P.M.
12:10 P.M.	Ar. Intervale	Lv. 5:10 P.M.

Dining Service

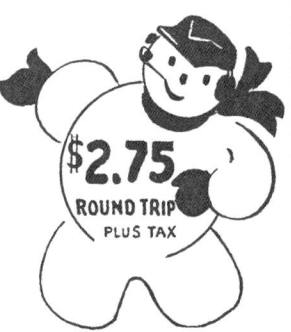

$2.75 ROUND TRIP PLUS TAX

A Sunday snow train timetable to the Eastern Slope (New Hampshire) Region—Sunday, February 1, 1942.

A History of the Boston & Maine Railroad

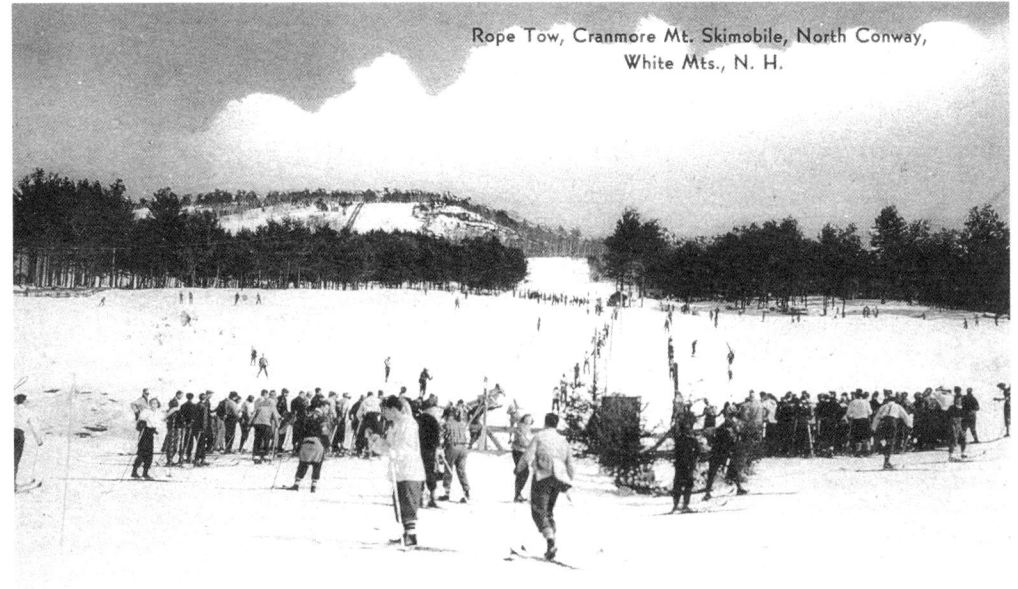

A rope tow and skimobile at Mount Cranmore, North Conway. Ascending to the summit of Cranmore Mountain where a magnificent panorama of the White Mountains is seen.

According to the T.N., we were due at North Conway at 1:55 p.m. According to my records, we reached there about 12:55, but there were no complaints. Everyone was ready to take off as soon as the train stopped. We had a few minutes to enjoy our meal in the diner. The complete dinner was still one dollar and the round-trip railroad ticket was just $2.75 from Boston to North Conway or Intervale station. What bargains for all!

On account of the holiday, a fourth train was setup to handle the overflow on the return trip. We were ready to leave Intervale station at 5:50 p.m. when I saw a bus racing toward the station. "Hold everything!" announced conductor George Gardner. He held the train in check until the group of thankful people were taken aboard. We arranged for a special stop at Malden, Massachusetts, for the convenience of some passengers. We were just ahead of "The Flying Yankee." Majestic Mount Washington—sun shining on its snow-covered slopes—was a memory that many had after this beautiful day in the North Country.

On February 22, 1939, there were two trains to North Conway. This was almost a duplicate of February 33, 1936. I was again on Train B with Henry McCarthy but this time we ran via the Western Route instead of Portsmouth. The afternoon was spent on Cranmore. The skiing was fast and exciting, the weather sunny and cold. Everyone returned to the trains with expressions of gratitude for a wonderful day. Sunset colors on Mt. Washington were again a sight to remember. This successful day was followed by another fast trip to Boston, with the dining car well filled for most of the way back.

On March 26, the destination was again North Conway. Somebody had goofed on the forecast this day, but the skiers went off to Cranmore as soon as the train had reached to depot. It was a very wet storm—snow mixed with rain. Within an hour or so, the passengers, not too happy, began to return to the train. The engineer had plenty of steam

The Eastern Division (Maine Central Mountain Division)

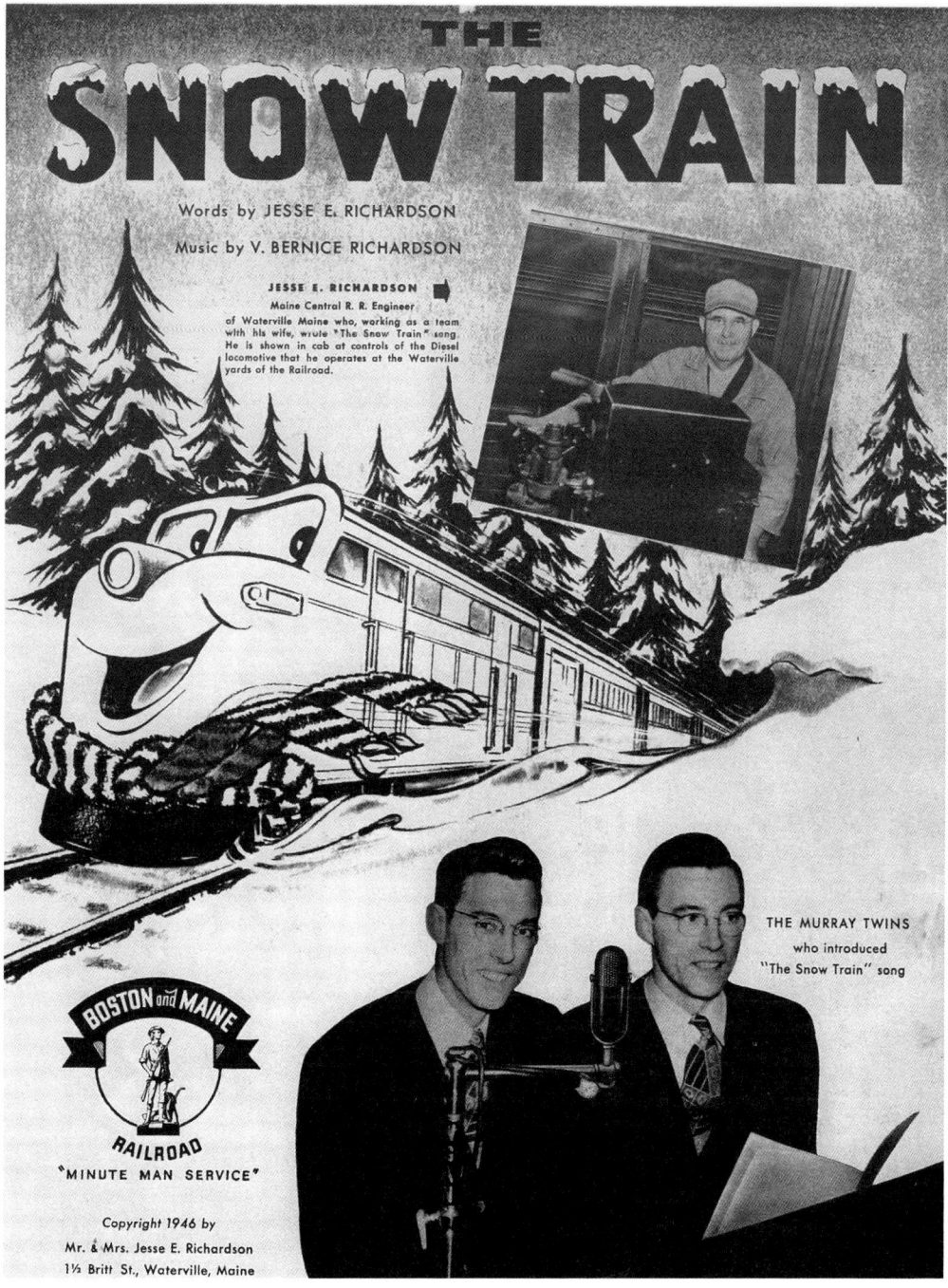

The snow train song, 1946. *Courtesy of the B&M Railroad Passenger Department.*

heat in the coaches and outer garments were shed and hung up to dry. But, with a schedule departure time of 5:00 p.m., we had a problem of what to do for the remaining hours. IDEA! Let's go to the movies! Unhappy thought, for Sunday movies were not allowed in the state of New Hampshire in those day. However, a phone call to the proper state officials gave us permission to operate a special showing at the local theater. Open wide the doors! Let the maddening crowd in! Never did a theater fill up so rapidly with such a group of grateful patrons! I don't recall now, what movie was shown, but there were only expressions of thanks after it was over. We renamed the train, Theatre Train for this day only. The next week the weather was good for winter sports activity.

A special snow train trip was made to Fabyan's on a February day of real wintry weather, which made the trip up Crawford Notch and the Maine Central Line really superb. The return trip down through the Notch by the light of a full moon was a never-to-be-forgotten experience, perhaps the best described in Whittier's Poem, "Snowbound" as "no earth below, no ski above…a Universe of cloud and snow." The glistening ice and snow-covered slopes of the Notch reflecting the moonlight was something to behold. All too soon, the train was in Bartlett and I went inside the car to thaw out. It was way below freezing and there was no heater on the rear platform of the rear car on the train. At Conway, a quick glimpse of Mt. Washington by moonlight and then another fast trip to North Station to end another beautiful day in the North Country.

The last snow train operated to North Conway on February 20, 1971, forty years after the idea had first been tried by the Boston & Maine. There were over three hundred passengers on the Budd car, about thirty of whom were skiers. "Snow fell most of the day. There was no evidence of any tracks when we were ready to leave North Conway, but the trip back was made without any trouble."

Chapter Six

The Logging Railroads in the White Mountains

With the arrival of the railroad, the logging industry came to the White Mountains, thus changing the climate, landscape and clientele of the once farmland.

Across the length and breadth of New Hampshire's mountains, the drama of logging unfolded between 1875 and 1909. It was an era dominated by hard-driving, lusty lumber kings. It was a time of large fortunes made and some lost, a time of ruthless tree slaughter, a time of grave concern and eventual opposition. It was a time of fires unequaled before or since; it was a day that left its scars, visible for many years to come.

Travel anywhere into the backcountry of the White Mountains today and the signs of this dramatic period will be seen: the tell-tale clearing in high, flat meadows with their signs of an old logging camp and the forest-fire lines in the Rocky Branch, the Kilkenny or the Pemigewasset areas. The logging roads on the sides of the high ridges of Lafayette, Lincoln, Hancock, Carrigain, the Bonds and many other slopes are well-nigh indelibly etched. It was by logging railroads that these hills shed their virgin cloak. By 1870 the door to the forest riches of the White Mountains was opened wide. According to the Chittenden Report of the U.S. Department of Forestry in 1904:

> *The policy of the state was to dispose of its public lands as fast as possible and large tracts were sold for almost nothing. The greater part of the White Mountain territory is a forestland, owned for the most part by large lumber and paper companies, and the timberlands are owned almost entirely by seven large companies.*
>
> *In recent decades the introduction of the steam locomotive as an…adjunct to the lumberman's logging outfit has increased the number of fires.*
>
> *The growth of the paper and wood pulp industry in New Hampshire…between 1890 and 1900 eclipse that of any state in the Union. During this period the value of its product had multiplied nearly six times.*

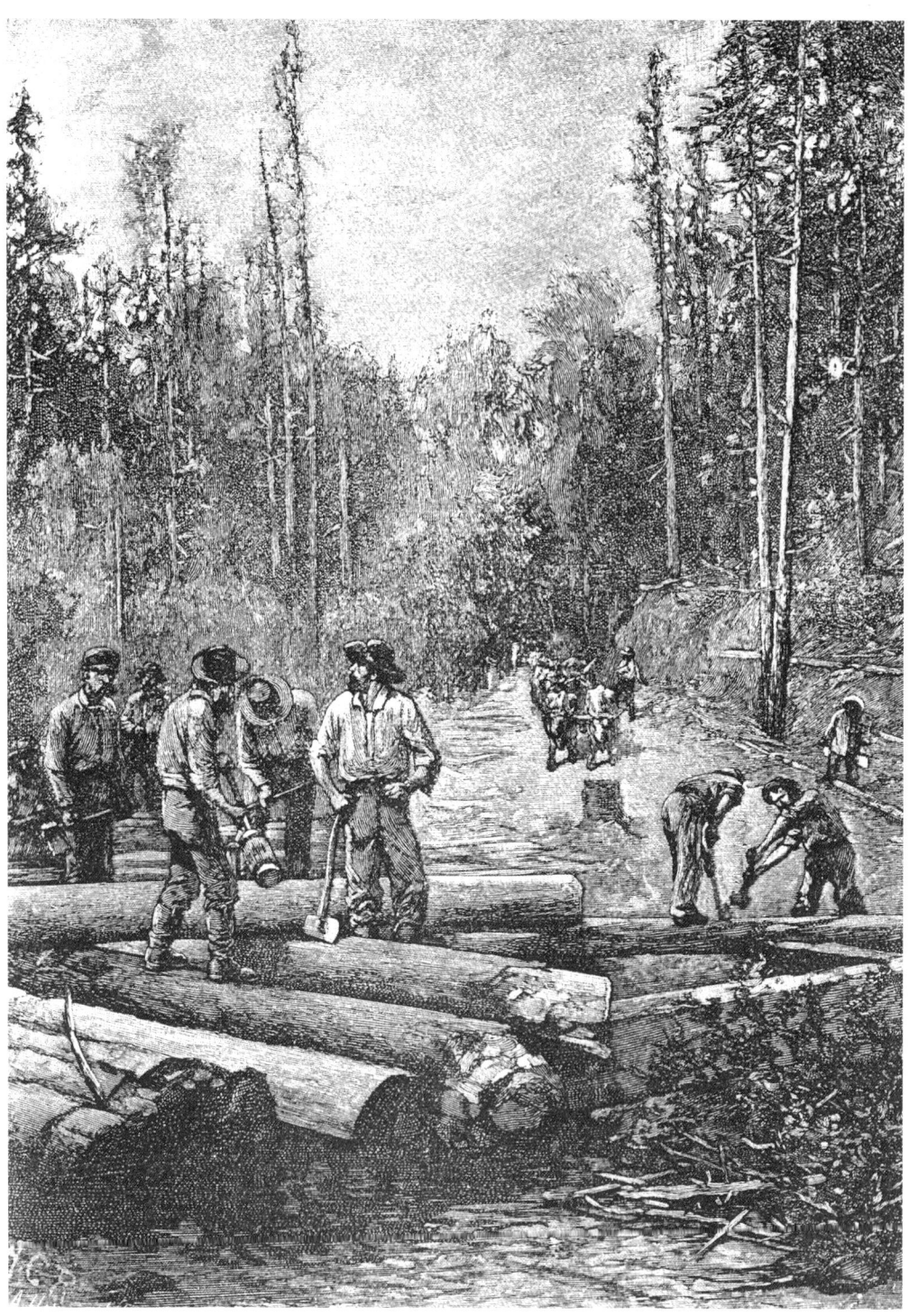
A logging crew preparing the logs for transport to the mill.

The Logging Railroads in the White Mountains

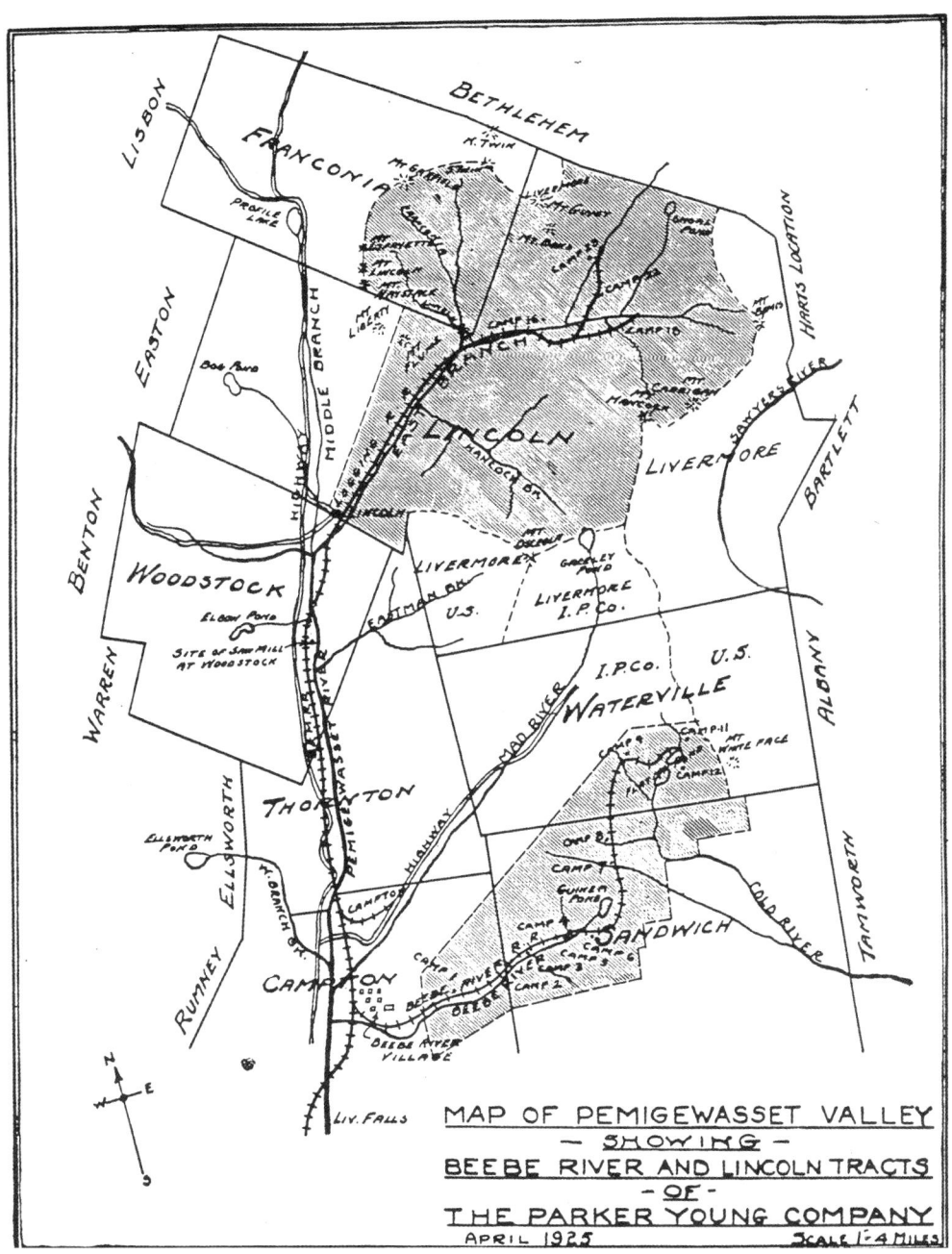

A map of the Pemigewasset Valley showing Beebe River and Lincoln tracks of the Parker-Young Company, 1925.

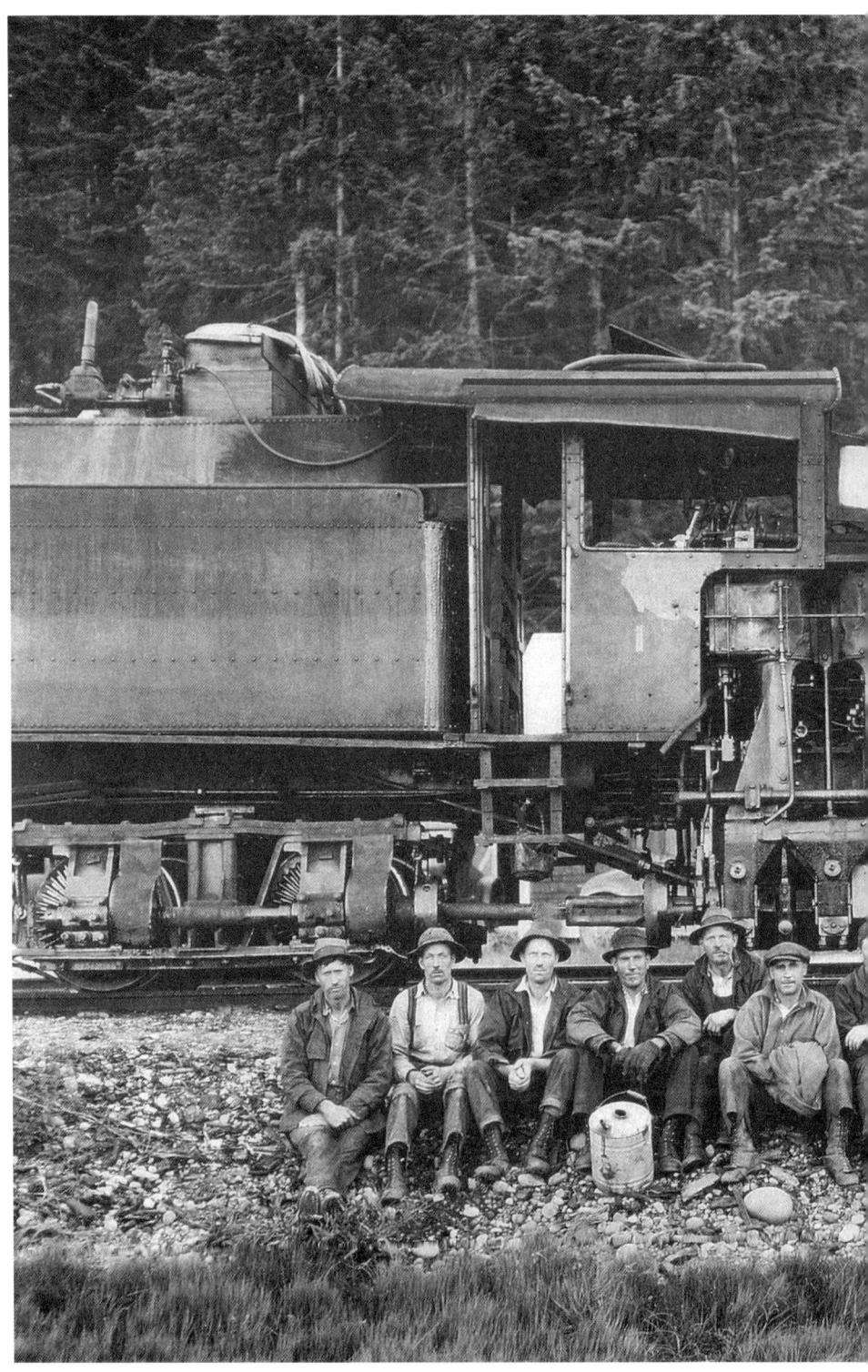

A logging crew and the locomotive pause for a moment on the Beebe River Railroad line, Sandwich Notch, New Hampshire.

The Logging Railroads in the White Mountains

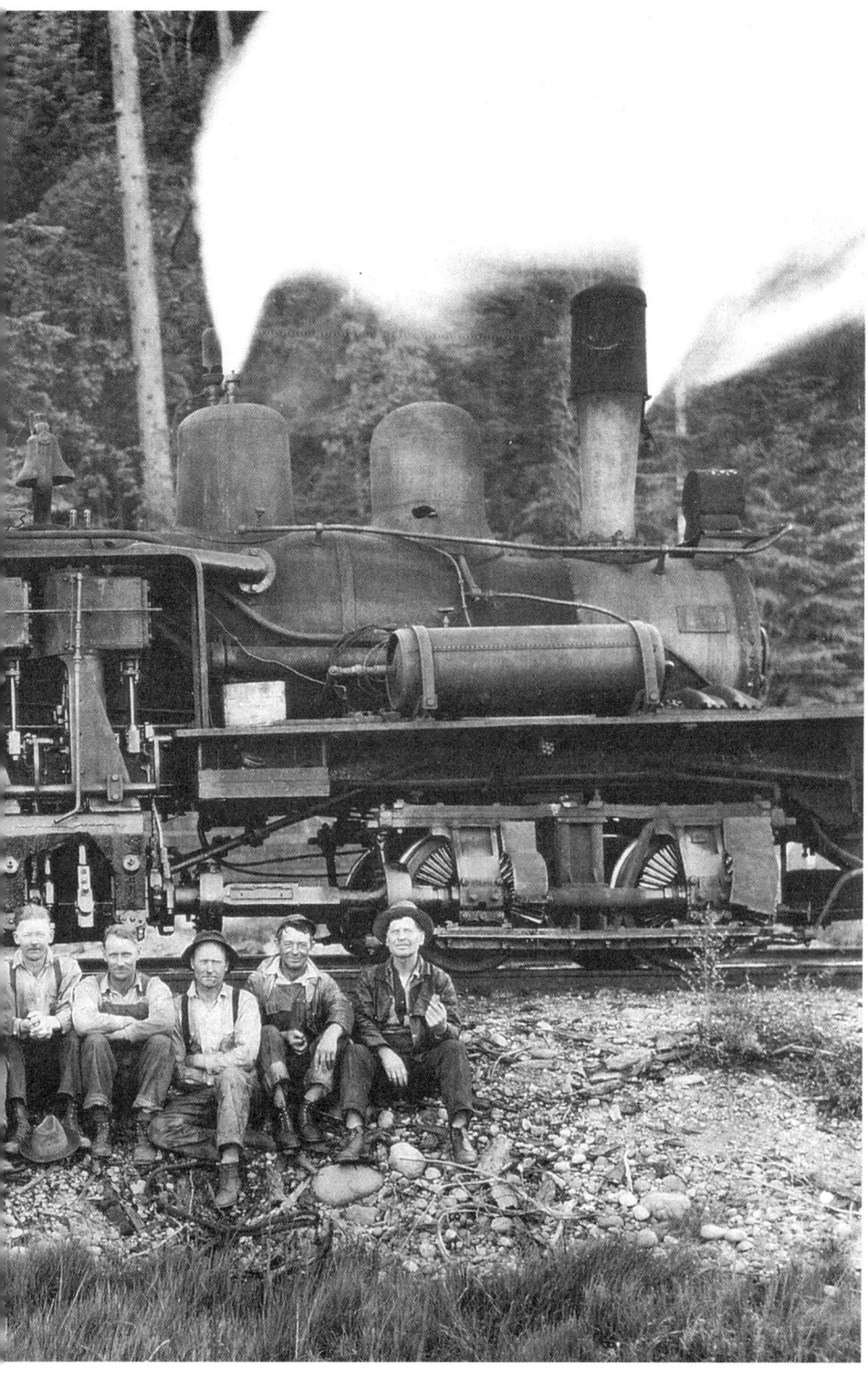

Some of the prominent logging railroads in the White Mountains were John's River Railroad, Lancaster & Kilkenney Railroad, Wild River Railroad, Pemigewasset Valley Railroad (the "Pemi"), Upper Ammonoosuc Railroad, Success Pond Railroad, Little River Railroad, Sawyer River Railroad, Zealand Valley Railroad, East Branch & Lincoln Railroad, Bartlett & Albany Railroad, Saco Valley Railroad, Swift River Railroad, Rocky Branch Railroad, East Branch Railroad, Gordon Pond Railroad, Woodstock & Thornton Gore Railroad and Beede River Railroad. Some of these railroads will be highlighted in more detail.

Throughout the White Mountains of New Hampshire, the major Class I carriers, primarily the Boston & Maine Railroad, owned many sidetracks on which they ran freight trains under agreements with the many lumber and pulp companies. Some of the B&M sidetracks built for logging in this area were the Alder Brook Siding in the Twin Mountains and Lyford's Siding in Campton.

For the first twenty years all the locomotives were wood-burners, consuming their own product on the premises. It is said that more than one engine crew in those days got caught short and had to cut fuel as well as load it on the tender. Later, most of these engines were replaced by the more efficient and less incendiary coal burners. The earlier engines were four- and six-wheeled shifters with no lead trucks, and often they were rentals or castoffs from the larger railroads. Later, as the derailment record piled up, different engines with lead trucks, smaller drivers and other refinements were built for the special duties these operations required. The mortality rate was high on the early engines, and their lineage was often difficult to trace. A fortunate logging engine frequently was owned by a number of companies before it reached the scrap pile. The most popular and durable engine used by the mountain logging companies was the Baldwin, one of the earliest locomotives from Philadelphia. However, it is hard to get an accurate fix on how long they lasted, because if they did survive a logging operation, they were usually sold off to other companies, and the lineage became unknown.

By the 1890s, improvements came fast on America's railroads, despite the hardship and accidents associated with the industry. These changes were emphasized with the engines used by logging railroads in the steep, winding valleys of the Northeast. The earliest engines used in the White Mountains were simple, rod-driven units made in New England by the Portland Company in Portland, Maine; the Manchester Locomotive Company in Manchester, New Hampshire; and the Taunton Locomotive Works and the Mason Company in Taunton, Massachusetts. In the beginning, New England was well established at the center for locomotive manufacturing. Angus Sinclair states in "The Development of the Locomotive," "The New England States, being the principal seat of Manufacturing of a metallic character at that time, it was natural that the people would secure the greater part of the building of locomotives throughout this whole country."

In general the smaller lines constructed a light roadbed with a very light rail and operated only during the winter months when nature had frozen everything. The larger logging lines, particularly those with long main lines from which stemmed many branches into side valleys, built a solid right of way on the main line and operated

The Logging Railroads in the White Mountains

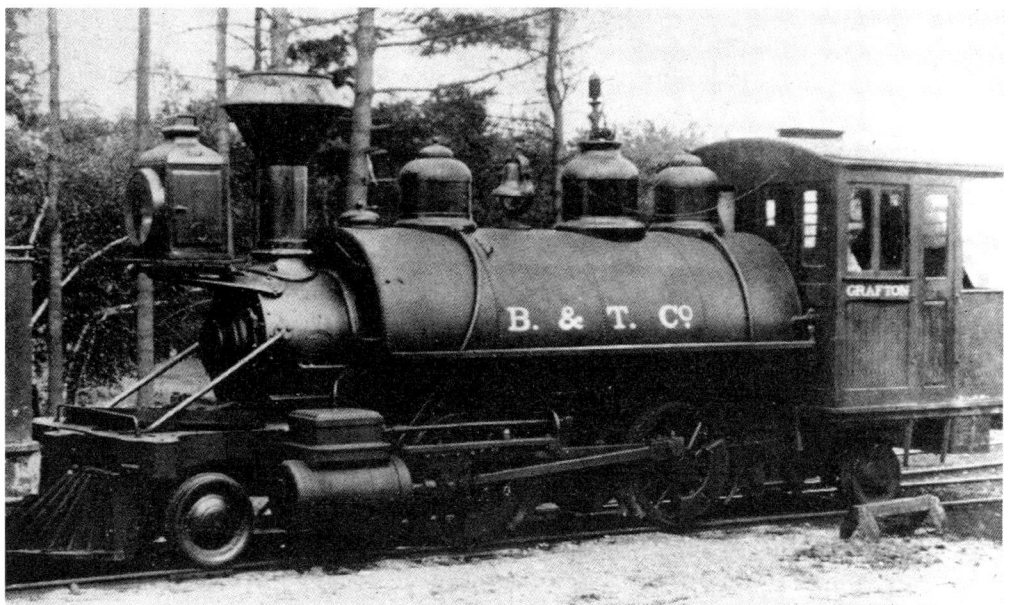

Blanchard & Twitchell Company locomotive—Success Pond Railroad. *Courtesy of the Appalachian Mountain Club.*

year-round. As a result, a number of them ran passenger extras consisting of flat cars with wooden benches. To take advantage of this, several Appalachian Mountain Club excursions were organized on the lines out of Livermore, Lincoln, Swift River and the Rocky Branch.

The major concern of these locomotives was not to haul their trains but to brake the heavy loads on the downhill run to the mill. The only air brakes were on the locomotives, with individual hand brakes on the trucks for the brakemen to set up tighter on a whistle from the engineer. It was a unique operation, and no doubt many engineers offered prayers that their long loads weren't too long for the many short curves between the landings and home. When the job boss (engineer) whistled his crew for more brakes for the steep grade ahead, woe betide the brakeman who wasn't careful going over the grinding, twisting log-serpent, often wet or icy and traveling in both daylight and after dark. In an official report on the death of a long-train brakeman in 1900 the New Hampshire Railroad Commissioners stated:

> *For it is to be said that the business in which he is engaged is an extra hazardous one, that the machinery and methods in use in moving logs appear to be primitive and crude, and to afford little chance of even the most prudent brakeman to do the work in safety... we must expect similar casualties in which the best of men lose their lives.*

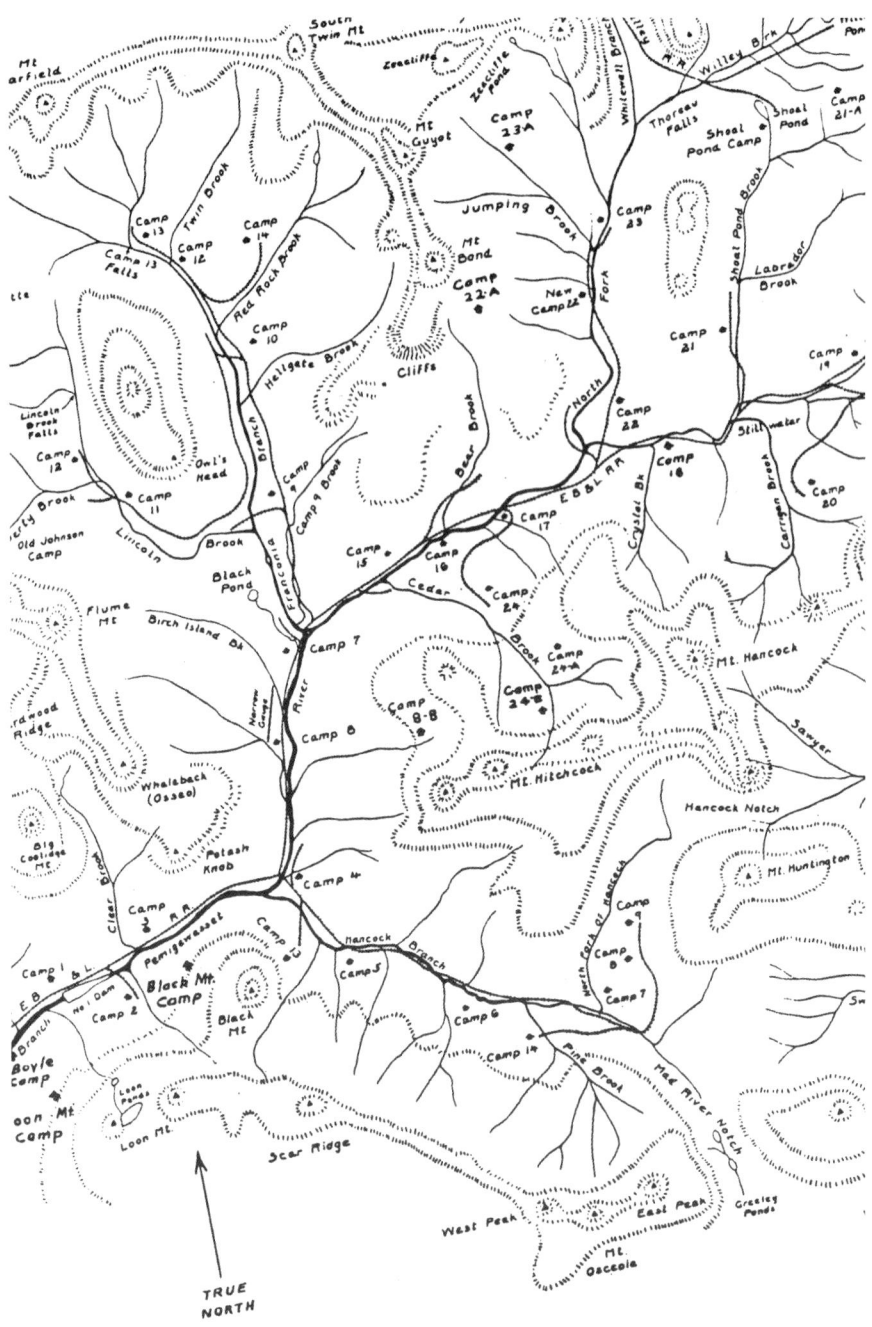

Site of logging camps and railroad in the Pemigewasset wilderness. Prepared for presentation before the Conway Historical Society on June 26, 1960, on the Kancamagus Highway. *From Henry Waldo's* A Brief History of Lincoln.

The Logging Railroads in the White Mountains

The Pemigewasset Valley Railroads
The New Hampshire Land Company (1880–1905)

The scenic Pemigewasset Valley Railroad (affectionately known as the "Pemi") was located above Plymouth. In 1893 J.E. Henry pointed out that there were endless wooden dollars to be coined in the valley. The Henry logging operations, located north and east of Lincoln, New Hampshire, opened the area to logging, but it would be more than ten years before any serious logging operation would develop in the area. With the advent of the Pemigewasset Railroad (later a branch of the Boston & Maine Railroad) in the early 1880s, a less pastoral era was in store for the scenic valley.

At its birth, the railroad company had claimed upward of 240,000 acres of prime forest in the towns of Livermore, Franconia, Bethlehem, Woodstock, Sandwich, Waterville, Ellsworth, Thornton and some scattered, unorganized locations and gores. James & Company was directly involved with land sales and mortgages to the White Mountain logging railroads. George B. James was the catalyst that funneled the hundreds of land units to the loggers in big enough bites that they could not refuse.

Defending his White Mountain speculations, Mr. James was a constant speaker at the forestry meetings in the state and advocated the "Preservation of the White Mountain Forests." In this and all his articles, he also advocated the cooperative ownership of these forests through the contributions of a few wealthy men. George James frequently stated, "These forests can never be saved by legislation, pure and simple."

In the 1950s the Boston & Maine abandoned that section of the White Mountain Division between Plymouth and Woodsville; thus the twenty-one-mile-long "Pemi" became the northern end of the White Mountain Branch, which operated north of Concord, New Hampshire.

Gordon Pond Railroad (1907–1916)

According to C. Francis Belcher, "In 1896, the Boston & Maine Railroad received proper state authority to extend its Pemigewasset Valley branch almost six miles north of North Woodstock to provide a rail connection for Frank Hall's sawmill near the Flume House." This came to be known as the Whitehouse, Hall and Burns Branch.

G.J. Johnson from Monroe, New Hampshire, was perhaps the smartest logger ever to set foot on Moosilauke. Belcher continues,

> *On May 1, 1908, Johnson officially leased two and one-half miles of the Whitehouse, Hall and Burns Branch, one hundred tons of rail, and odd track equipment from the Boston & Maine to start the wheels rolling on his infant Gordon Pond Railroad, incorporated by the New Hampshire Legislature in 1907…During the first two years Johnson leased enough rails and track equipment from the Boston & Maine to extend his little line to its two pronged heads near Elbow Pond and Lost River on the Moosilauke Brook.*

A History of the Boston & Maine Railroad

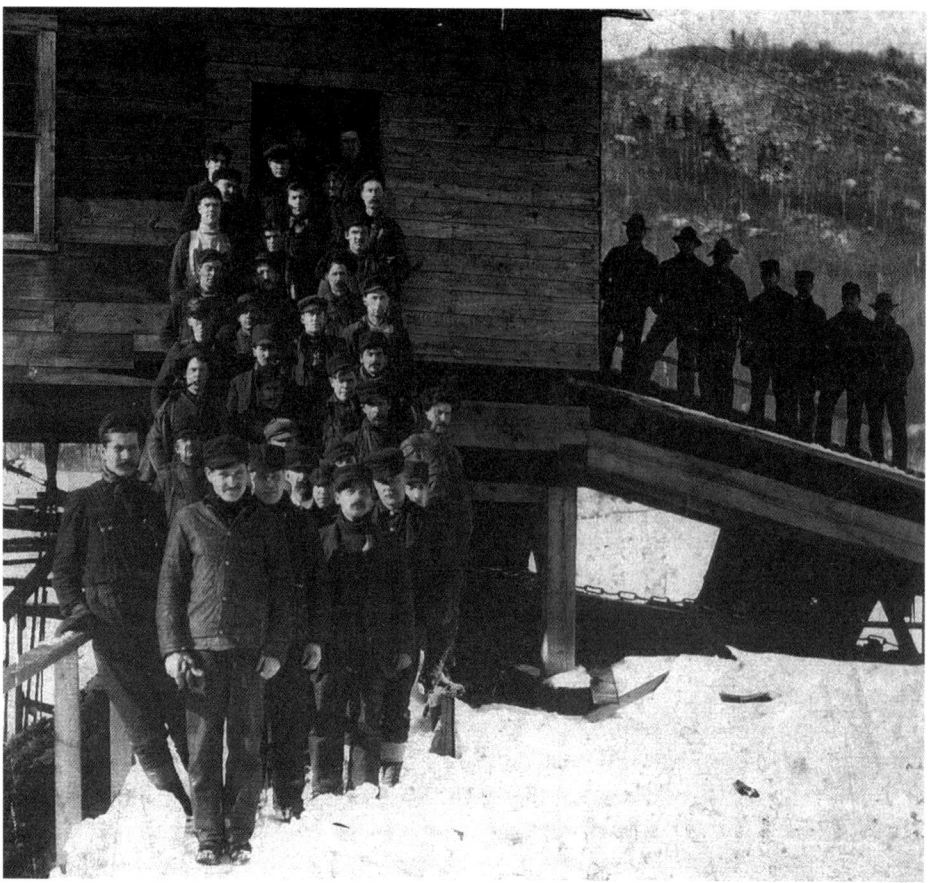

The mill crew of the Johnson Lumber Company as they pose outside the mill, early 1900s. *Courtesy of the Appalachian Mountain Club.*

The locomotive used by George Johnson for his logging railroad was the Shay geared locomotive. This engine weighed fifty tons and was considered to be the largest used on the operation. It goes without saying that the logging railroads were important and valuable tools that provided the transportation of logs and pulpwood from landings deep in the forest to mills at railway points of transfer to public carriers, thus completing the delivery of the timber to the paper mills.

During this period, and for only one year, the Boston & Maine had agreed to allow Johnson to run his train to Henry's mill subject to Boston & Maine orders.

THE WOODSTOCK & THORNTON GORE RAILROAD (1909–1914)

Starting in 1907, and for the next ten years, the presence of the railroad brought many loggers. The Woodstock & Thornton Gore Railroad originated at a sawmill

The Logging Railroads in the White Mountains

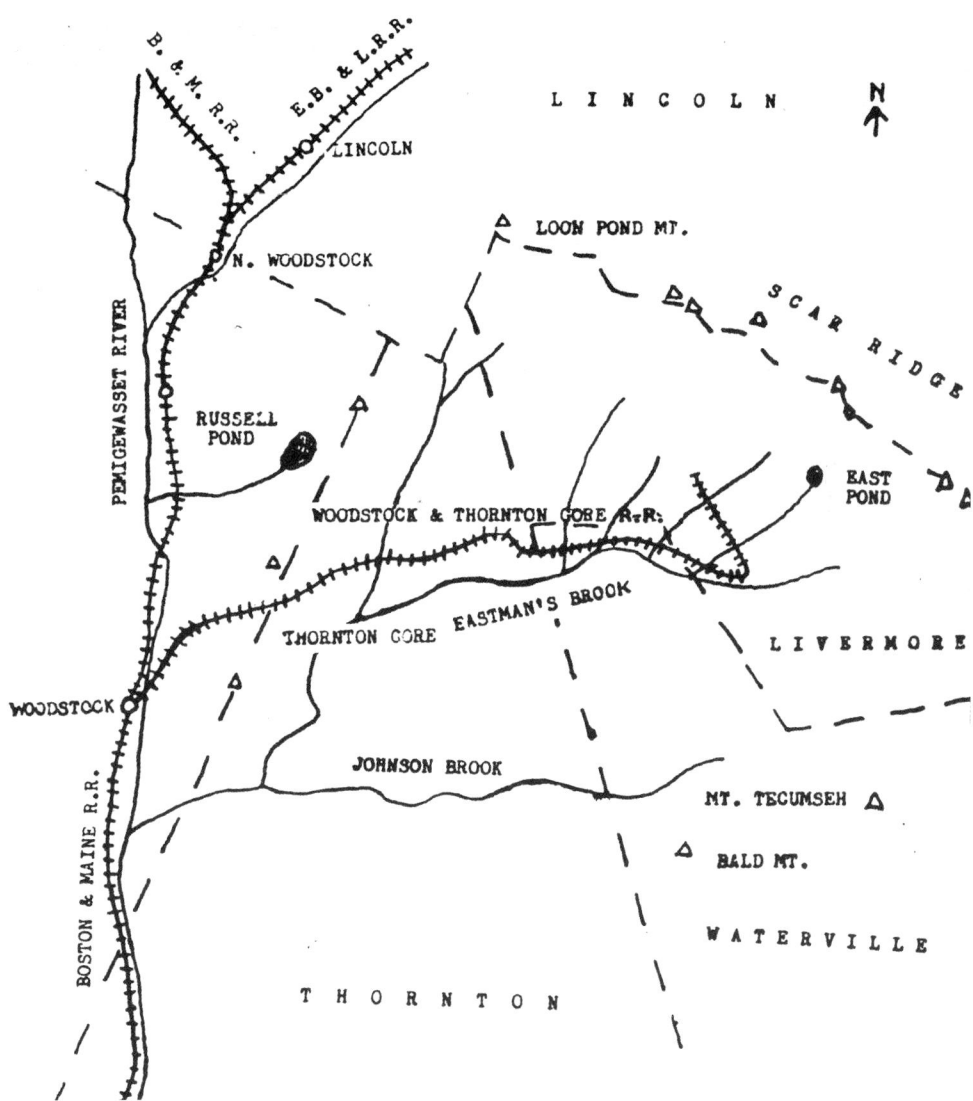

Map of Woodstock & Thornton Gore Railroad. In 1909, the logging rail line was extended to the section of Thornton known as the Gore. Later the Gore became the midpoint on the line, with the end of the tracks at Tripoli Road near the East Pond Trail. *Courtesy of the Appalachian Mountain Club.*

built by Thorne's Publishing Company in 1906, which was located on the banks of the Pemigewasset River at Woodstock. In 1909 the logging railroad line was incorporated to run through Thornton Gore. The entire track was the property of George B. James and his New Hampshire Land Company.

This short logging railroad line made it much easier to transport the timber and, once again, the Boston & Maine Railroad took control. Again the Boston & Maine Railroad leased all the rails and track equipment, this time on the basis of 5 percent at twenty dollars per ton valuation. Business was very prosperous for five years. During their heyday, the Woodstock companies had approximately three hundred persons on its payroll, most of them at the mill.

The locomotive used a geared Shay, which was purchased from the Johnson Lumber Company. According to Bill Gove in his *Logging Railroads Along the Pemigewasset River*, "In the mill yard the Woodstock Lumber Company used an old 0-4-0 locomotive built by the Boston & Maine in 1884. In 1910 another 0-4-0, an 1883 Rogers, was brought in as a switcher in the mill yard."

What eventually ended the logging operations was not the lack of timber, but rather a fire. The Woodstock fire of 1913 was the beginning of the end for the Woodstock Lumber Company. March 2, 1915, marked the official close of logging on the short railroad line.

THE BEEBE RIVER RAILROAD (1917–1942)
WOODSTOCK LUMBER COMPANY & THE PARKER-YOUNG COMPANY, DRAPER CORPORATION (1924–1942)

The Beebe River Railroad was incorporated by the New Hampshire Legislature in 1917. The line ran for approximately twenty-two miles from the Beebe River Mill to the base of Whiteface Mountain. Along this line were located twelve logging camps.

According to Bill Gove, "During the month of March officials from the Woodstock Lumber Company made their way through the snow and set out stakes at the site for a new sawmill near the Beebe River and beside the Boston & Maine tracks. The Parker-Young Company was the controlling corporation; the Woodstock Lumber Company was the operating company."

Bill Gove also tells us that logging crews were sent into the woods during the summer of 1917 to set up a mill. A logging railroad was part of the original plans. In 1921 the railroad line was completed to Camps 11 and 12. "There were reportedly over twenty trestles to carry the tracks along the side-hill terrain. The largest was 175 feet long and 301 feet high."

C. Francis Belcher relates the following:

> *Today there is barely room between the trees to fit a moving freight train on the former Pemigewasset Valley Branch of the Boston & Maine Railroad, but that was not the case in the heyday of the Beebe River and the East Branch & Lincoln Railroad.*

The Logging Railroads in the White Mountains

Between 1917 and 1924 the railroad movement on the sixteen-mile stretch kept one train dispatcher busy down in division headquarters at Concord.

The Parker-Young Company made sure to keep the trains on the move—seven days a week. Passenger excursion trains were often seen on the Beebe River line during the Parker-Young days. On August 25, 1921, it was documented in the Sandwich Historical Society booklet that 270 persons celebrated Old Home Day with a train excursion. The following is recorded:

> *Our train was arranged for this excursion. Besides the engine and buggy there were three heavy flat cars, open at the top, protected at the sides and ends by heavy planks three feet high to keep the forgetful and venturesome from falling off; heavy stepladders constructed for the occasion led from the ground to the car tops…These cars, which were not Pullmans, were not vestibuled and the best climbers and jumpers concluded that it was safest to stick to the car they started in. The inside of the cars were lined with seats taken from the company's amusement hall and securely fastened.*
>
> *We reached Camp 10 at 12:15; our train halted beside Flat Mountain Pond, and we were informed that it would start on its return at 1:15. We had an hour for lunch…to inspect Camp 10 to watch frolicking scores of pig, which consumed camp waste and furnished winter pork for lumberjacks.*
>
> *The afternoon's return was as pleasant as the morning's outgoing. The Carter's Mills party left the train at Carter's Mills Station while the others kept on to Beebe River Station where, after three cheers for the Parker-Young Company, the Woodstock Lumber Company, the Beebe River Railroad and a hasty inspection of the splendidly-equipped boarding hall and the big saw mill, we took our home-bound conveyances.*

J.E. HENRY & THE ZEALAND VALLEY RAILROAD

The Zealand Valley was considered the "Treasure Chest" of the Pemigewasset wilderness. It was the first stage of New Hampshire's greatest lumber baron, James E. Henry. Here, on ten thousand acres of forest was the largest woodland to be controlled by one man or family. J.E. Henry put together operations for harvesting trees and a lumber railroad with "devastating efficiency" never equaled in the White Mountains.

A very descriptive narrative through the Zealand wilderness appeared in the August 23, 1879 issue of the *White Mountain Echo*, a summer weekly, entitled "Echo Explorations."

> *New Zealand Notch really lies between Mt. Thompson on the west and Mt. Hastings on the east and runs almost directly north and south. It is variable in width its greatest span being in the south outlet, where it is over 400 feet, while at its narrowest portion it is from 300 to 350 feet. There are two outlets to New Zealand Pond, one running north and the other south.*

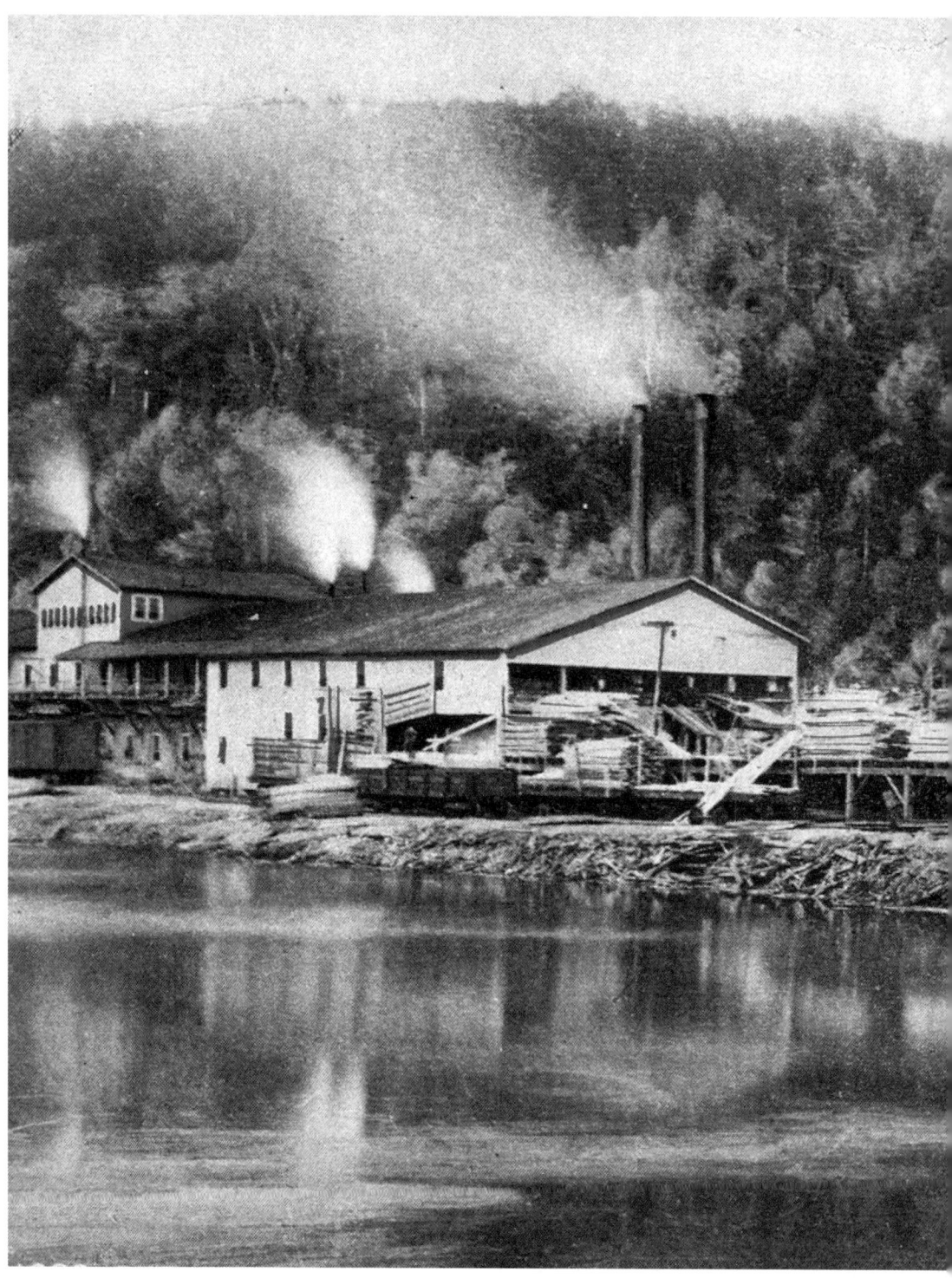

The Woodstock Lumber Company, Woodstock, New Hampshire. One of many mills that once operated in the Pemigewasset Valley.

The Logging Railroads in the White Mountains

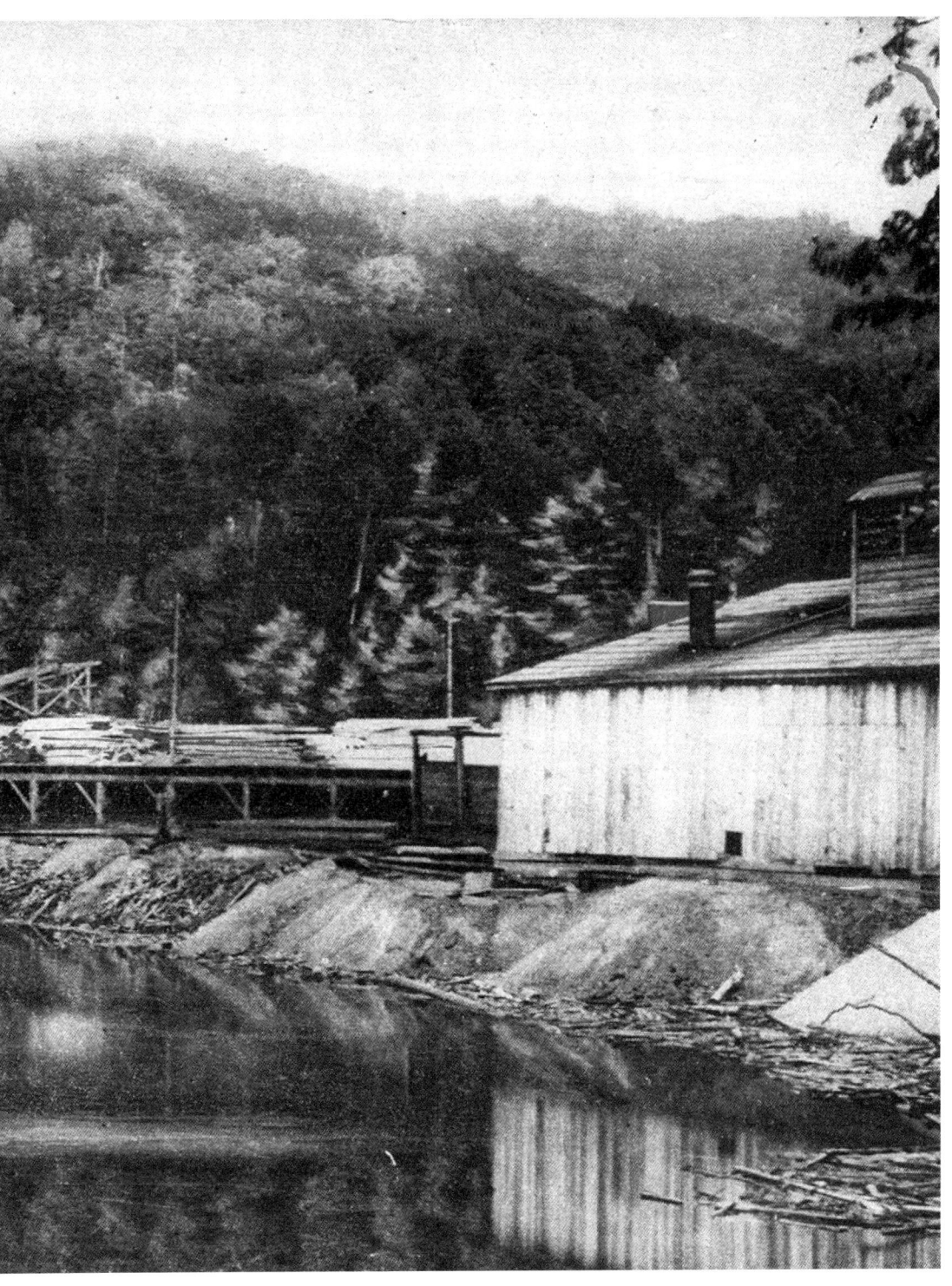

A History of the Boston & Maine Railroad

A logging train with passengers at Carter's Mill, Sandwich Notch, New Hampshire, 1920s.

The Logging Railroads in the White Mountains

Although an exact date for the beginning of the logging operations at Zealand is not available, some say it was 1881. According to interviews with the Henry family, as well as local articles, for three or four years all cutting operations were located on the lower elevations of Crawford's Purchase and Nash and Sawyer's Location, along the tracks of the Mount Washington Branch of the Boston, Concord & Montreal Railroad (later the Boston & Maine Railroad). The logs were hauled, by agreement, to Henry's Fabyan and Zealand Mills.

It was approximately two years before the Zealand lands were passed into Henry's possession, and at that time the New Hampshire Legislature incorporated the Zealand Valley Railroad.

C. Francis Belcher documents the following:

> *These interests, the Boston, Concord & Montreal and the Boston & Lowell (precursors of the Boston & Maine), had been unsuccessfully looking for a more direct route than the existing one through Woodsville from the Concord, New Hampshire, area to the great vacation attraction in the Twin Mountains, Fabyan, and Crawford Notch region. In the Legislature's act, the incorporators were authorized to extend and maintain a line south to the New Zealand River, with rights to connect with any other line in the state. The railroads had much room in which to move—and never did.*

There were two fine articles written during the period of the Henry operations in Zealand, which provide a vivid description of the rail line. Frank H. Burt, in his newspaper *Among the Clouds*, states:

> *The Zealand Valley Railroad is the crookedest and, with one exception, the steepest road in New England. Its sharpest grade is 285 feet to the mile, 15 feet less than the maximum grade between Fabyan's and the Base. How many crooks and turns there are in its length of five miles, or how many times it crosses the equally crooked river, we dare not guess...The zig-zags of the track become more marked. "When they built the road," Mr. Henry [James Henry's son, John] tells us, "they said they would straighten the track the next year; but they soon said that instead of taking out any curves, they would rather put in a few more, they are such a help in holding a heavy train when going down grade."*

It is interesting to note that the files of the Boston & Maine Railroad contained references to a No. 2 engine with no name, as well as agreements for the winter rental by Henry of the Boston & Lowell's engines, which the railroad used in the summer for the short hill runs between Fabyan's and the Base Station.

The Zealand engines were light (thirty-five tons) wood burners. Frank H. Burt in *Among the Clouds*, provided an interesting portrait of these engines, which were observed by many:

> *The engines are the oldest ever seen in this part of the country. The tank is over the boiler, the weight of the engine is borne of the four drivers, and there is a simple pair of small*

A History of the Boston & Maine Railroad

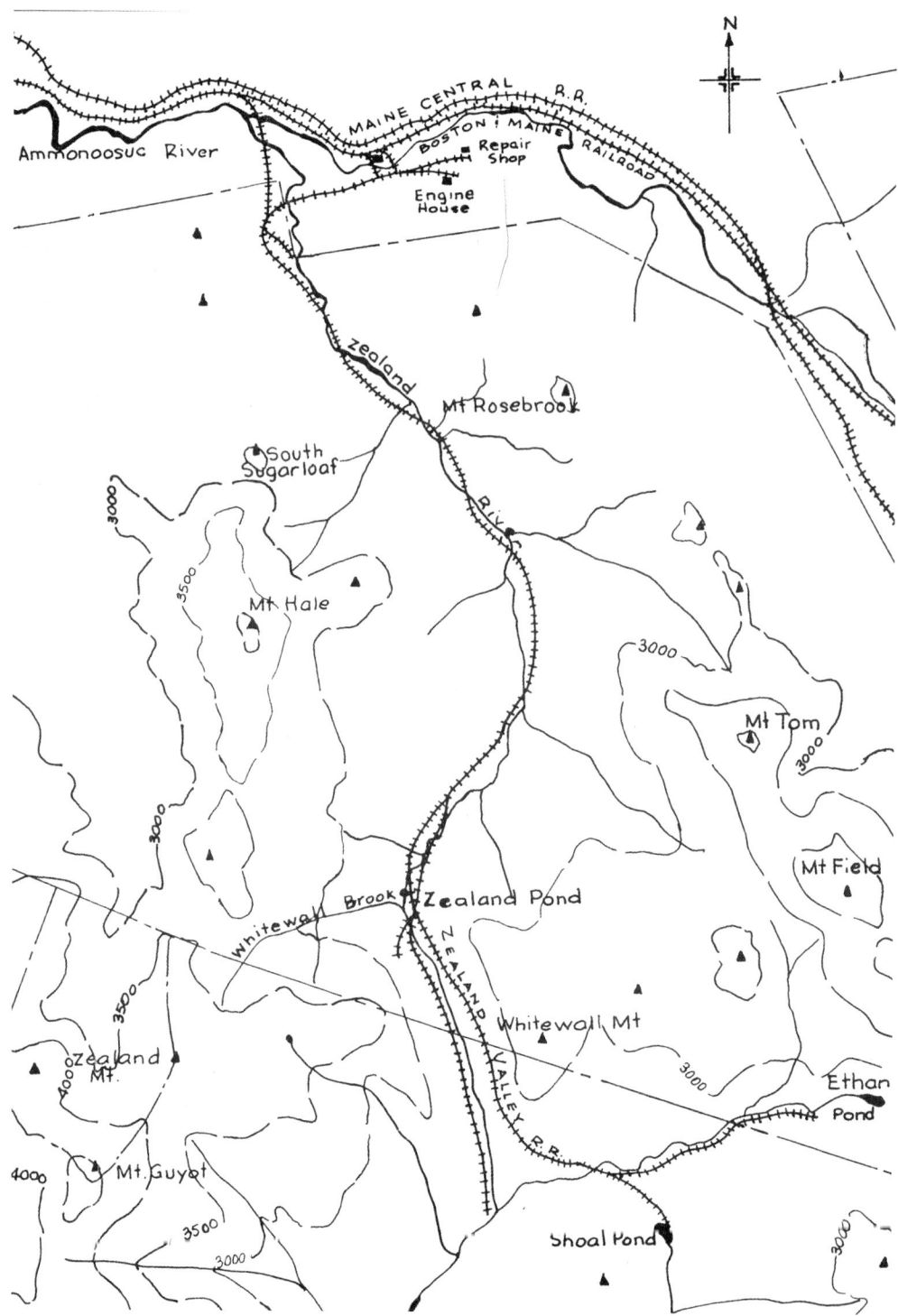

A map of the Zealand Valley Railroad in the White Mountains. *Courtesy of the Appalachian Mountain Club.*

The Logging Railroads in the White Mountains

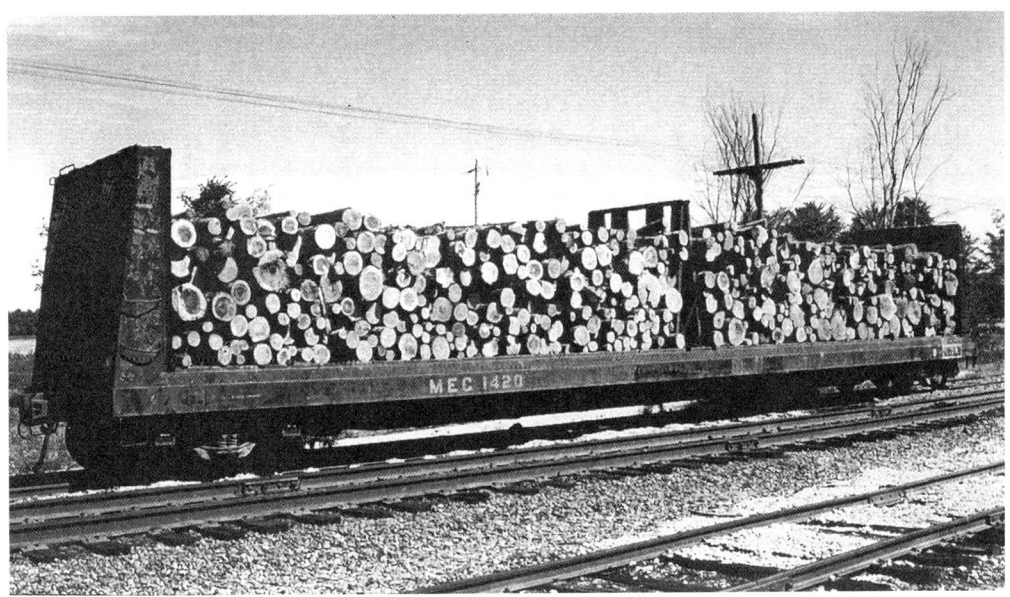

Bulkhead flatcar No. 1420, series 1400–1599, was commonly used to haul lumber and pulpwood. *Courtesy of the B&M Railroad Historical Society.*

wheels "fore and aft". The engines can haul 15 empty log cars up a steep grade, and have sometimes brought down 16 loaded cars, though eight is the regular number to a train.

The *White Mountain Echo* published the following article in its July 10, 1886 issue. The headline read "Forest Fire—Great Conflagration in the New Zealand Woods," and the story went as follows:

On Wednesday afternoon [July 8] a fire started in New Zealand wood. At the time of publication the information received regarding it is somewhat vague, but it is reported that the fire is supposed to have originated from the locomotive of the lumber train drawn over Mr. J.E. Henry's railroad, which leaves the line of the Boston & Lowell R.R. between the Twin Mountain House and Fabyan's at New Zealand Station, and penetrates some distance into the woods in the direction of the New Zealand Notch.

Three logging camps, several horses and hogs, a considerable portion of Mr. Henry's railroad, and a vast amount of lumber, are said to have already been consumed. Fears are also entertained for the safety of some men, who were measuring wood. The reflection of the blaze in the sky was plainly visible in Bethlehem on Wednesday evening and the clouds of smoke seen rising over the fated locality at the time of going to press on Thursday evening indicate that the fire is still raging. The imperiled men, five in number, we learn, narrowly escaped by plunging into a brook and are now safe.

A week later the same publication reported: "The forest fire reported last week as having started along the line of the New Zealand Railroad continued to burn for several

days, consuming much timber, so that the rainstorm of Wednesday night [July 15] was much welcomed in the district." It was estimated and accepted that twelve thousand acres—$50,000 worth of stumpage—were lost.

Behind the death of the Zealand operations stood the waste of the forest and the beckoning of fresh timber from the Pemigewasset. The Henrys sought a new home in Lincoln, New Hampshire.

THE EAST BRANCH & LINCOLN RAILROAD (1893–1948)

In 1892 James E. Henry, his sons and others arrived in Lincoln and established a new home for his logging industry. The J.E. Henry & Sons logging settlement received early mention in the following article written for the *Granite Monthly* by George Moses:

> *Pullman, New Hampshire—you may not find it on your map; you may not mail a letter to that address and have it delivered; no enterprising scalper may sell you a reduced railroad ticket to that destination; yet it exists and there is some basis of the fact for my fancy in thus titling the lumber town of Lincoln on the East Branch of the Pemigewasset...But this is digression. On the first of September 1892, where now stands the lumber town of Lincoln was a dense, virgin forest. A year later the village of Lincoln with a school, store, dwellings, shops, and mills was visible evidence to all. It had sprung up almost over night through the boundless energy and unflagging courage of its owners, who in fact of a steadily falling market, deepened their investment and increased their risk.*

In an article written for the *Northeastern Logger*, J.E. Henry employee Jim Doherty recollects the following:

> *That day in August 1892, we drove over from the other side, down through the notch. There was quite a party of us, Mr. Henry, his sons, George, John, Charlie, and others, as well as the womenfolk and the children. Well, the day after we got here we all went to work, clearing land, building houses, and putting in a railroad...During the fall we had 100 to 150 men working and by winter we had finished six houses, a store, a barn, a blacksmith shop, and harness shop. Besides that, we had cleared a lot of land, and made a start on the railroad, so that by March, two miles of railroad were finished and the logs started rolling into Lincoln.*

On the back of the passes issued to the Henry company workers was printed the following description of Lincoln: "Lincoln...is one mile from the town of North Woodstock on the Concord & Montreal Railroad. It is one of the largest firms in the state. A good man can find work all year. A poor man better not go there, as such men are not wanted."

Between 1893 and 1917, J.E. Henry and company built, operated and maintained more miles of logging railroads and hauled out more timber than any of their competitors.

The Logging Railroads in the White Mountains

Their railroad line exceeded fifty miles of track, which traveled up and down the valley to the east of Lincoln. It was customary that the road engines would make two round trips a day between Lincoln and the current logging area. During the heaviest cutting in the 1900s, two Baldwin locomotives would make three round trips daily. Every Tuesday and Friday, there would be whole trains, which brought loads of supplies to the camps. Belcher writes, "In between these main supply days the ever present flat car next to the engine carried a wonderful confusion of incidentals—food, mail, axes, people, and dynamite. The unique operation of excursion trains was instituted in the summer by the Henrys, once they saw that it could pay its way."

Karl P. Harrington writes in his book, *Walks and Climbs in the White Mountains*:

> *During our gala days in the height of the summer season two or three flat cars used to be rigged up with extemporized railings and filled with chairs, and a hundred or more excursionists made the trip up to "Henry's Woods," to wonder at the new mountains and valleys, exclaim over the winding road, marvel at the various camps, and raid the cook's quarters for hot doughnuts.*

It should be remembered that the Henrys' (and later Parker-Young) railroad was considered to be high-grade construction. Its excellence did not go unnoticed. George Moses in his article in the *Granite Monthly* stated, "For solidity of construction the railroad is the equal of any in the state if not in New England, and its equipment is of the most powerful and superb quality, for modern lumbering demands only the best."

Philip R. Hastings, an acknowledged authority on railroads, wrote an interesting article about the railroad in the January 1948 issue of *Railroad Magazine*, including the following comments on the operations he observed: "Handling of the log cars is one phase of the EB&L railroading which has changed little since the brakemen displaying the latest in handle-bar foliage first rode the line; shakes [brakemen] still lift the pins and hold the links to make couplings, and run alongside the cars turning ratchets with a wrench to set the brakes."

The Henry operation was different from other logging operations. This was attested by an article that appeared in the official journal of the American Forestry Society, *Forestry and Irrigation*, in May 1902. The article compared the Henry camps with the usual structures of the day:

> *J.E. Henry and Sons lumber camps are very much after the fashion of logging camps in general, save for some exceptions worth mention. First of all, the camp buildings are made of boards instead of logs…Another interesting feature of their system is that of transporting camp buildings from place to place by means of the railroad. Buildings of this sort are either long and narrow or so built that they can be readily taken apart. They are usually 14 feet in width and from 30 to 50 feet long. Of course, camps of this description are usually confined to the railroad at the foot of the mountain, while those further up are built of logs. These are burned down when they are abandoned to discourage possible campers who might carelessly start fires.*

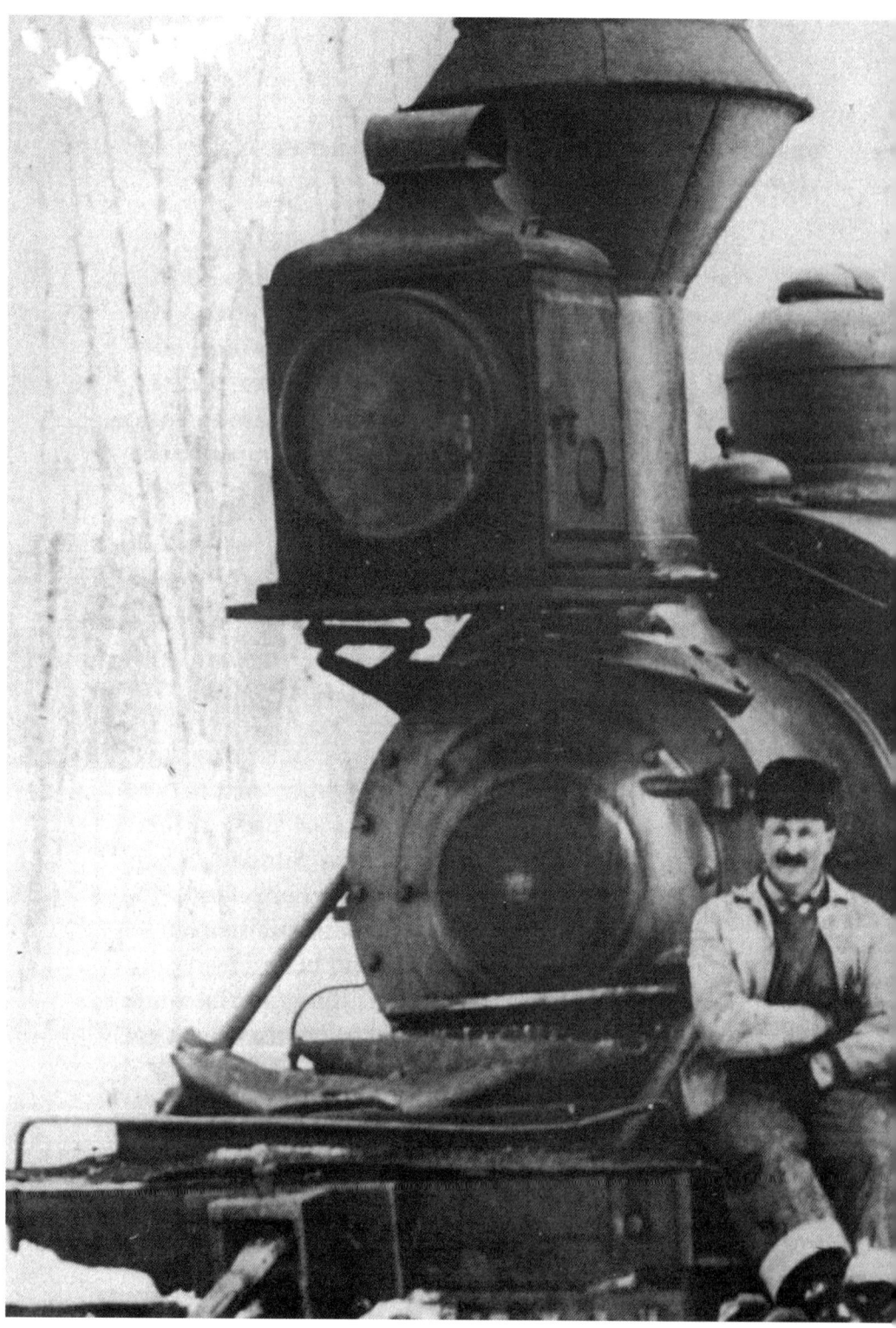

Baldwin engine of the Swift River Railroad, 1910. *Courtesy of the Appalachian Mountain Club.*

The Logging Railroads in the White Mountains

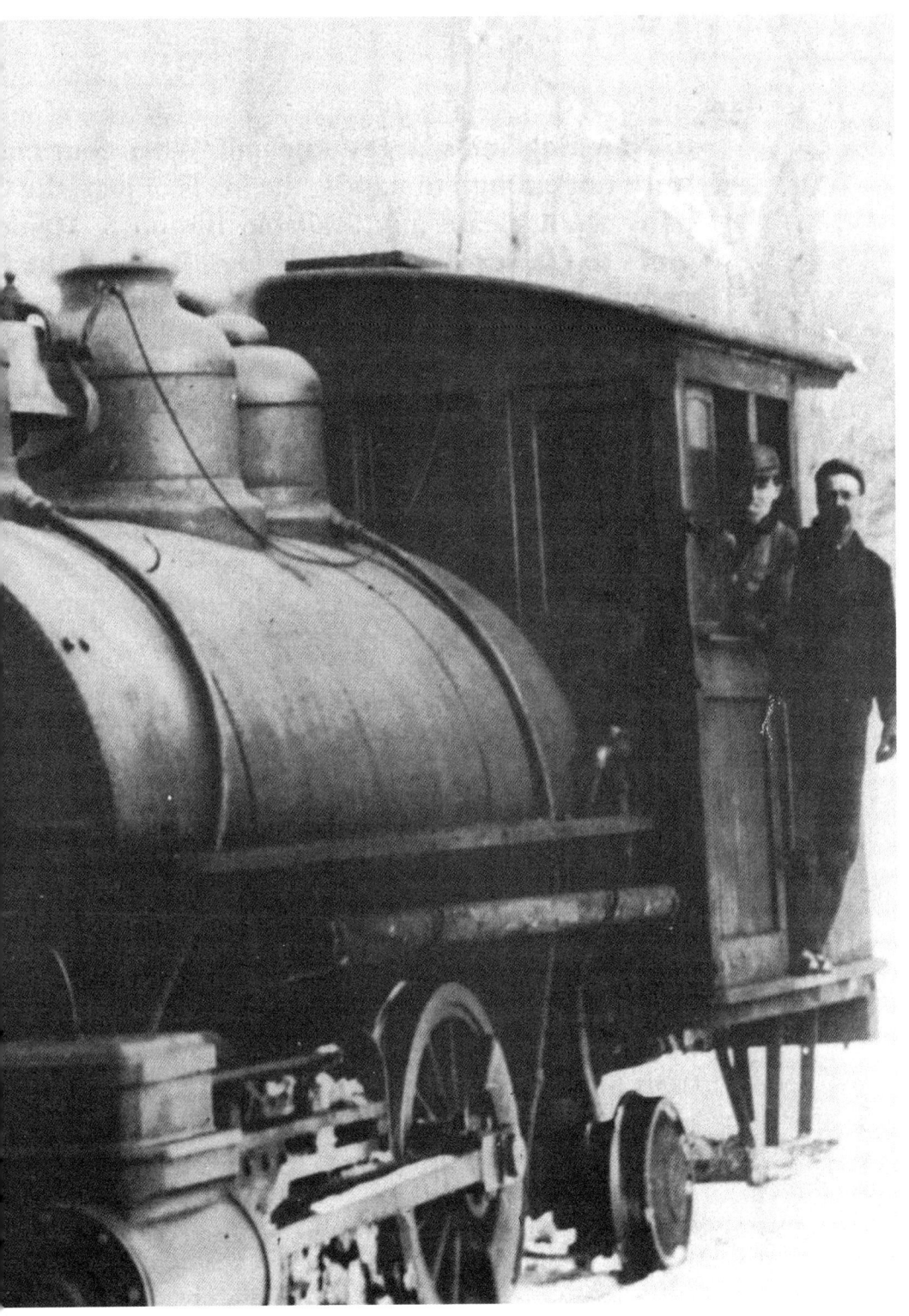

A great deal more could be written, and some has by C. Francis Belcher in his *Logging Railroads of the White Mountains*. To learn more of the logging adventures in the White Mountains, this book is highly recommended!

In closing it is fair to state that James E. Henry led a rugged life, but his life is a testimony to his vitality. As C. Francis Belcher stated in *Logging Railroads of the White Mountains*,

> *Somewhat apart from the closely-clustered village, in a little white-painted house which overlooks the valley, and faces the huge rampart of Loon Pond Mountain, lives—if you can call it—Jim Henry. Sightless, feebly with his eighty years, relinquishing to his sons, because he must, an industry that has been the very core of his existence, he frets away his few remaining years....Now he has his millions—perhaps the Lord knows how many, the assessors don't and that is all.*

James Henry died on April 19, 1912, just two days before his eighty-first birthday. A legacy—Mr. Henry had cut a memorable but devastating window across the White Mountains history of New Hampshire.

SUCCESS POND RAILROAD (1894–1907)

This railroad company is also known as the Blanchard & Twitchell Company Railroad, 1894–1904, and George W. Blanchard & Sons Company Railroad, 1904–1907.

C. Francis Belcher makes the following observation:

> *Success was more than a town in the lives of George W. Blanchard and Cassius M.C. Twitchell of Milan, New Hampshire. It was another notch on their way to personal financial success and a large step toward a place in the logger's hall of fame.*
>
> *In 1907 the George W. Blanchard & Sons Company went out of business, and the railroad operations ceased. The Boston & Maine Railroad took over control of the 1,600 feet of connecting track. The only connection, that by rail, between Berlin and Success was broken.*
>
> *Success and its timber would be harvested in the future by other means of transportation and by other persons, but only after it had had long years in which to stretch and grow another verdant crop. Success has had meanings in this part of the White Mountains.*

LITTLE RIVER RAILROAD, VAN DYKE & COMPANY (1893–1900)

This company was a short-lived, six-mile logging railroad, which ran south from the Boston & Maine Railroad lines approximately one mile west of Twin Mountain to the head of Little River and was located between Mount Hale, North & South Twin, Mount Zealand and Mount Guyot. This was George Van Dyke's only lumber railroad experience.

The Logging Railroads in the White Mountains

To properly describe Van Dyke's logging railroad venture we refer to Poole's book, *The Great White Hills of New Hampshire.*

> *Though Van Dyke kept to the Upper Connecticut through the main part of his life, he once ventured down our way and in the Pemigewasset Valley, went into partnership with the big timber king of the region—J.E. Henry was his name. Seeking his next slaughter ground, J.E. Henry looked over the Pemigewasset wilderness across our rugged range, and in that lovely valley and upon the mountain sides he found such grand spruce and pine that in 1890, with George Van Dyke, he bought 70,000 acres and by hand bargaining paid a mere pittance for the tract. To survey it he employed a Dartmouth graduate and a friend of mine. When the survey showed about a billion feet of lumber, figuring how to edge Van Dyke out of their next prize, J.E proposed: "Now George, I'll make you a proposition. We bought in here together, but this ain't big enough for two of us, and besides you're busy on other big jobs. So, I'll leave it up to you. I'll give or take $100,000 for your share or mine. What do you want to do, buy or sell?" Pleased by the price and figuring that if he stayed, J.E. would trim him soon or later, Van Dyke sold stumpage valued at five million dollars later on.*

During the time of this transaction, the Henry center of operation was located in the Zealand Valley at the confluence of the Zealand and Ammonoosuc Rivers. However, J.E. Henry was in the process of moving to Lincoln. It seemed that he had already cleared the land of the upper Pemigewasset by way of his Zealand Valley Railroad, but he had not gotten around to developing the adjacent Little River Valley, which he owned.

It was on August 5, 1893, that Van Dyke contracted with the Concord & Montreal Railroad for the rental of six miles of complete track material. In January 1894, a second contract was made by Van Dyke and Company with the Concord & Montreal in order to provide operations of Van Dyke's logging trains over the main line of the Concord & Montreal from Little River Junction to Zealand mill. On August 5, 1900, the Van Dyke contract with the connecting railroad was canceled. It wasn't until June 1909 that the Boston & Maine recovered the track equipment rented to the Little River Railroad some seventeen years before.

THE SAWYER RIVER RAILROAD (1877–1937)

As compared with other logging railroads in the White Mountains (with the exception of the Little River Railroad), this railroad was smaller—only eight miles up the valley of the Sawyer River, just above the town of Bartlett and to the south end of Crawford Notch.

Saunders brothers Daniel Jr. and Charles W. of Lowell, Massachusetts, entered into the lumber business. It may be said that both married into their later interest in the White Mountains. Charles W. married Caroline Norcross of Lowell, the daughter of Nicholas G. Norcross, who was a famed lumber baron from both Maine and New

A History of the Boston & Maine Railroad

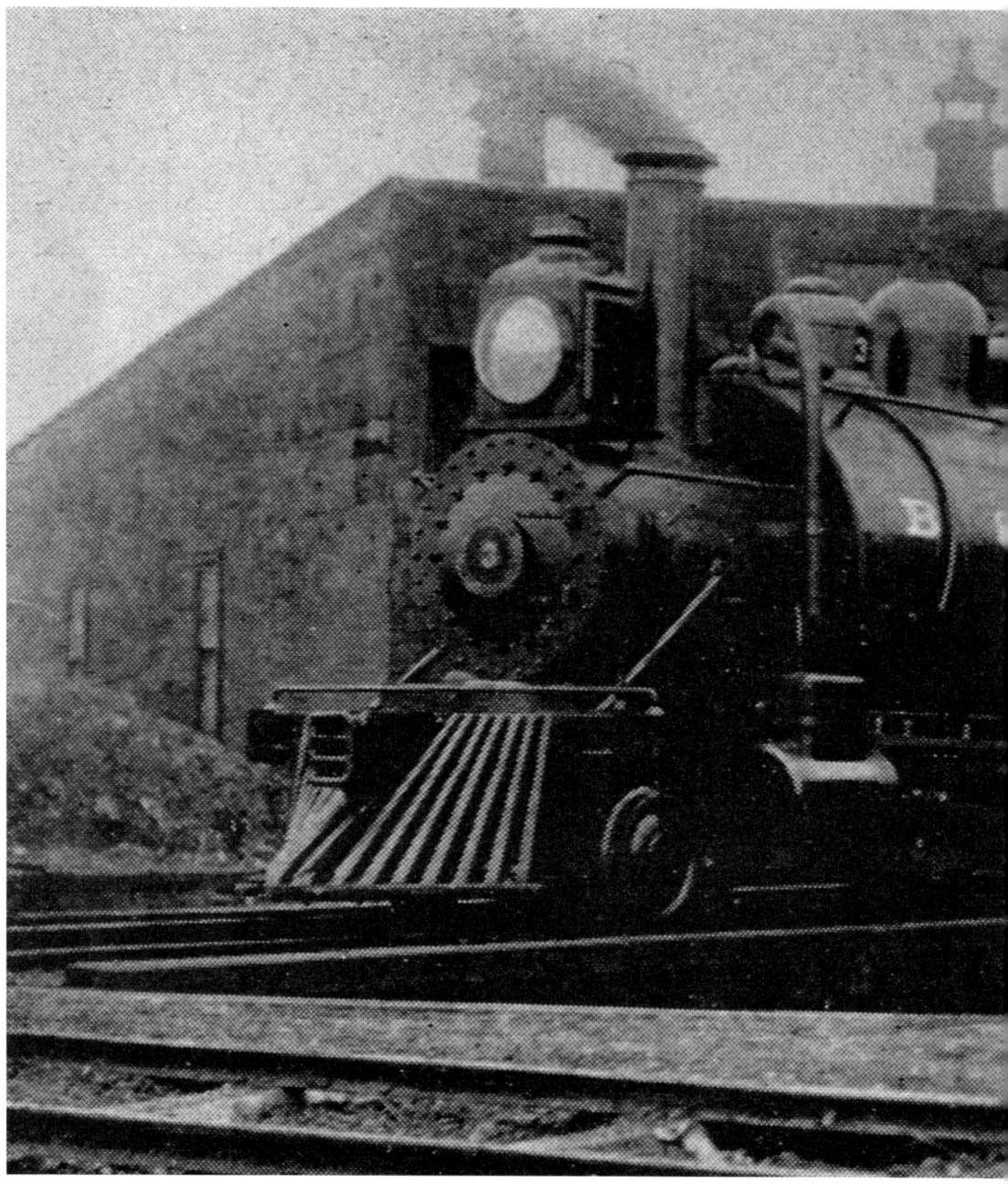

Blanchard & Twitchell Company locomotive—Success Pond Railroad. *Courtesy of the Appalachian Mountain Club.*

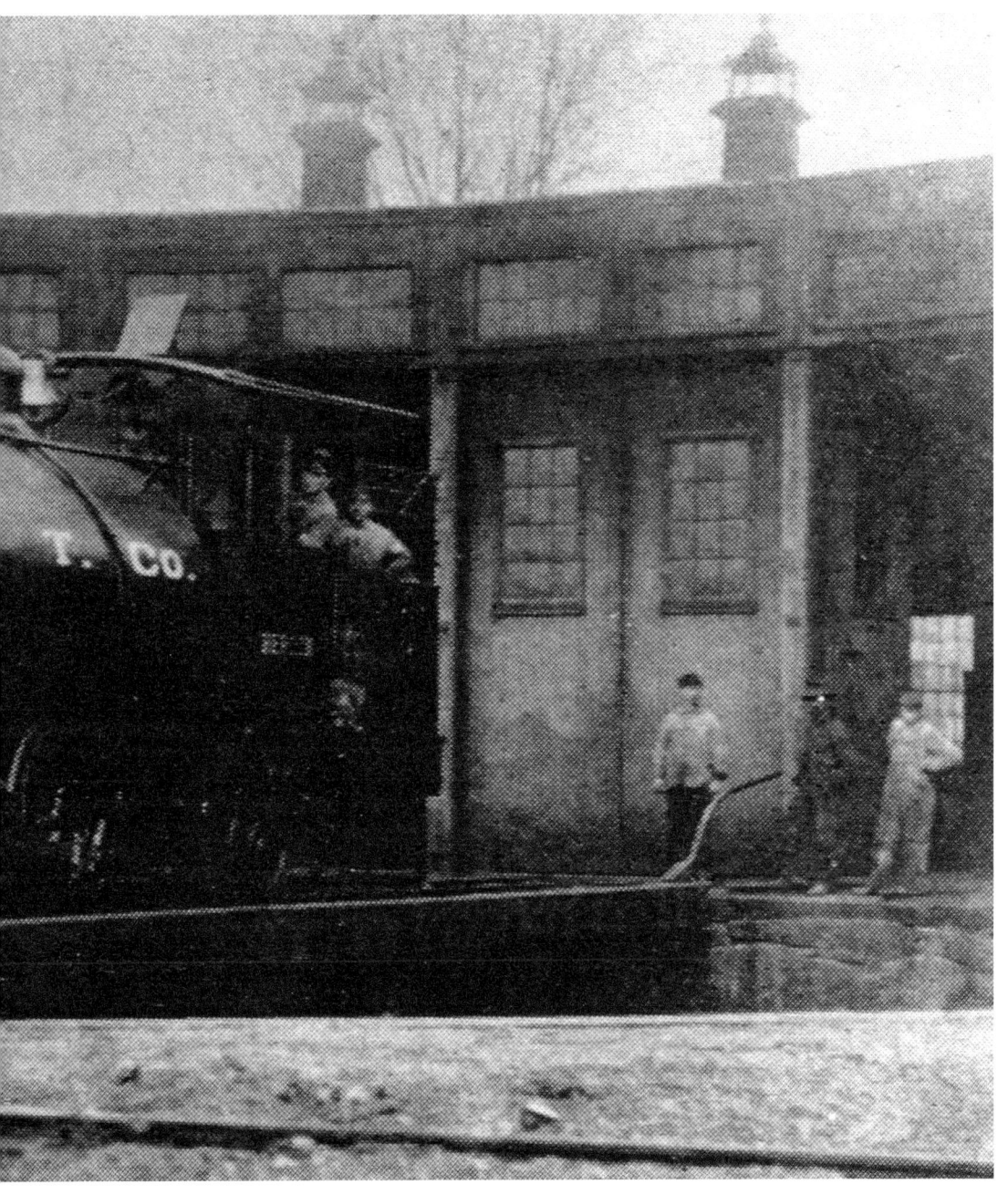

A History of the Boston & Maine Railroad

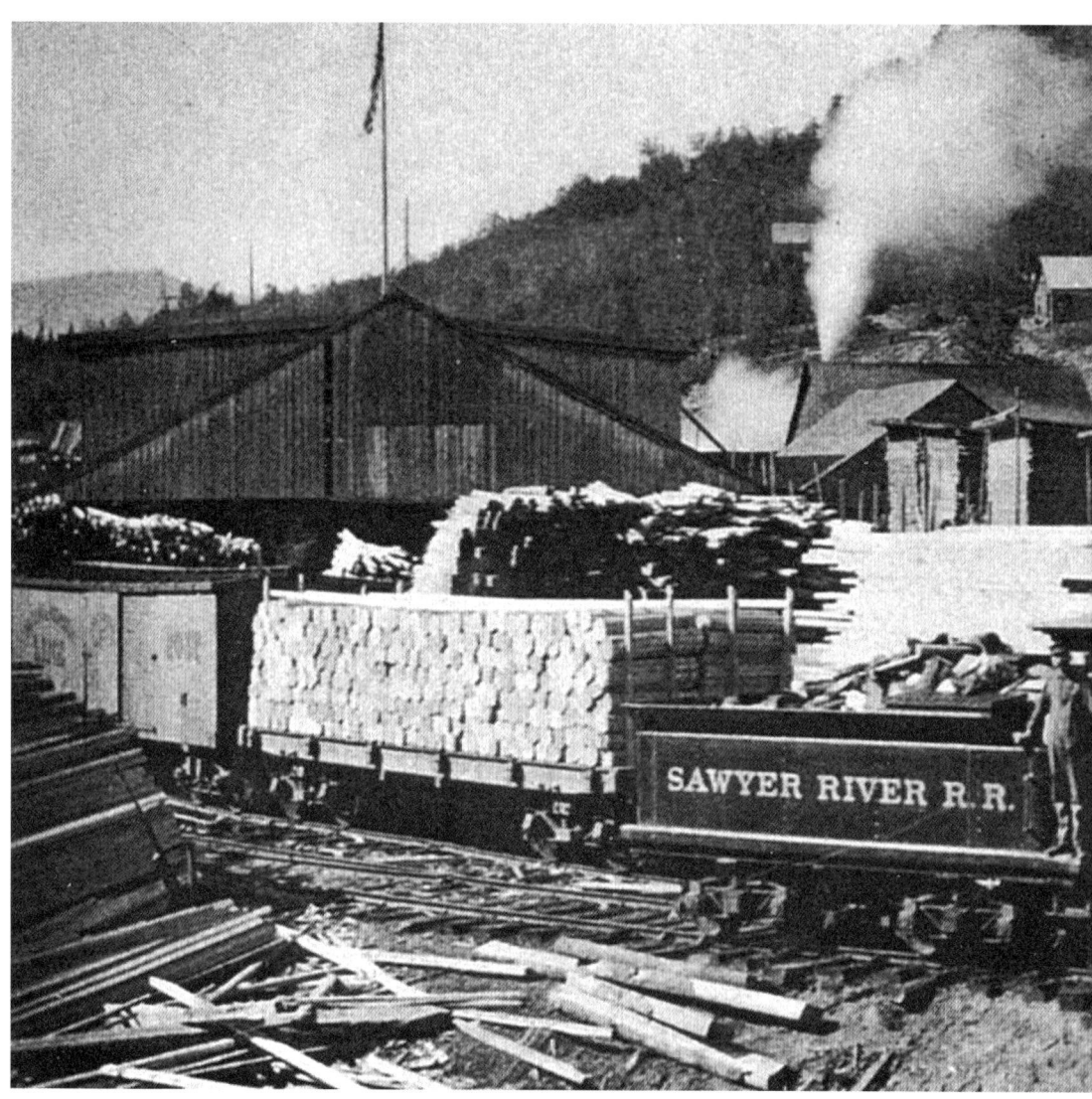

Sawyer River Railroad at the Livermore terminal in the White Mountains, Lancaster, New Hampshire. *Courtesy of the White Mountain Region Association.*

The Logging Railroads in the White Mountains

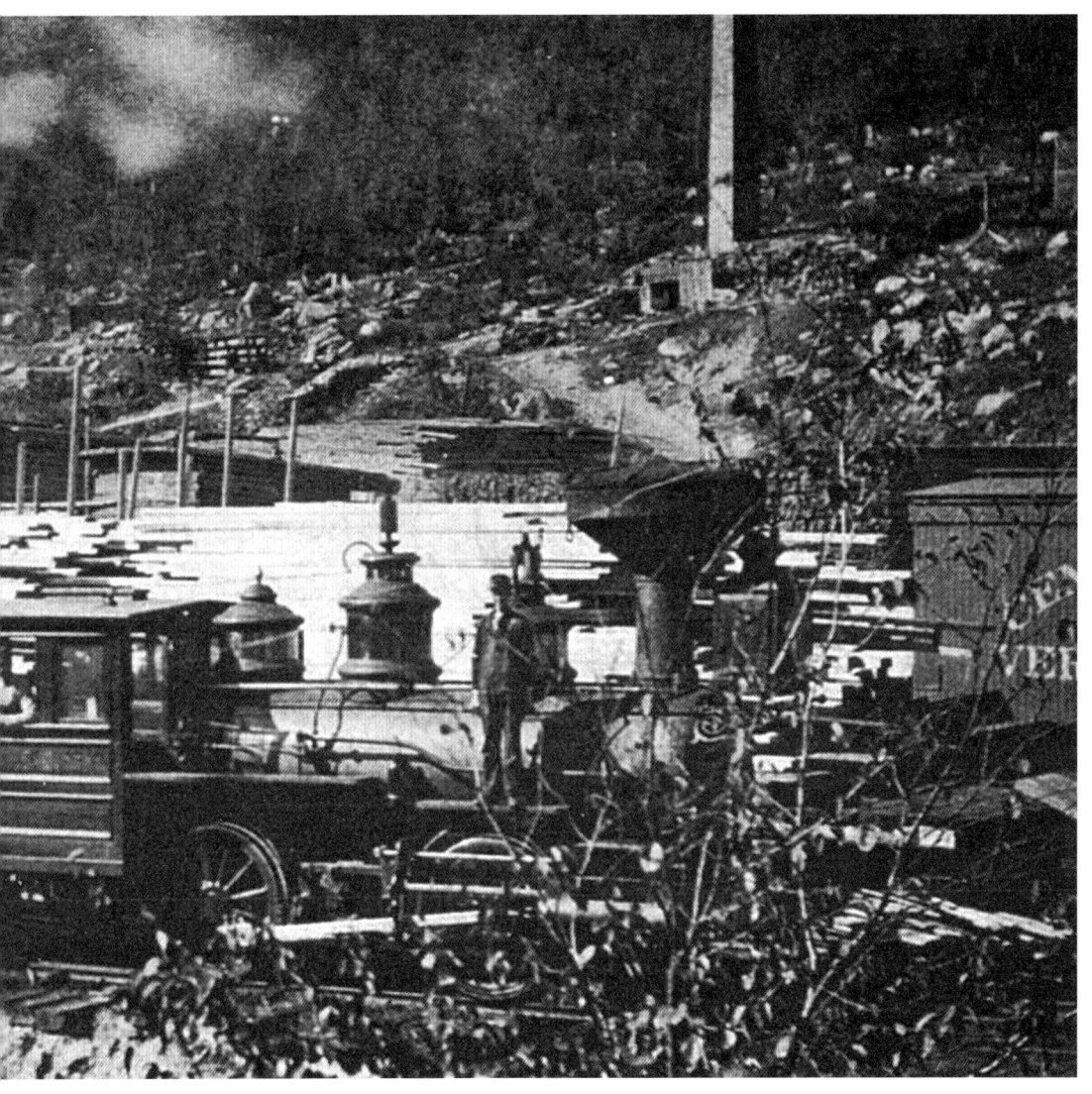

Hampshire. Norcross's part in this story of New Hampshire logging is best explained by quoting from *The Merrimack River* by J.W. Meader.

> *In 1844, Nicholas G. Norcross, who had already made himself rich and earned the title of "The New England Timber King" on the Penobscot, came to Lowell and established himself permanently on the Merrimack…Mr. Norcross prefaced his operation by the outlay of more than one hundred thousand dollars in improving the channel and adapting it to his purposes. He blasted rocks and removed obstructions, bought land and provided for the stringing of booms for timber harbor, bought rights in some of the important falls, built two dams on the Pemigewasset at Woodstock, New Hampshire, and purchased the Elkins Grant of eighty thousand acres of heavy timber adjoining the above town, Lincoln, and several others. He also bought a tract of forty thousand acres in the un-granted lands of New Hampshire and several other tracts…*
>
> *In 1845, Mr. Norcross built a large lumber mill at Lowell, where, with gangs of saws, upright and circular, he wrought out much of the lumber for the mills and dwellings of the city. This mill was twice destroyed by fire, but was soon rebuilt. He also built a large mill at Lawrence, which was managed by his brother, J.W. Norcross. Mr. Norcross died in 1860, since which time the business has been conducted by I.W. Norcross, Charles W. Saunders and N.W. Norcross.*

It was in 1864 that Charles W. Saunders helped his brother Daniel secure the rights to the Elkins Grant before eventually joining him in the Sawyer River enterprise.

Once the Saunders family had control of the area and had finally selected a site of operations beside the Sawyer River there came a series of acts of incorporation. First, in 1874 was the founding of the Grafton County Lumber Company. Chapter 111 of the Acts of New Hampshire of 1875 gave the rights of incorporation for the Sawyer River Railroad to the three brothers of the Saunders family, namely Daniel, Charles W. and Caleb. They were "authorized and empowered to locate, construct and maintain a railroad not exceeding six rods in width from some convenient point at the height of land dividing the waters between the Pemigewasset and the Sawyer Rivers."

It was not until 1875 that a railroad could be laid in this confined valley; however, when the Portland & Ogdensburg Railroad was driven through Crawford Notch it provided a connection with other outside lines. C. Francis Belcher states, "In 1877 the Saunders started laying rails for their line up Sawyer River, and by agreement with the Eastern Railroad (later part of the Boston & Maine) they leased three miles of relay rail and other track equipment. This was enough equipment for connections and yards at Sawyer River Station and Livermore and the two miles in between."

In 1909, the Boston & Maine renegotiated these contracts to provide for increased rentals and additional replacement rails and equipment.

The locomotive for the line was named the C.W. Saunders. It was a 0-4-0 wood-burning switcher bought new in 1876 from the Portland Company. For more than forty years the locomotive faithfully operated in the woods carrying large loads of logs to the sawmill.

The Logging Railroads in the White Mountains

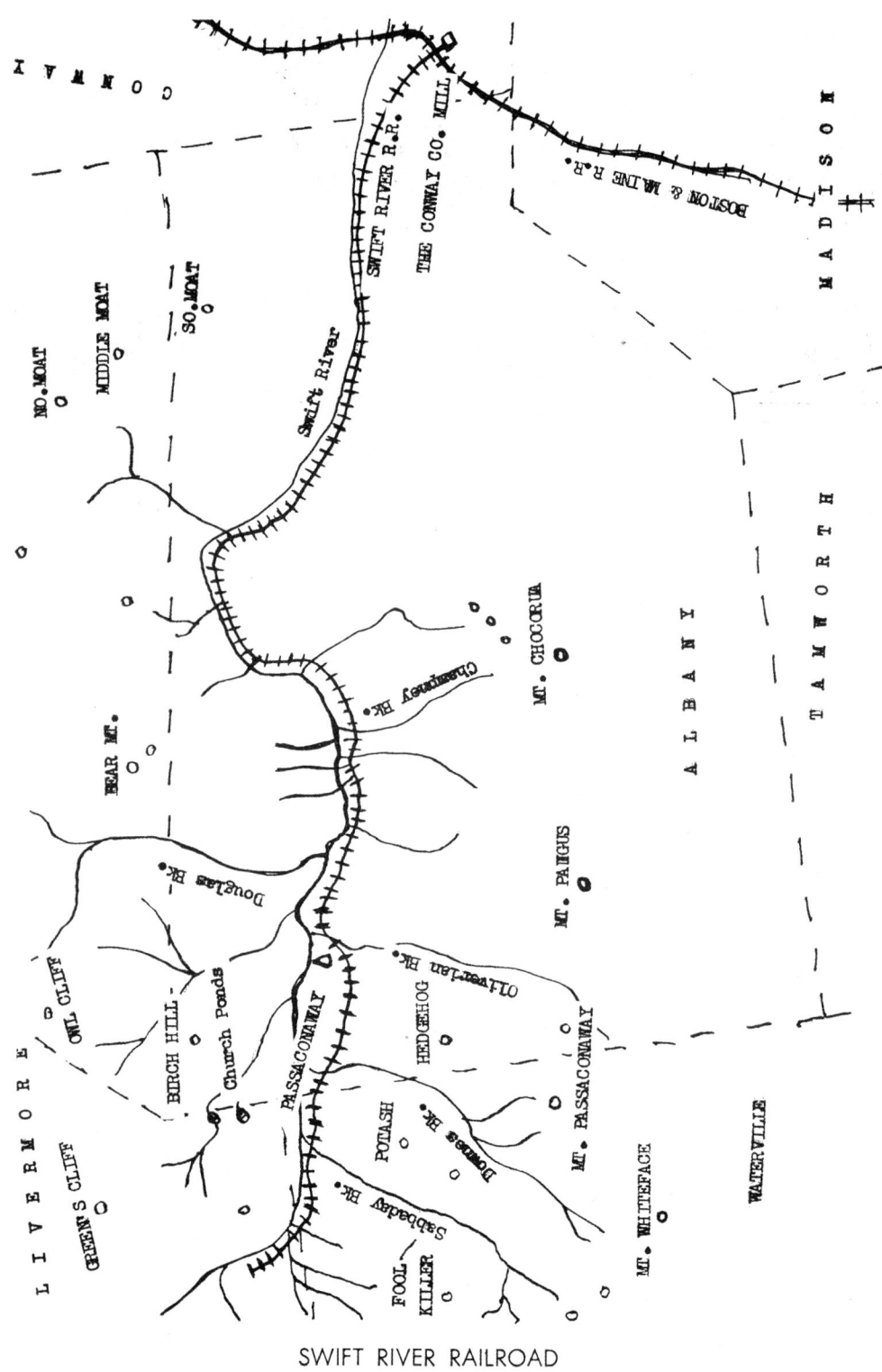

A map of the Swift River Railroad, circa 1910. *Courtesy of the Appalachian Mountain Club.*

In Belcher's *Logging Railroads of the White Mountains*, he records, "Since the Saunders logged their territory with selective cutting methods, the length of the operating section of the track varied greatly from year to year. Engines and log trains ran up and out from the upper camp, Camp 7, in three separate periods over the C.W. Saunders locomotive."

To place the Saunders family of Sawyer River in proper prospective with their rightful niche in the legacy of the White Mountains, it should be known that they never asked for the limelight, which so often had been given to their contemporaries—the wasteful lumber barons.

The Conway Lumber Company Operations
The Swift River Railroad (1906–1916)

At the height of the cutting, when there was a total of twenty miles of logging railroad in the Saco Valley, the lumbermen kept four Shay and Climax logging engines, forty-five sets of log trucks and two cabooses busy shuttling up and down from the broad watershed to the sawmill. When four engines were not enough to handle the loads of logs, the company would lease any available Boston & Maine engine to take care of the extra. During this ten-year stretch, foreign tongues, particularly French-Canadian, were heard more frequently than the native twang.

The Intervale was the only King's Pine country in the White Mountains. It was the home of persevering pioneers, such as Shackfords, Georges and Allens, long before any major lumbermen arrived. This was the country that was finally reached by the Swift River Railroad in 1906. At the Conway end this railroad bed was essentially the base of what is now the Kancamagus Highway, well beyond Passaconaway or Albany Intervale. When the Swift River Railroad reached Passaconaway in 1906, it was forced into service immediately by the popular cry for the preservation of these mountains from the clearing of forestland by the lumber kings.

The Passaconaway country, the Swift River and Albany were part of an intense ten years during the Swift River Railroad era. Nonetheless, Passaconaway has absorbed the signs of this time and is returning more to wilderness with each passing year about as completely as one of the Swift River logging trains was swallowed up by a snowstorm, described by Charles E. Beals in *Passaconaway*:

> *Hoooo! Hoooo! Suddenly shrieked something a few rods ahead. Coming, as I did, out of the depths of the wilderness, it sounded uncanny and almost supernatural. But the next instant the mystery was solved, for there leaped into view, about fifty feet below us and near the riverbank, a locomotive of the lumber train. With a great puffing, rattling and clanging, the train of perhaps thirty little logging cars, loaded high with snow-covered logs, rushed into view. Almost as quickly as it had come, with a clanking and creaking and squeaking of breaks, it disappeared. Again the brownish-white snow curtain shut out the scenery, and we were once more alone amid a solitude of spinning, driving flakes.*

The Logging Railroads in the White Mountains

Railroads left more of a mark on the land than just the clear-cut mountains. Fires were a major cause of concern in the mountains. Some of the fire scars are still visible on the north slopes of the Sandwich Range.

As early as February 1893, Julius H. Ward published an article entitled "White Mountain Forest in Peril" in the *Atlantic Monthly*. Sounding a note of warning, he told of the wasteful and destructive lumbering—"unwise and barbarous," he characterized it—giving a number of typical instances of the results of such cutting and asserting that a few lumbermen have it in their power "to spoil the whole White Mountain region for a period of fifty years, to dry up the East Branch of the Pemigewasset, to reduce the Merrimack to the size of a brook in summer, and to bring about a desolation like that which surrounds Jerusalem in the Holy Land." He declared that the protection and preservation of these forests should be regarded as a national problem, as the White Mountain forests were "worth infinitely more for the purpose of a great national park than for the temporary supply of lumber which they furnish to the market."

On January 10, 1903, the New Hampshire Legislature passed a bill favoring the proposal to establish a White Mountain reserve, giving the state's consent for the acquisition of lands that the federal government might need to purchase for the purpose.

At the same session, the legislature authorized and directed the State Forestry Commission to have the Department of Agriculture's Bureau of Forestry examine the forestlands of the White Mountains. To protect this area and other vast tracts of land in the White Mountains from private logging operations, landslides and fire, the Society for the Protection of New Hampshire Forests was established. In February 1911, the Sixty-first Congress passed a bill for the protection of the White Mountain forest. The bill became law when President William Howard Taft signed it on March 1, 1911.

For over a hundred years the railroad was king of transportation throughout New England, and the Boston & Maine Railroad was a New Hampshire dynasty. The B&M once transported many along the Merrimack River to the Lakes Region; up the stately, pastoral Pemigewasset Valley to Franconia; over the highlands along the Ammonoosuc River to Fabyan's and the base of the Presidential Range; and also through the picturesque Saco River Valley and Crawford Notch. May we preserve its memory, and let us not forget the early logging railroads and camps and the impact they made on our forests.

In recent decades railroad passenger service has become limited to tourist railroads and a few short miles of Amtrak service. Many railroad rights of way have been abandoned and lost, except to memory. Hopefully, this journal has refreshed the romance and celebration of those railroad years and especially the Boston & Maine Railroad—the New Hampshire dynasty.

A History of the Boston & Maine Railroad

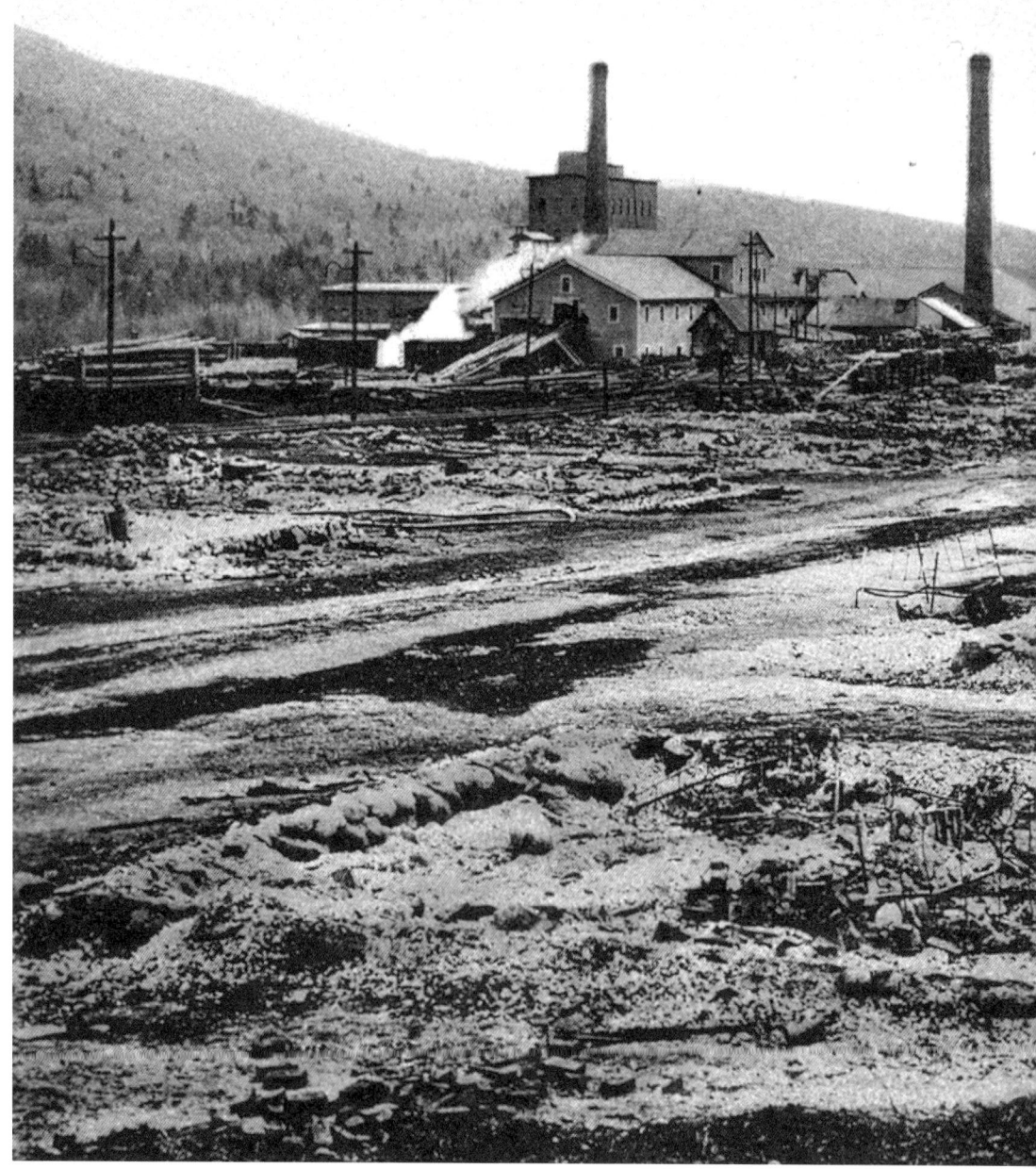

The ruins of Main Street, Lincoln, New Hampshire, looking south after fire. The fire of May 13, 1907, left Main Street, which included most of Lincoln's business district, in ruins. This view includes the sawmill on the left.

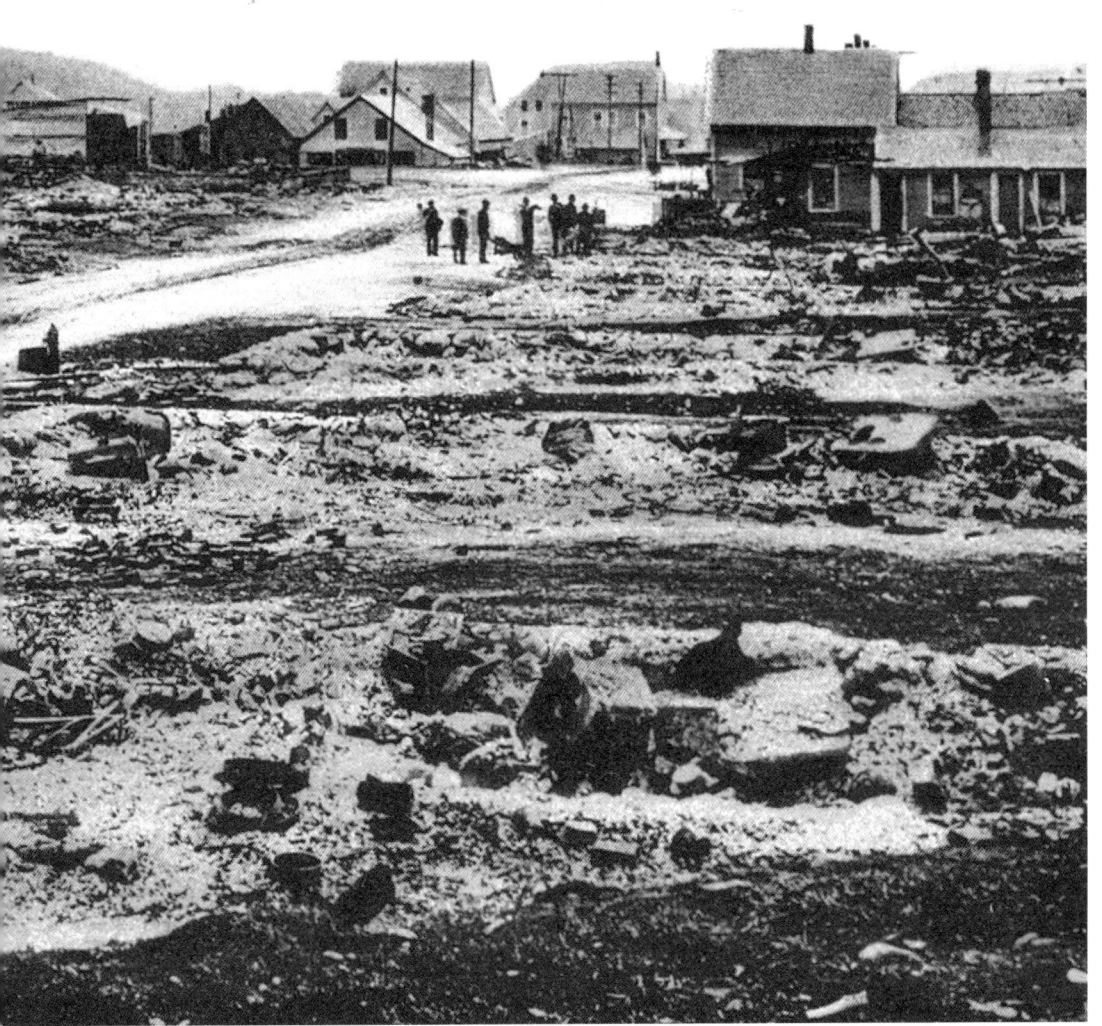
king south after the fire.

A History of the Boston & Maine Railroad

"Your Dollar Will Stop This." This illustration was published in the December 27, 1927 edition of the *Boston American*. The notice was seeking $82,800 in contributions to preserve the "6,000 acres of woodland" that were "seriously threatened by the lumberman and his axe."

The Logging Railroads in the White Mountains

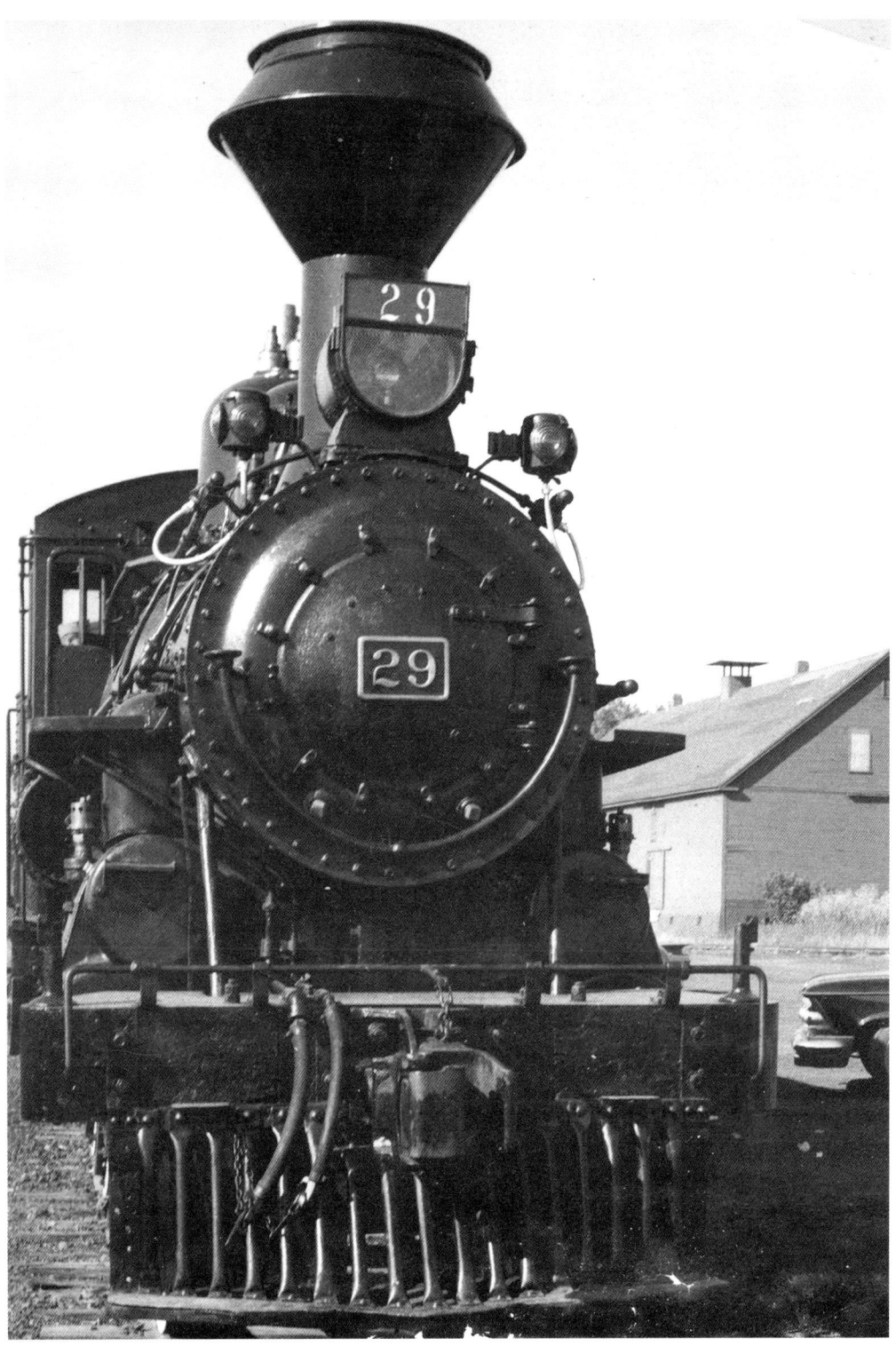

Boston & Maine locomotive No. 29, early twentieth century. *Courtesy of the B&M Railroad Historical Society.*

BIBLIOGRAPHY

Alden, John C. "Snow Train Memories." *Boston & Maine Bulletin*, December 1973.

Anderson, John, and Morse Sterns. *The Book of the White Mountains*. New York: Minton, Balch & Company, 1930.

Appalachia. Vol. XI. Boston, 1907.

Beals, Charles E. *Passaconaway in the White Mountains*. Badger Publishers, 1916.

Belcher, C. Francis. *Logging Railroads of the White Mountains*. Boston: Appalachian Mountain Club, 1980.

Bolles, Frank. *At the North of the Bearcamp Water*. Cambridge, MA: Riverside Press, 1893.

Boston & Maine Railroad. *Among the Mountains*. Boston, 1898.

———. Employees timetables (collection of J.R. McFarlane).

———. *New England Vacation Resorts*. Boston, 1907.

———. *Summer Saunterings*. Needham, MA, 1886.

———. *The White Mountains of New Hampshire*. Boston, 1902.

Browne, G. Waldo. *The Franconia Gateway*. Manchester, NH, 1920.

Burt, Frank H. *Among the Clouds*. Gorham, NH, 1888.

Chittenden, Alfred K. "Forest Conditions of Northern New Hampshire." *U.S. Department of Agriculture, Bureau of Forestry Bulletin*. 1904–05.

Concord & Montreal Railroad. *Summer Outings in the Granite State*. Boston, 1890.

Drake, Samuel A. *The Heart of the White Mountains*. Boston, 1882.

———. *Lumbering in New Hampshire*. Forestry and Irrigation, American Forestry Society. 1902.

Dwight, Timothy, and Barbara Miller Solomon. "Travels in New England and New York." *The New England Quarterly* 43, no. 2 (June 1970): 344–46.

Goodrich, Hanson, and Dorothy M. Goodrich *Bicentennial Commemorative Book of the Town of Lincoln. 1764–1964*.

Gove, Bill. *Logging Railroads Along the Pemigewasset River*. Littleton, NH: Bondcliff Books, 2006.

Harrington, Karl P. *Walks and Climbs in the White Mountains*. New Haven, CT: Yale University Press, 1926.

Bibliography

Heald, Bruce D. *Boston & Maine in the 19th Century*. Charleston, SC: Arcadia Publishing Company, 2000.

———. *Boston & Maine in the 20th Century*. Charleston, SC: Arcadia Publishing Company.

———. *Follow The Mount*. Meredith, NH, 1968.

———. *Steamboats in Motion*. Meredith, NH, 1980.

Johnson, G.L. *Gordon Pond Railroad*. 1908.

Kilborne, Frederick W. *Chronicles of the White Mountains*. Boston, 1916.

King, Thomas Starr. *The White Hills*. Boston: Crosby and Nichols, 1864.

McClintock, John N. *New Hampshire History*. Concord, NH, 1889.

Meader, J.W. *The Merrimack River*. Concord, NH: B.B. Russell, 1871.

Metcalf, H.H. *Granite Monthly* 13 (1894).

Moses, George. *Granite Monthly*, 1892.

New Hampshire Railroad Commission, The New Hampshire Department of Transportation. 1900.

Pillsbury, Hobart. *New Hampshire History*. New York: Lewis Historical Publishing Company, 1929.

Poole, Ernest. *The Great White Hills of New Hampshire*. Garden City, NY: Doubleday, 1946.

Poor, Henry V. *History of the Railroads and Canals of the United States of America*. New York: John H. Schulz & Co., 1860.

Sewell, Richard H. *A Concise White Mountain Guide*. Littleton, NH, 1998.

———. *John Parker Hale and the Politics of Abolition*. Cambridge, MA: Harvard University Press, 1965.

———. *Tourists' Guide Book for the State of New Hampshire*. Concord, NH, 1902.

Sweetzer, M.F. *Chisholm's White Mountain Guide*, Portland, ME, 1907.

———. "Echo Explorations." *The White Mountain Echo*. Bethlehem, NH, 1879.

———. *Osgood's White Mountains*. Boston, 1876.

———. *The White Mountains (A Handbook for Travelers—A Guide)*. Boston: James R. Osgood & Company, 1876.

Waite, Otis, ed. *Eastman's White Mountain Guide*. Concord, NH: C.E. Eastman, 1895.

Wallace, R. Stuart, and Lisa B. Mausolf. *New Hampshire Railroads Historic Context Statement*. Concord, NH: New Hamshire Department of Transportation, 2000.

Ward, Reverend Julius H. "The White Mountains in Peril." *Atlantic Monthly*, 1893.

Wilder, H. Arnold. "Passengers to the White Mountains." *Boston & Maine Bulletin Summer*. 1976.